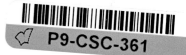

FLOWERS A to Z

with DONNA DEWBERRY

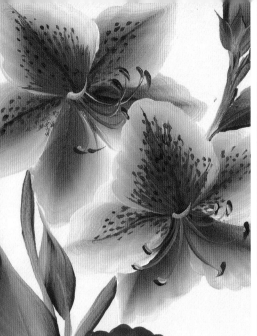
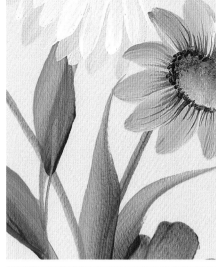
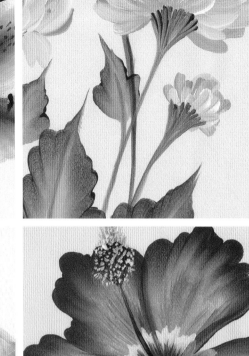
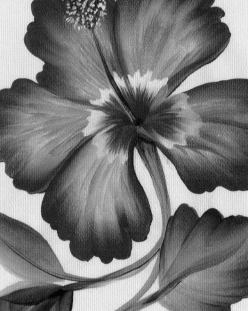
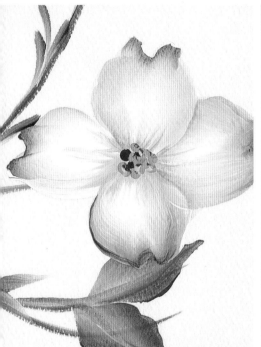
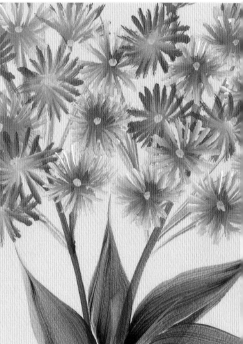
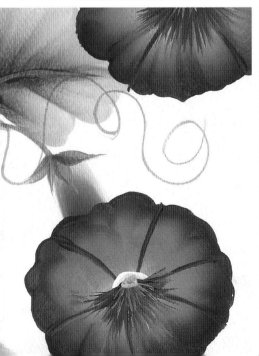
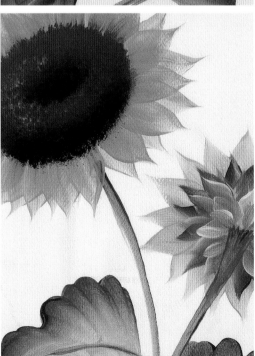

FLOWERS
A to Z
with DONNA DEWBERRY

NORTH LIGHT BOOKS
CINCINNATI, OHIO
www.artistsnetwork.com

Flowers A to Z with Donna Dewberry.

Published by North Light Books,
an imprint of F+W Publications, Inc.,
4700 E. Galbraith Rd., Cincinnati, Ohio, 45236.
(800) 289-0963. First edition.

Other fine North Light Books are available from your local bookstore,
art supply store, or direct from the publisher.

08 07 06 05 5 4 3

Library of Congress Cataloging-in-Publication Data

Dewberry, Donna S.
 Flowers A to Z with Donna Dewberry : more than 50 beautiful
blooms you can paint / Donna Dewberry
 p. cm.
 Includes index.
 ISBN 1-58180-624-8 (alk.paper) -- ISBN 1-58180-484-9 (pbk. :
alk. paper)
 1. Flowers in art. 2. Painting--Technique. 3. Decoration and
ornament--Technique. I. Title.

ND1400.D43 2004
758´.42--dc22

 2003071064

EDITORS: KATHY KIPP AND GINA RATH
PRODUCTION COORDINATOR: KRISTEN D. HELLER
DESIGNER: MARISSA BOWERS
LAYOUT ARTIST: KATHY BERGSTROM
PHOTOGRAPHER: CHRISTINE POLOMSKY

METRIC CONVERSION CHART

TO CONVERT	TO	MULTIPLY BY
Inches	Centimeters	2.54
Centimeters	Inches	0.4
Feet	Centimeters	30.5
Centimeters	Feet	0.03
Yards	Meters	0.9
Meters	Yards	1.1
Sq. Inches	Sq. Centimeters	6.45
Sq. Centimeters	Sq. Inches	0.16
Sq. Feet	Sq. Meters	0.09
Sq. Meters	Sq. Feet	10.8
Sq. Yards	Sq. Meters	0.8
Sq. Meters	Sq. Yards	1.2
Pounds	Kilograms	0.45
Kilograms	Pounds	2.2
Ounces	Grams	28.3
Grams	Ounces	0.035

DEDICATION

I would like to dedicate this book to my oldest daughter, Maria Donna Dewberry. Maria was born in 1977 and passed away in the year 2000. Maria was away at school and passed away unexpectedly. As many of you know, the loss of a child can be a very trying and defining moment in your life. I dedicate this book to her because Maria could see the inner beauty in everyone and everything that she came in contact with. Maria was studying to be a Social Worker working with children, which she enjoyed more than anything. Child development and child welfare were an important part of her life. Maria had a great mission and that mission is carrying on today with the Maria Dewberry Children's Foundation.

I WOULD LIKE TO SHARE A STORY WITH YOU ABOUT MARIA.

Every year in the spring, Maria would spend time helping in the Special Olympics. One year she met a young man who really wanted to win. Don't we all want to win? Whether it is the Special Olympics or running around the block, we all want to win. And this young man had a strong desire to win as well. Unfortunately when the race was over, he did not win. In fact he came in last and far behind all the others. Maria talked to him and tried to bolster his confidence but his heart was broken. That night when she came home she shared something with us that was so special. She told us, "Everything is so simple; it's just that we make it difficult. This young man wanted to win so badly, however, he was so caught up in wanting to win the race that he forgot he had already won. He wasn't even supposed to run the race. Physically he shouldn't have been in the race, but he was and he finished. In his own right he was a miracle, he did win. There is nothing wrong with wanting to win, but when you disregard your overall achievements you make it difficult to appreciate the little things that you won on your way to getting there."

I wanted to dedicate this book to Maria because when I look at a flower I see the simplicity of the flower and how little things are combined to create it. Even the flowers that are intricate are put together simply. Since Maria shared that story with us, shortly before her passing, I've noticed that I have been looking at things differently. Thing are simple, we are the ones that make things difficult, we make things complicated. Let's try to keep things simple. When you paint, what you do may not be perfect to your eyes or anyone else's, but when you finish the race, it will be beautiful. Simply Beautiful. ❋

ACKNOWLEDGMENTS

I would like to acknowledge all the people who have tried decorative painting, who will try decorative painting, who are afraid to try decorative painting, and who have anything to do with decorative painting. Allow yourself the opportunity to try; acknowledge the fact that you do have special talents. You can share what you see with others through decorative painting. You can share your inner beauty as you paint. I would like to acknowledge all those in the industry who do what they do to make decorative painting available to anyone. I would like to acknowledge the artists in the industry who share with each of us the beauty they see. It is an amazing thing that such a group of people exist. I know that decorative painting has changed my life. It has given me the ability to see the inner beauty and simplicity of all things. If it weren't for the people in the industry — artists, writers, publishers, and you, there would not be as much beauty as there is for us to enjoy. I would like to thank each of you for the contribution you have made, do make or will make to the art of decorative painting. Thank you.

TABLE OF CONTENTS

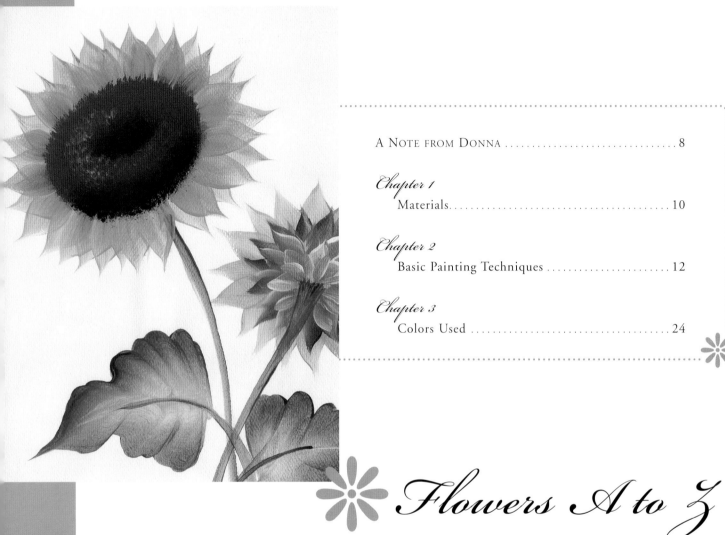

Flowers A to Z

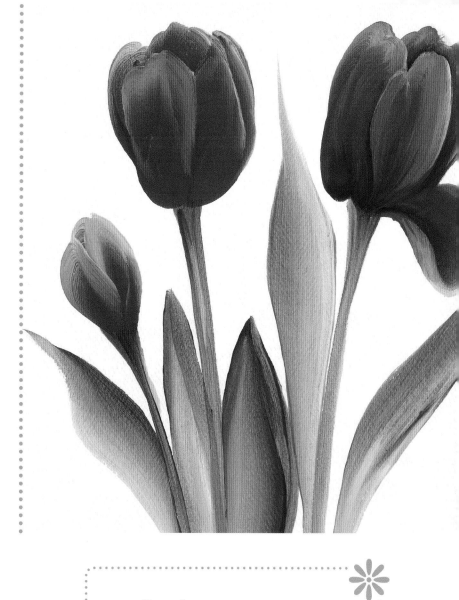

A NOTE *from* DONNA

Welcome to the beautiful world of flowers! I invite you to come along with me as we discover the joy and satisfaction of painting flowers of all kinds and all colors.

I believe all flowers are beautiful, and I also believe that you will see a beauty in each flower that no one else will see. So if you paint the flower you see, whether it is beautiful to others or not, you give that flower a new life. Of all the things I paint — landscapes, animals, fruits, vegetables and more —flowers will always be my favorite.

When I began working on this book, I knew I wanted to paint as many different flowers as possible, hopefully at least one for almost every letter in the alphabet, yet I wasn't really sure there was a flower for every letter from A to Z. But as I learned more about them, I realized that, from Asters to Zinnias and almost everything in between, there are a huge number of flowers to choose from. Some are more well known than others. Some may be indigenous to your area and others may not be. For this book, I concentrated on the most popular and beloved flowers, and I used the common name for each instead of its botanical designation.

Besides enjoying my own gardens at my home in Florida, I love looking at pictures of flowers in books, magazines and catalogs. It's the fastest and easiest way to learn about a flower's structure, its colors, the placement of its leaves and stem, and the shape of its petals. I use these as reference photos, then I paint my own interpretation and use the colors I like.

This book is designed to do just the same. I encourage you to enjoy your own creativity as you paint your favorite flowers from this book. For that reason, I have not included line drawings or patterns in this book — I feel they may take away from the creativity in your design, for the creativity comes from within you. However, if you want to make your own pattern, just place a sheet of clear acetate over the full page

photo of the painted flower and use a black, fine point permanent pen to trace the major outlines. Try not to copy the smallest details — freehanding them will produce a more lively painting and will give you the confidence to break your reliance on patterns.

Although I am now very passionate about decorative painting, in the beginning I never considered myself a decorative painter. I wasn't even sure that such a distinction existed. I just knew I liked to sit down and use a variety of brushes and paints to create new designs and embellish those wonderful items I seemed to have a knack for finding at garage sales, or what my husband Marc referred to as "junk sales." (See pages 140-141 for some great examples of found treasures and other inexpensive surfaces I have painted with fresh and colorful floral designs.) Being the mother of seven children, I had many responsibilities, not only with the children but with running the household. I needed a creative outlet for myself and decorative painting became that outlet. It was something I could do after the children had gone to bed, or when there wasn't a soccer game or recital to attend.

In the beginning, I was not a great painter and to this day I am not an advocator of "great" painting. Instead, I am an advocator of the "love" of painting, the passion to create and embellish, to define and make something beautiful. Let yourself be part of this world. The feeling it gives you is not just about painting, it's the freedom to express yourself in a way that no words can describe. It is my hope that this book will help you express yourself in many different ways.

MATERIALS

PAINTS

PLAID FOLKART PAINTS

Plaid FolkArt acrylic colors are high-quality bottled acrylic paints. Their rich and creamy formulation and long open time make them perfect for decorative painting. They are offered in a wide range of wonderful pre-mixed colors and in gleaming metallic shades.

PLAID FOLKART ARTISTS' PIGMENTS

Artists' Pigments are pure colors that are perfect for mixing your own shades. Their intense colors and creamy consistency are wonderful for blending, shading and highlighting. Because Artists' Pigments are acrylic paints, they're easy to clean up.

PLAID FOLKART FLOATING MEDIUM

Floating medium allows the paint to stay wetter, which helps you with your brushstrokes. When painting the one-stroke techniques, please do not follow the instructions on the bottle. This will make your strokes very muddy looking. Instead, load your brush as instructed in the Techniques section, then dip the tip of the bristles straight down into the puddle of floating medium. Stroke two or three times on your palette; then you are ready to paint.

BRUSHES

FLAT BRUSHES

Painting the one-stroke technique requires the use of flat brushes. The Donna Dewberry One-Stroke Brushes are designed with longer bristles and less thickness in the brush body to allow for a much sharper chisel edge. A sharp chisel edge is essential to the success of the one-stroke technique, since most strokes begin and then end on the chisel edge.

ANGULAR BRUSHES

Angular brushes can make it easier to paint such things as rose petals and vines. The One-Stroke Angular Brushes come in 3/8-inch (0.95cm), 5/8-inch (1.6cm) and 3/4-inch (1.9cm) sizes.

SCRUFFY BRUSHES

The scruffy brush that I have created is ready to be used straight from the package. All you have to do is "fluff the scruff." Remove the brush from the package and form the natural hair bristles into an oval shape by gently pulling on them. Then twist the bristles in your palm until you have an oval shape. Now you are ready to pounce into the paint and begin. When fluffed, the scruffy brush is used for painting moss, wisteria, lilacs, some hair and fur, faux painting and shading textures. Do not use this brush with water. To clean the scruffy brush, pounce the bristles into the brush basin. Do not rake them or you will break the natural hair bristles.

LINER BRUSHES

There are two sizes of liner brushes. The no. 1 script liner (sometimes referred to as the mini) is usually used for small detail work when more control is needed. The no. 2 script liner is used when less control is needed.

The liner brush is used with paint of an "inky" consistency. To create this consistency, pour a small amount of paint onto your palette. Dip the liner brush into water, then touch the water to your palette, next to the paint. Do this three or four times. Roll your brush where the water and paint meet to mix them until you have an inky consistency. Don't mix all of the paint with the water or your mixture will be too thick. Roll the brush out of the inky paint to prevent it from dripping. See page 23 for instructions on how to

load the liner brush. Clean these brushes the same way as the flat brushes. Once again, be gentle but clean them thoroughly.

Time Saving Tip

To save time when starting a project, properly load every brush you will be using ahead of time. Dip the tip of each handle into the main color on the loaded brush, then place all the brushes into the filled water basin. When you are ready to paint, take your brush out the the water basin and lay it on a fresh paper towel to drain the excess water. Brush back and forth across the palette a few times and you are ready to go.

Palette

The FolkArt One-Stroke Paint Palette that I use is a durable and handy palette. It allows you to keep your paint and tools at your fingertips. The palette has numerous paint wells, holes for brushes and a base for paper towels. The palette is designed for left- or right-handed use and holds a 9-inch (23cm) disposable foam plate. What I especially like about the palette is how comfortable it is. There is no need to grip the palette, as it is designed to balance comfortably on your hand.

Here are the paints, brushes, palette and brush basin I used for the projects in this book. The brushes are, from top to bottom: 2 sizes of angular brushes, 6 sizes of flats, 2 liners, and 3 scruffy brushes. The brush on the palette is a no. 8 filbert. The instructions for each flower painting lists the brush sizes you will need as well as the paint colors so there's no guesswork.

BASIC PAINTING TECHNIQUES

TRACING THE PATTERN

I encourage you to learn to paint without relying on patterns, so you will not find them in this book. My one-stroke painting is simple and allows you to easily create beautiful flowers. However, if you feel you absolutely must have a pattern, you can lay tracing paper over any flower picture in this book and use a fine point permanent marker to trace the flower. Then transfer the pattern to your painting surface using graphite paper underneath your tracing.

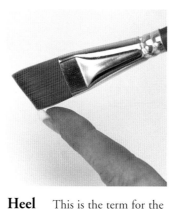

PARTS OF THE BRUSH

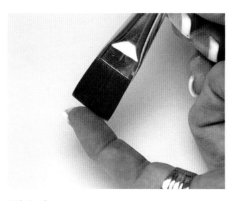

Chisel This is the edge of the flat or angled brush bristles.

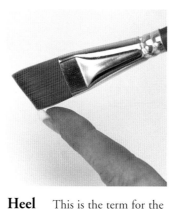

Heel This is the term for the short bristles of the angle brush.

Toe This is the term for the long bristles of the angle brush.

Loading the Brush with Paint

Double Loading

1 To double load your brush, dip a corner of the brush into the first color. Make sure the brush is angled when you dip it.

2 Tip the opposite corner into the second color. This forms triangles of paint on each corner of the brush.

3 Brush back and forth on the palette, pushing down hard to work the paint into the brush. Don't spread the paint out too far on the palette—no longer than about two inches (5cm)—or you will wipe the paint off your brush instead of working the paint into the bristles.

4 Repeat dipping the corners into the paint and brushing back and forth on the palette two or three times or until you've worked the paint two-thirds up the brush bristles.

5 This is how your brush will look when properly loaded. Once it's fully loaded, dip each corner ever so lightly into each paint color one more time, but don't stroke on your palette. Now you're ready to paint.

MULTI-LOADING

Double load your brush. Then ever so lightly dip the light corner (yellow as shown) into the third color (a darker yellow as shown). You can add even more colors if you want. Add darker colors to the dark side of the brush and lighter colors to the light side.

SIDE LOADING

 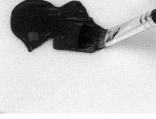

1 To sideload the brush, begin by pulling some paint from the edge of the first paint puddle.

2 Stroke right next to the second color puddle to pick up a little paint on the edge of the brush.

ADDING FLOATING MEDIUM

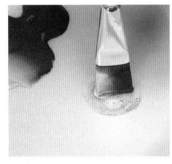

1 If the bristles begin to feel dry, add floating medium. Dip the loaded brush straight into the puddle.

2 Work the medium into the bristles on your palette. Use floating medium only every third or fourth stroke.

LOADING THE BRUSH FOR FLOATING

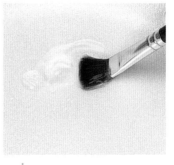

1 Load the brush by pulling the floating medium from the edge of the puddle (just as you did for side loading).

2 Sideload ever so lightly on the corner of the brush.

MAKING A STARTER STROKE

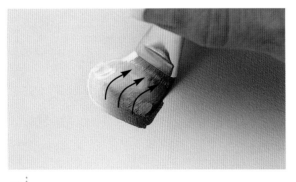

1 Every time you load your brush and before you apply a stroke to your painting, you need to do a starter stroke. A starter stroke is actually three or more strokes right on top of each other. Touch and push upward.

2 Then lift and repeat three or more times until the color is how you want it to be. The starter stroke spreads the bristles and blends the color.

BASIC FLOWER PETAL STROKES

DAISY STROKE

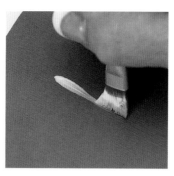

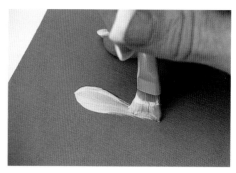

1 This stroke is used for many different flowers—daisies, asters and zinnias are just a few. Double load the brush with the flower colors you need. Begin on the chisel and then lean.

2 Pull and lift back up to the chisel to finish the stroke.

3 For a thicker petal, touch down and lean, pushing a little harder for the thickness you want. Then lift to the chisel.

DAISY SIDE PETAL (COMMA STROKE)

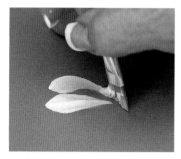

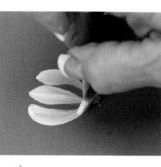

1 Begin with one straight daisy stroke then add the curved side strokes.

2 Lean and curve as you lift to the chisel to create a comma shape.

CONE FLOWER PETAL

Double load the brush. Touch down, lean and as you pull, and then lift to the chisel.

TEARDROP

Begin on the chisel, touch, push, curve around and lift back up to the chisel.

SUNFLOWER PETAL

This is the same stroke as a one-stroke leaf. Push, turn the brush, and then lift to the tip of the leaf.

SEA SHELL STROKE

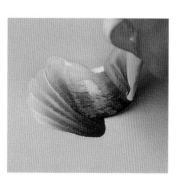

1 This stroke is used for many flower petals and for large leaves. Begin after the third starter stroke. Wiggle out and slide back in half way. Then wiggle out for the second section. Again, slide back half way and wiggle out for the third section, pivoting the dark edge. Keep your eye on the outside (light) edge, which forms the sea shell shape.

2 Continue wiggling. Once you see the sea shell shape, lift and slide evenly up to the chisel to end the stroke.

Basic Flower Petal Strokes, continued

Trumpet Flowers with Ruffled Edge Petals

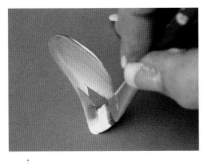 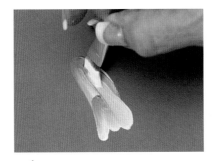 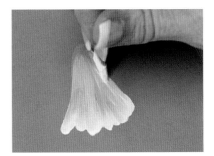

1 Paint the trumpet using a C-shaped stroke. Begin on the chisel, push up, curve around, and then lift back up to the chisel.

2 Now paint the petals. Begin on the chisel, wiggle, and then slide back down into the trumpet.

3 Repeat for the rest of the petals. When you feel you have enough, slide back up to the trumpet, ending on the chisel.

Five-Petal Flowers

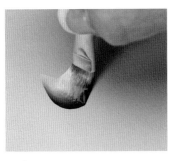 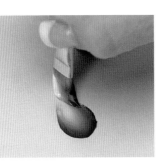

Layering Petals

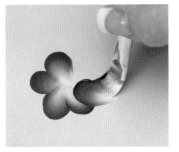

1 Double load the brush. Paint a short teardrop-shaped stroke: touch, push and curve around.

2 Then lift back up to the chisel.

Paint the first layer of petals. Then overlap the next layer of petals on top of the completed blossom as shown.

Jagged-edged Petals

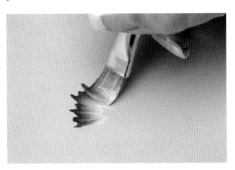

Double load the brush. Stay on the chisel, touch, and use a quick zig-zagging motion.

Water Lily Petals

1 Slide to the tip and lean down.

2 Reverse direction, wiggle, lean, and then lift to the chisel.

AZALEA OR ORCHID PETALS

1 Slide up to the point, wiggling the brush slightly as you go.

2 Reverse direction, wiggle, lean and lift to the chisel.

OVERLAPPING BUD PETALS

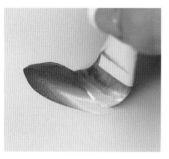 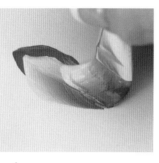 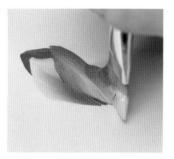 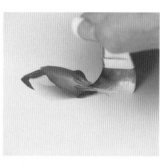

1 Slide up to a slightly rounded point, and reverse direction.

2 Flip the brush and paint the same stroke slightly shorter.

3 Paint the next petal using the same stroke. If you can't see your stroke, flip the brush.

4 For the bud sepal, use tight little chisel-edge strokes until the sepal looks solid.

ROLLED PETALS

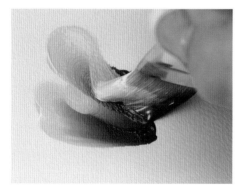 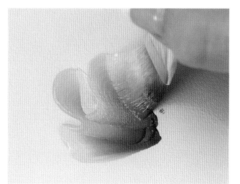

1 Begin on the chisel. Ripple up and then down and then back up again.

2 Now roll the brush over, then roll the brush back over again.

Basic Flower Petal Strokes, continued

Rose

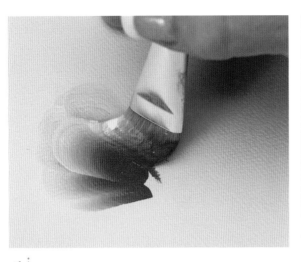

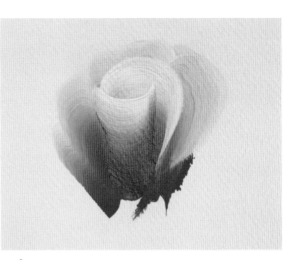

1 Begin with a ruffled back skirt. The inside back petal is a C-shaped stroke going up and over and then lifting up to the chisel.

2 For the next petal, pull across in a U-shaped stroke, stopping short of the side of the back stroke.

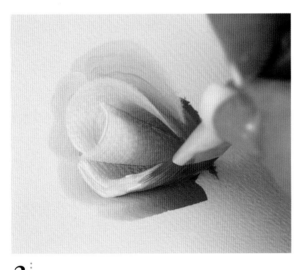

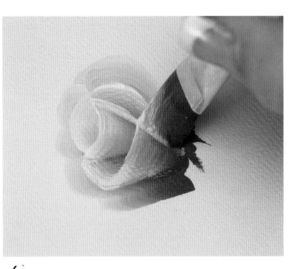

3 Using the angular brush, lean the lighter color out and stroke the other side petal.

4 Then pull out and across, rolling the brush and fingers and pivoting on the heel of the brush (darker color).

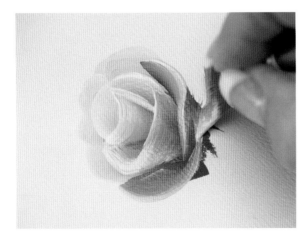

5 Chisel in the last petals, keeping your eye on the light edge. Lead with the heel of the brush.

ROSEBUD

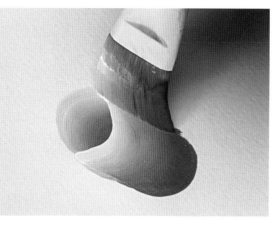

1 Load the brush. Beginning on the chisel, push up and over in a C-shaped stroke. Your eyes should be watching the yellow edge of the brush.

2 Keep watching the lighter edge and form a U-shaped stroke in front of the back stroke.

CALYX

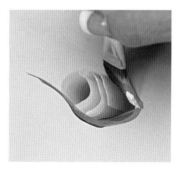

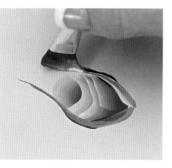

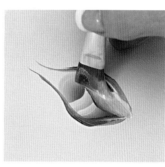

1 Use the angular brush. Touch and pull, leading with the heel of the brush.

2 Lean forward on the chisel of the angle, and then lift to the toe.

3 For the center petal, lean and lift up to the toe right away.

CALLA LILY PETAL

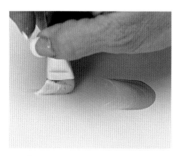

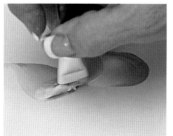

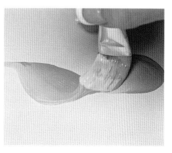

1 Paint the trumpet using a C-shaped stroke. Start at the top of the lily, chiseling down from the top.

2 Lean out and then stand up to the chisel.

3 Then lean to the other side to connect to the trumpet.

Leaves

Long, Slender Leaf

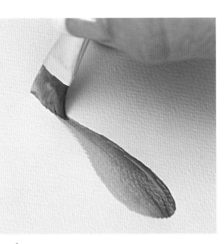

1 Double load the brush. Touch and lean at an angle.

2 Lean at an angle and pull, then twist slightly to slide the green toward the tip as you lift to the chisel.

Hyacinth or Orchid Leaf

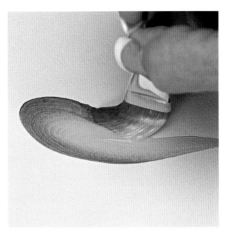

Hyacinth and orchid leaves are formed with a long C-shaped stroke. With a double-loaded brush, slide up on the chisel, make a curve and go back down, lifting up to the chisel at the base.

Rolled Leaf

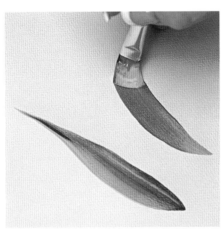

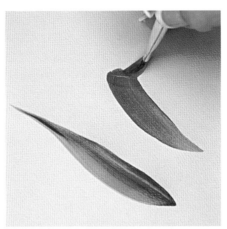

2 To roll the leaf, stand up on the chisel, slide it to the side slightly and start rolling the brush over.

1 The rolled leaf is an even longer long, slender leaf that folds over on itself. With a double loaded brush, touch, lean at an angle and pull.

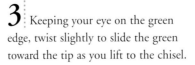

3 Keeping your eye on the green edge, twist slightly to slide the green toward the tip as you lift to the chisel.

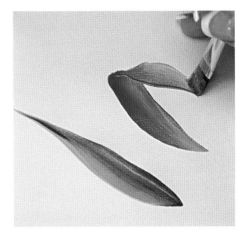

ONE-STROKE LEAF AND CLUSTER

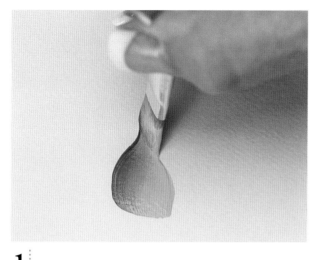

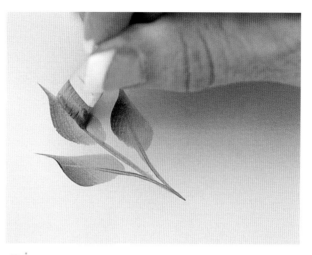

1 Keep your eye on the dark edge as you form the leaf's shape. Begin on the chisel, then push down on the bristles. Turn the green corner of the brush towards the tip of the leaf and lift back up to the chisel.

2 To paint a cluster of one-stroke leaves, stroke the leaves, then using the chisel, pull a stem immediately into the center of each leaf.

FERN STEMS AND LEAVES

1 With a double-loaded brush, chisel in the stem. Touch with the chisel edge, leading with the lighter color.

2 Tilt back slightly on the chisel.

3 Ever-so-lightly drag the last few bristles.

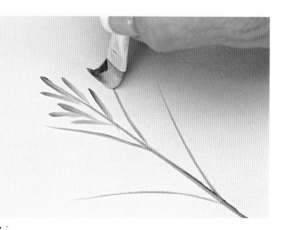

4 After the stem is chiseled in, chisel in a few branches. Then add the leaves. Touch, lean and pull little short strokes to the main stem.

LEAVES, CONTINUED

WIGGLE LEAVES

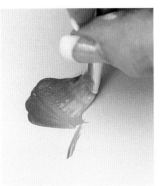 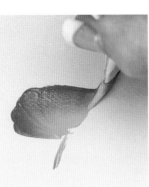 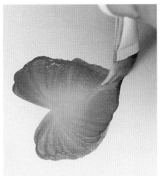 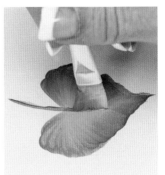

1 Load the brush with two colors. Use the brush's chisel to make a V, which is where you'll begin each side of the leaf. Begin at one side of the V with a starter stroke. Then push and wiggle the brush in and out, pivoting the light edge to create the sea shell shape. Keep your eye on the outside (green) edge, which forms the leaf's shape.

2 Once you see the sea shell shape, stop, lift and slide evenly up to the chisel to end the leaf stroke.

3 Go back to the other side of the V and repeat the steps for the second half of the leaf.

4 Finally, pull a stem into the leaf. With your brush on the chisel edge, lead with the light color and pull the stem halfway into the center of the leaf.

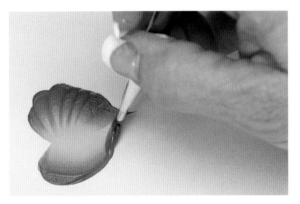

WIGGLE LEAF WITH ONE SMOOTH SIDE

Paint the first half of the leaf exactly as you painted the wiggle leaf. The second half is painted without a wiggle. Keep your eye on the green edge of the brush as you create the leaf shape. Touch, slide, pivot on the lighter side of the brush, then slide evenly up to the chisel.

RUFFLED-EDGE LEAF

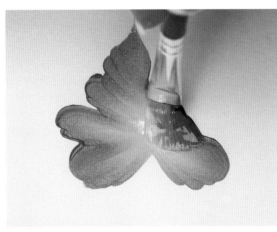 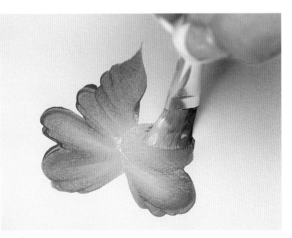

1 Load the brush with two colors. Keeping your eye on the green edge of the brush, wiggle down and slide back to the vein.

2 Slide back out, wiggle down to the tip, turn the brush and then lift and slide to the chisel.

Dip Dots, Vining, and Curlicues

Dip Dots

1 Use the end of the brush to dip into the paint color.

2 Dot onto the surface.

Angular-brush Vining

For those of you who have trouble painting vines with a flat brush, here's my secret weapon —the angular brush. Double load as you would a flat brush. Then as you pull the vine, lead with the heel but drag the toe.

Inky Paint and Curlicues

1 Dip a liner brush into water three times. Then make a circular motion, barely touching the edge of the paint puddle; repeat this a couple of times until you've achieved an inky-thin solution.

2 Then roll the brush out of the inky puddle. Rolling the brush out helps you to make sure the paint is inky and not watery or pasty. Rolling also prevents the paint from dripping. This solution is too watery.

3 This is the inky consistency you want the paint to be.

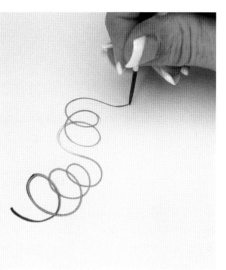

4 To paint curlicues and tendrils, keep the liner brush handle perpendicular to the surface. Brace the brush handle against the second knuckle of your pointer finger and use your little finger to guide you. Move your whole arm, not just your wrist.

COLORS USED

To paint the flowers in this book, I used Plaid FolkArt Acrylic Colors and FolkArt Artists' Pigments. The colors shown here are all the colors I used to paint the individual flowers, leaves and floral compositions. The instructions for each flower list the colors used for that flower. If you are using a different brand of acrylic paint, you can use this chart to mix and match your colors as closely as possible.

PLAID FOLKART ACRYLICS

Berry Wine　　　Engine Red　　　Fresh Foliage　　　Grass Green

Green Forest　　　Licorice　　　Magenta　　　Midnight

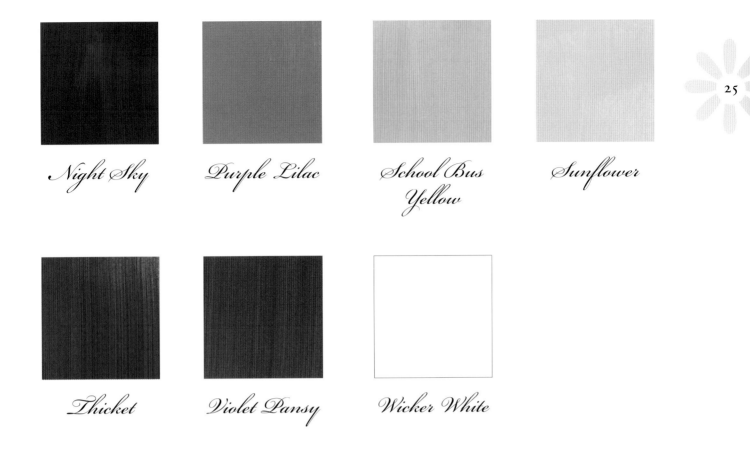

Night Sky

Purple Lilac

School Bus
Yellow

Sunflower

Thicket

Violet Pansy

Wicker White

FolkArt Artists' Pigments

Burnt Carmine

Burnt Sienna

Burnt Umber

Dioxazine
Purple

Pure Orange

Yellow Light

Yellow Ochre

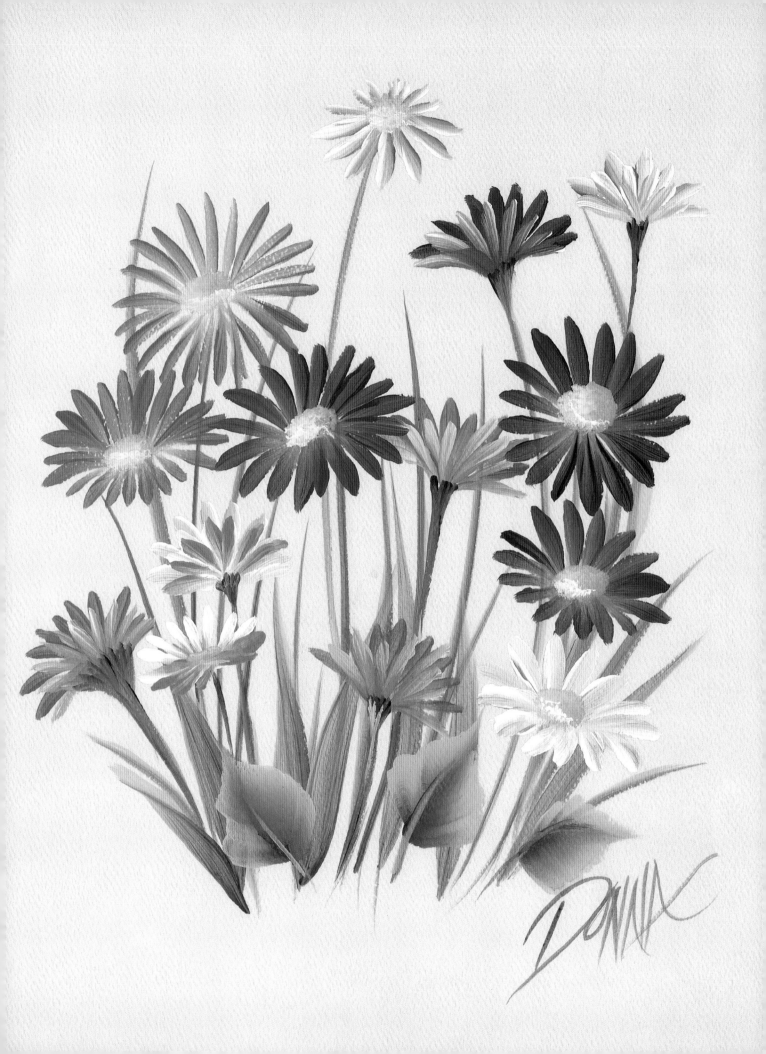

Aster

BRUSHES
- ¾-inch (19mm) flat
- no. 12 flat
- small scruffy

PAINTS
FOLKART ACRYLICS
- Thicket
- Sunflower
- Violet Pansy
- Wicker White
- Purple Lilac
- School Bus Yellow

FOLKART ARTISTS' PIGMENTS
- Dioxazine Purple

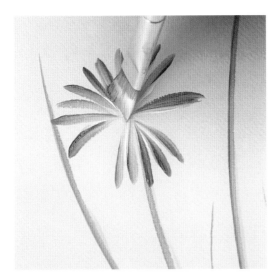

1 Paint in all of the stems with Thicket and Sunflower on the chisel of the ¾-inch (19mm) flat. Using the no. 12 flat with Thicket and Sunflower, paint the leaves; place all the yellow on the outside of the brush.

Paint the petals with Violet Pansy and Wicker White, leading with the white. Begin spacing the petals out like on a clock: 12, 3, 6 and 9; then start filling in the petals between.

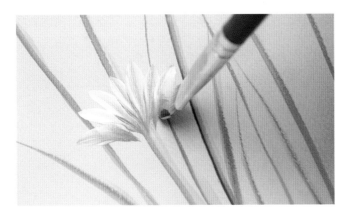

2 Using a no. 12 flat with Purple Lilac and Wicker White, paint half of a bud (the back-facing flower). These are lighter strokes in the back; lead with the Purple Lilac.

3 Add a second shorter layer of petals to the half bud (the back-facing flower), using the same brush and colors but now leading with the white. Also add short petals to the tilted flower.

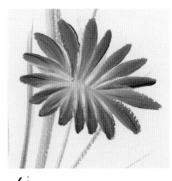

4 For the tilted flowers, use Dioxazine Purple and Wicker White on a no. 12 flat, leading with the white edge of the brush. Painting longer petals in the back and shorter petals in the front makes the blossom look tilted.

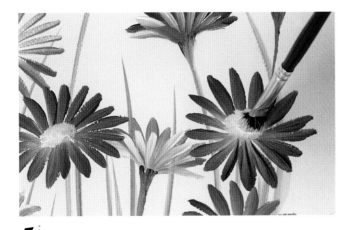

5 Using a small scruffy, pounce the centers with School Bus Yellow and Wicker White. Keep the white close to the petals. .

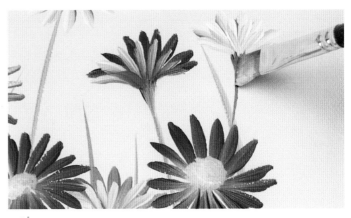

6 Where you see the base of a flower, attach the flower to the existing stem using a no. 12 flat with Thicket and Sunflower.

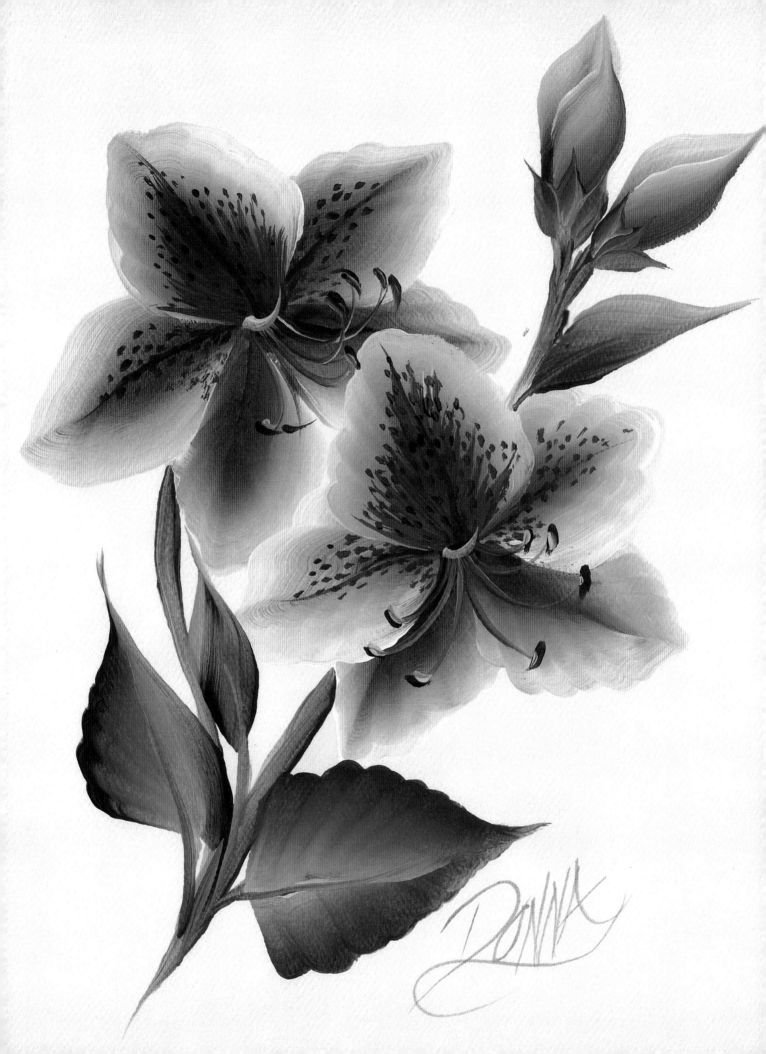

Azalea

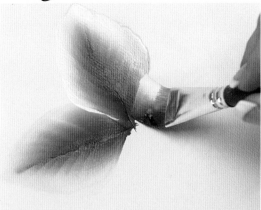

BRUSHES
- ¾-inch (19mm) flat
- no. 2 liner

PAINTS
FOLKART ACRYLICS
- Berry Wine
- Wicker White
- Thicket
- Fresh Foliage

FOLKART ARTISTS' PIGMENTS
- Yellow Light

1 Using a ¾-inch (19mm) flat with Berry Wine and Wicker White, paint the bottom two petals of the Azalea (turning your work to make the strokes easier.) See page 17 for petal instructions.

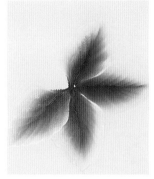

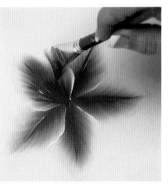

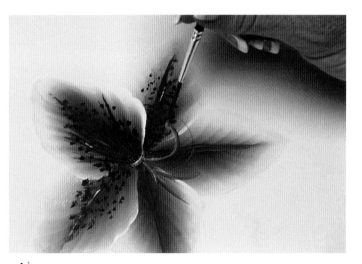

2 Lay the next two petals over top of the first two as shown.

3 Add the back center petal. Pull in the center line using Berry Wine on the chisel of a ¾-inch (19mm) flat. Also add the little fine lines on the petals, using the chisel. Heavily accent the color on the back-center petal.

4 Add the dots on the petals with Berry Wine on a no. 2 liner. Double load a no. 2 liner with Thicket and Yellow Light, and pull the stamens, curving them up.

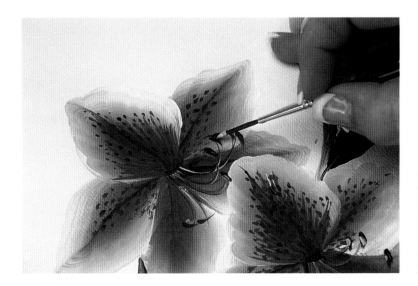

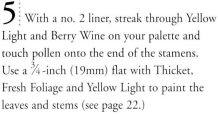

5 With a no. 2 liner, streak through Yellow Light and Berry Wine on your palette and touch pollen onto the end of the stamens. Use a ¾-inch (19mm) flat with Thicket, Fresh Foliage and Yellow Light to paint the leaves and stems (see page 22.)

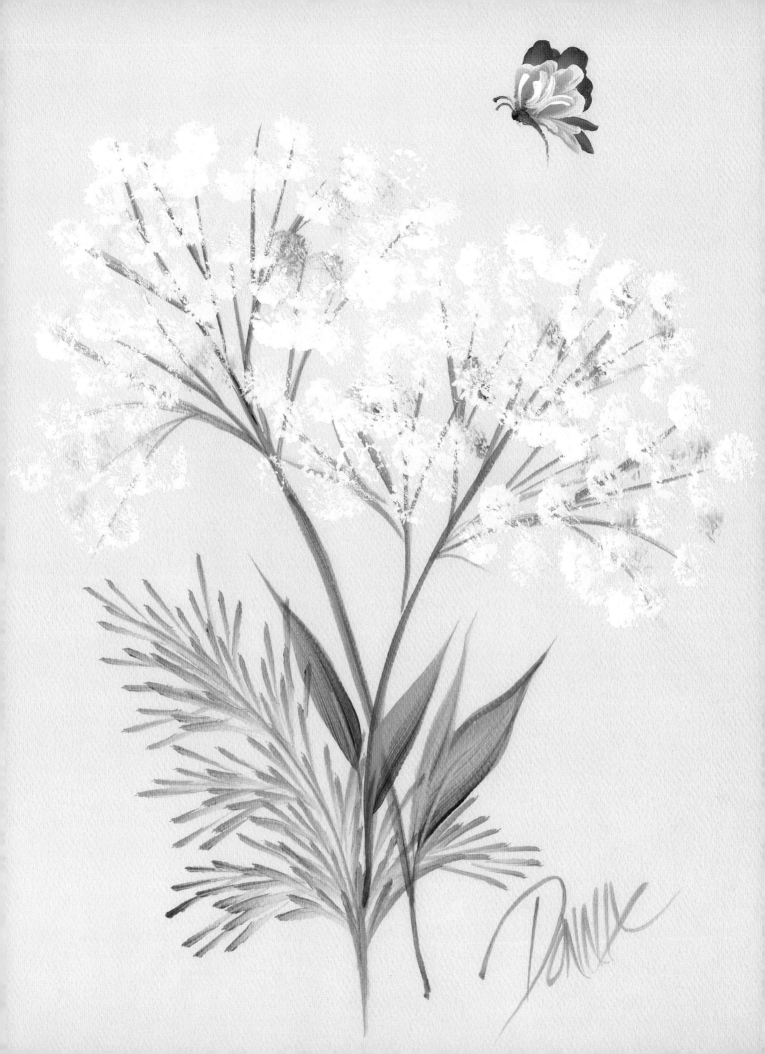

Baby's Breath

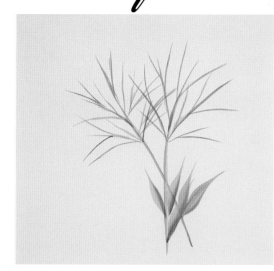

BRUSHES
- no. 12 flat
- medium scruffy
- liner brush

PAINTS

FOLKART ACRYLICS
- Thicket
- Wicker White

FOLKART ARTISTS' PIGMENTS
- Dioxazine Purple
- Yellow Light
- Burnt Umber

1 Double load a no. 12 flat with Thicket and Yellow Light and paint the stems and leaves first (see leaf techniques on pages 20-22.)

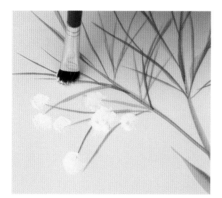

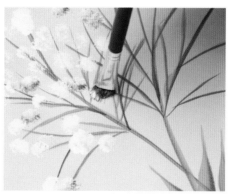

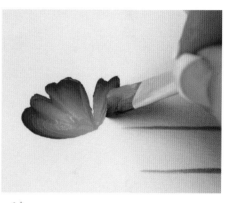

2 With the medium scruffy, dab Wicker White blossoms onto the end of each stem. Then lightly pounce some in between the stems for fullness.

3 Every so often, pick up a tiny bit of Burnt Umber on the scruffy; this gives the blossoms some depth and shading.

4 To paint the butterfly hovering over the baby's breath, double load a no. 12 flat with Dioxazine Purple and Wicker White. Turn your surface to a comfortable angle and paint the back wing using a stroke similar to the ruffled-edge leaf stroke (see page 22.) Keep your eye on the purple edge as you form the shape of the wing.

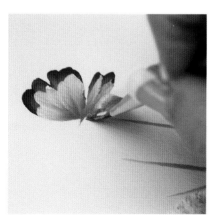

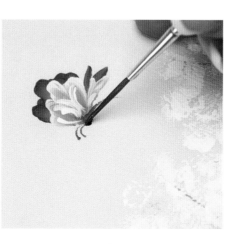

5 Re-load, flip the brush over and watch the white edge as you paint a shorter wing in the front.

6 Use a no. 12 flat with thick Wicker White to add little comma strokes on the wing. Load a liner brush with inky Thicket and stroke in the body. Lay the bristles down, then lift the brush, curving the body down as you lift. Finish with two little antennae.

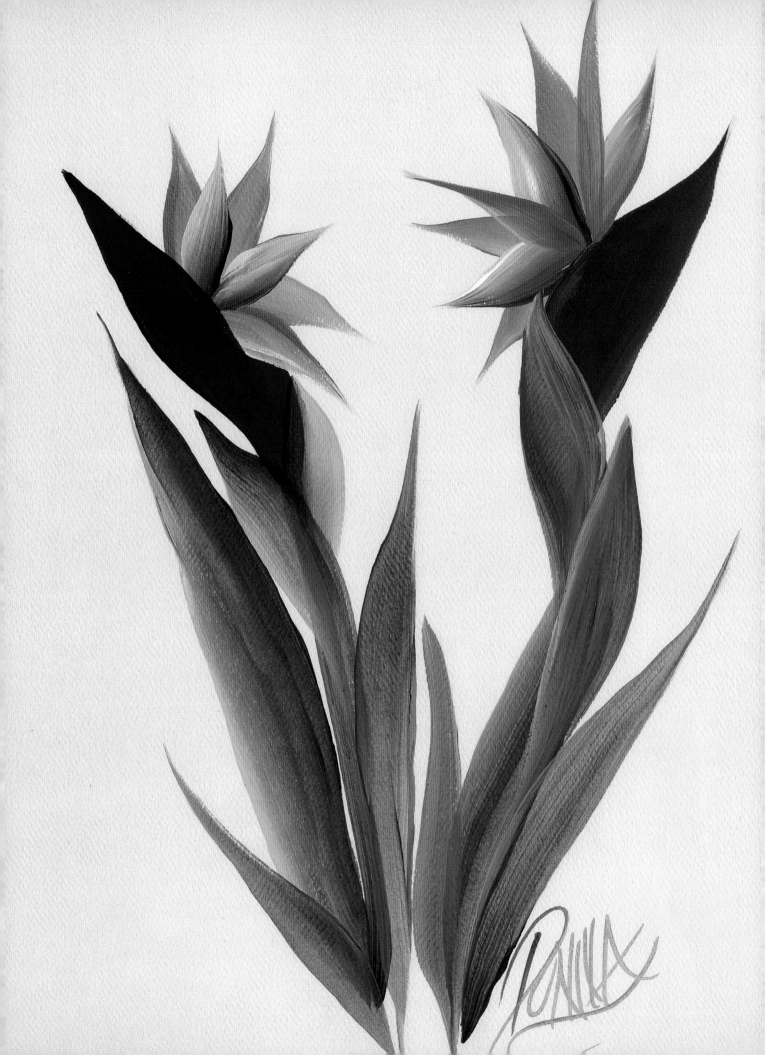

Bird of Paradise

BRUSHES
- ¾-inch (19mm) flat
- no. 12 flat

PAINTS
FolkArt Acrylics
- Engine Red
- Wicker White
- Berry Wine
- Green Forest

FolkArt Artists' pigments
- Yellow Ochre
- Yellow Light
- Dioxazine Purple
- Pure Orange

1 Double load a ¾-inch (19mm) flat with Engine Red and Berry Wine and paint the stems for placement. These are painted with a long leaf stroke.

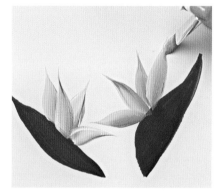

2 Double load a no. 12 flat with Yellow Ochre and Yellow Light. Paint four petals emerging from the stem, using long leaf strokes.

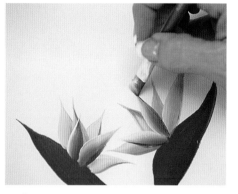

3 Double load a no. 12 flat with Dioxazine Purple and Wicker White. Use long leaf strokes to add two more petals in front of the last set, pulling from the stem.

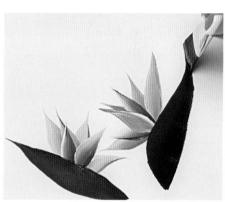

4 Using the same brush with Yellow Light and Pure Orange, you can add another petal in front of the purple petals. Re-stroke the back stem using a ¾-inch (19mm) flat with Engine Red and Berry Wine, with a touch of Green Forest on the Berry Wine edge. Re-stroking makes the petals look as if they are coming out of the stem.

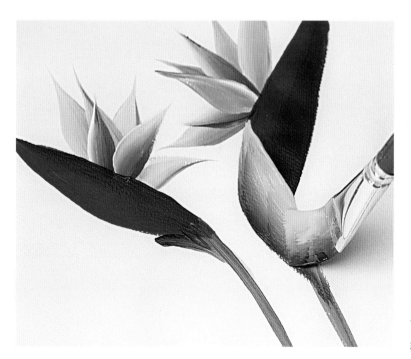

5 Load a ¾-inch (19mm) flat with Green Forest and Yellow Light and connect the stems. Encase them with a green calyx and paint the long leaves.

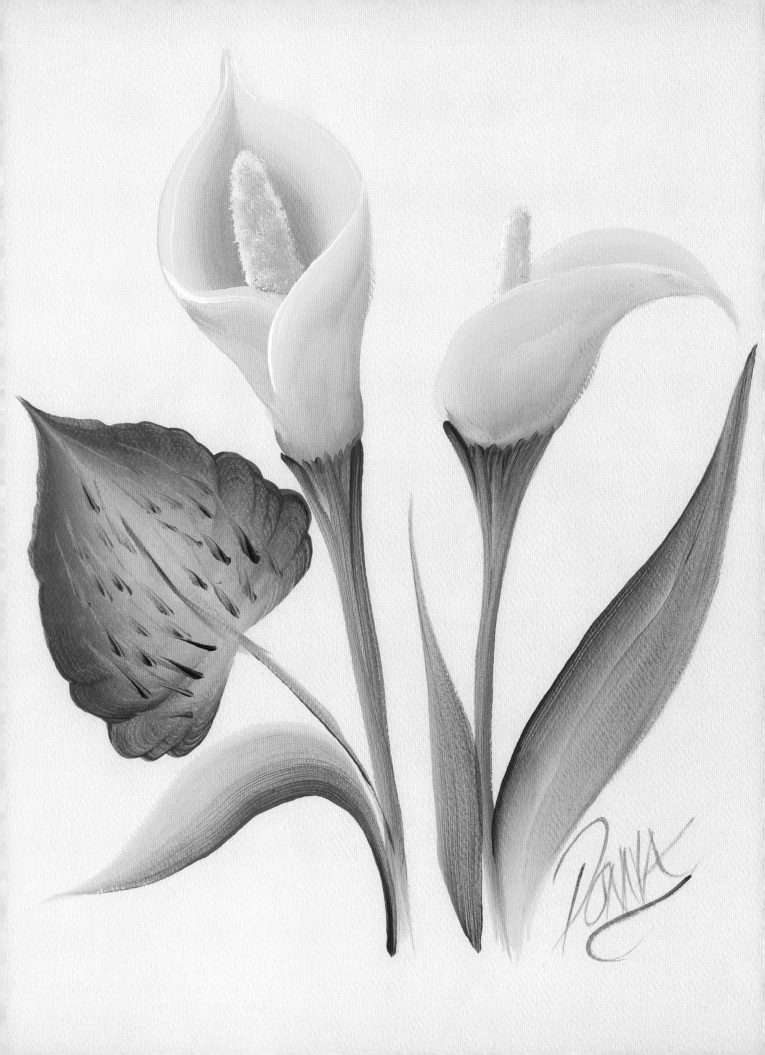

Calla Lily

BRUSHES
- ¾-inch (19mm) flat
- small scruffy

PAINTS

FolkArt Acrylics
- Thicket
- Wicker White

FolkArt Artist's pigments
- Yellow Ochre
- Yellow Light

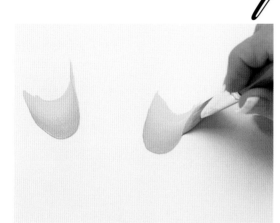

1 Load one side of a ¾-inch (19mm) flat two-thirds of the way over with Yellow Ochre and load the other one third with Yellow Light. Then dip the Yellow Light corner into Wicker White and work it into the bristles on the palette. Stroke in the base of each flower with a "C"-shaped stroke (see page 19). Watch the Yellow Ochre edge of the brush.

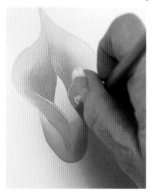

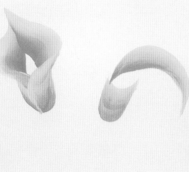

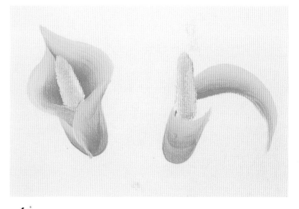

2 Use the same colors and brush. Beginning on the chisel, lean to the side as you slide, then lift and roll (lean the white edge over into the front). The right petal lays over the left petal.

3 Paint the side-facing calla using the same brush and colors. Start on the chisel, push down as you slide, then lift back up to the chisel. Keep your eye on the light edge.

4 Use the small scruffy and pounce in the stamen using Yellow Ochre and Yellow Light with Wicker White. Keep the white to the outside edge.

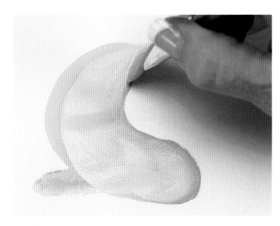

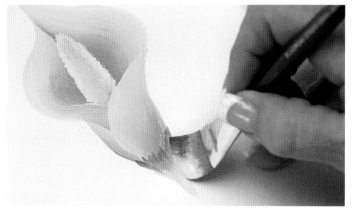

5 Add the front petal of the side-facing calla using the same colors and brush. Turn your work so you are stroking to the right. Start on the chisel, push down, slide and lift back up to the chisel.

6 Add the stalk using Thicket and Yellow Light. Chisel in short little strokes from the base of each lily, leading with the light edge. Pull the last stroke all the way down to form the stem. Finish with a couple of long leaves and a wiggle leaf if you wish (see page 22).

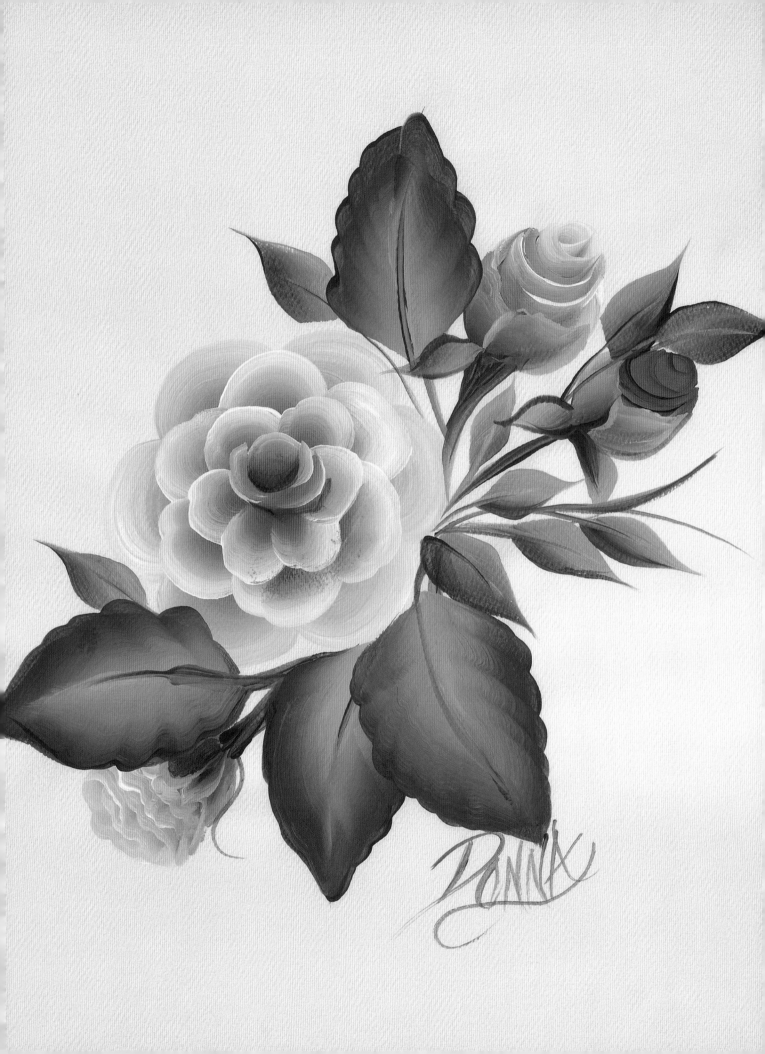

Camellia

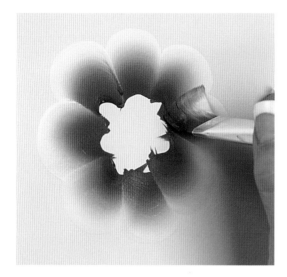

BRUSHES
- ¾-inch (19mm) flat
- no. 16 flat

PAINTS

FolkArt Acrylics
- Berry Wine
- Wicker White
- Thicket
- Sunflower

FolkArt Artists' pigments
- Yellow Light

1 Double load a ¾-inch (19mm) flat with Berry Wine and Wicker White. Paint the smooth, fan-shaped petals of this flower. Begin on the chisel, push up and slide back down to the chisel. Keep your eye on the white edge as you form the shape of the petal. Paint a complete circle to form the bottom layer..

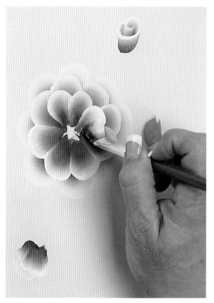

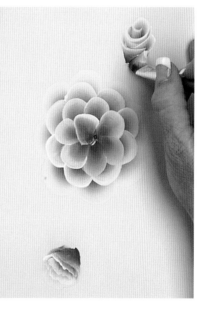

2 Switch to a no. 16 flat and paint the next two layers of petals using the same colors. Start the bud and the side-view flower.

3 With the same brush, paint another layer of petals on the open blossom and on the bud and the side-view flower (add a little ruffle to these petals.)

4 Still using the no. 16 flat with the same colors, add the center petals to the open blossom. Finish with very small, chisel-edge strokes under the center petals.

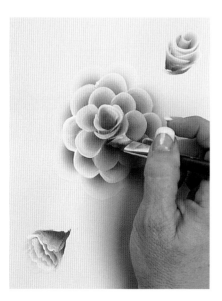

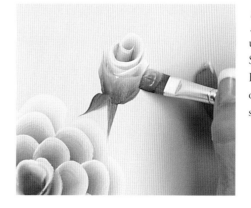

5 Add the calyx to the bud using a no. 16 flat with Thicket, Sunflower and Yellow Light. Finish with large leaves and one-stroke leaves, pulling stems into their centers.

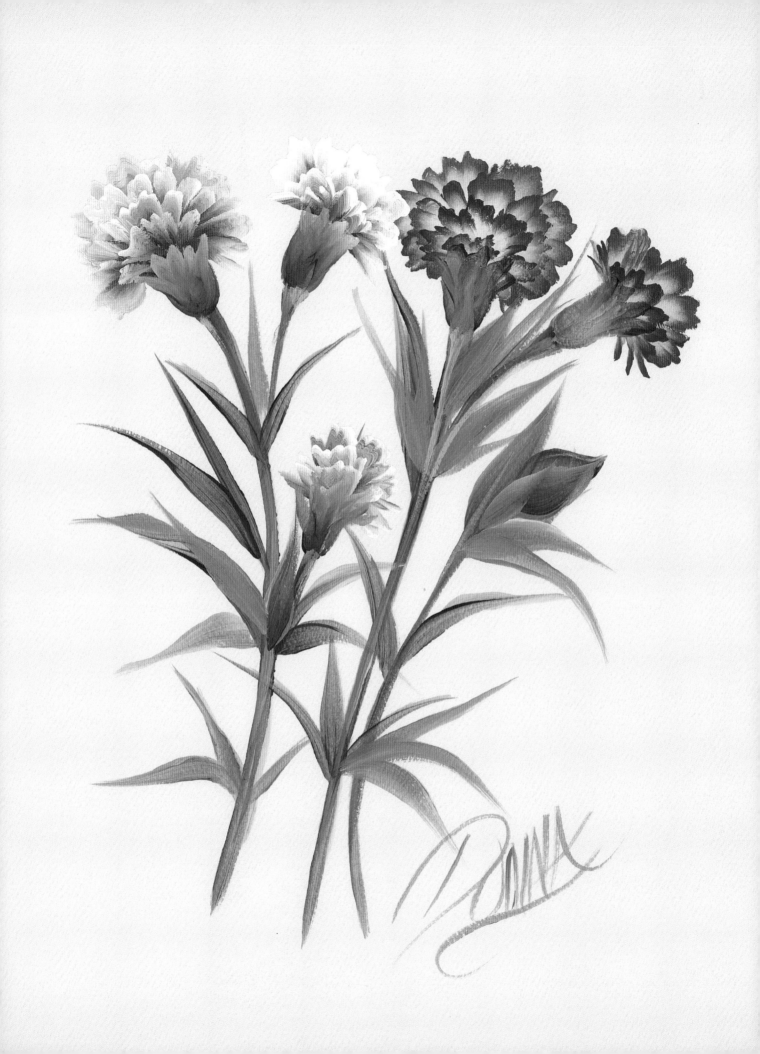

Carnation

BRUSHES
- no. 12 flat
- no. 16 flat

PAINTS

FOLKART ACRYLICS
- Thicket
- Sunflower
- Engine Red
- Berry Wine
- Wicker White

FOLKART ARTISTS' PIGMENTS
- Yellow Light

1 Begin by painting the greenery, including the base of each flower, for placement. Use a no. 16 flat double loaded with Thicket and Sunflower and paint long slender leaves (see page 20).

2 Load a no. 12 flat with Yellow Light and side load a little Engine Red on just the edges. Paint little jagged-edged petals (see page 16) with red on the outside. Be sure to paint little sharp points. Repeat with the rest of the layers, working back to front.

3 Using Thicket and Sunflower, add a green calyx to the base of each flower; touch and pull down into the base, keeping the green side up.

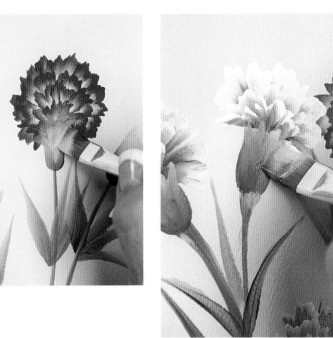

4 The pink carnations are painted with Berry Wine and Wicker White. Use a no. 16 flat and repeat the steps for the petals, keeping the white to the outside. Finish with a green calyx as you did in Step 3.

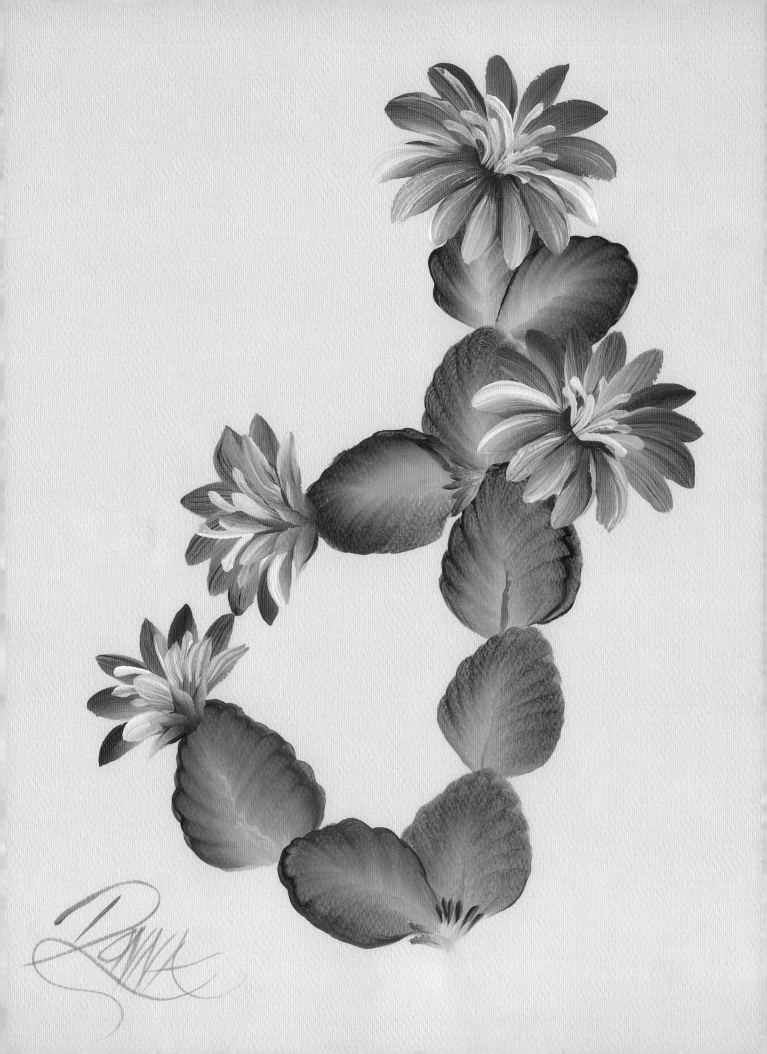

Christmas Cactus

BRUSHES
- no. 2 liner
- no. 12 flat

PAINTS

FOLKART ACRYLICS
- Sunflower
- Thicket
- Magenta
- Wicker White
- School Bus Yellow

FOLKART ARTISTS' PIGMENTS
- Yellow Light

OTHER
- Floating Medium

1 Begin this plant's greenery at the top and work downward, building it in sections. To paint these ruffled-edge leaves (see page 22), load a no. 12 flat with Yellow Light and Sunflower on one side and Thicket on the other. Keep the Thicket to the outside edge.

2 Double load a no. 12 flat with Magenta and Wicker White and paint the back petals of the side-view flowers. Touch, lean, pull, and lift to the chisel, making sure to lead with the white.

4 Add the front petals onto the side-view flowers. Use the same colors as for the back petals, but this time lead with the pink edge of the brush.

5 For the full flowers, continue using the no. 12 flat. Paint the back petals leading with the white, and the front petals leading with the Magenta. Add a little "C"-shaped stroke to form the center, using the same brush with Magenta and floating medium.

3 Pull the stamens into the centers of the side-view flowers using a no. 2 liner with School Bus Yellow, Yellow Light and Wicker White. Touch, then pull into the centers.

6 Finish the full flowers by pulling yellow stamens emerging from the centers. Load a no. 2 liner with School Bus Yellow, Yellow Light and Wicker White. Touch to make the stamen's tip, then pull into the center.

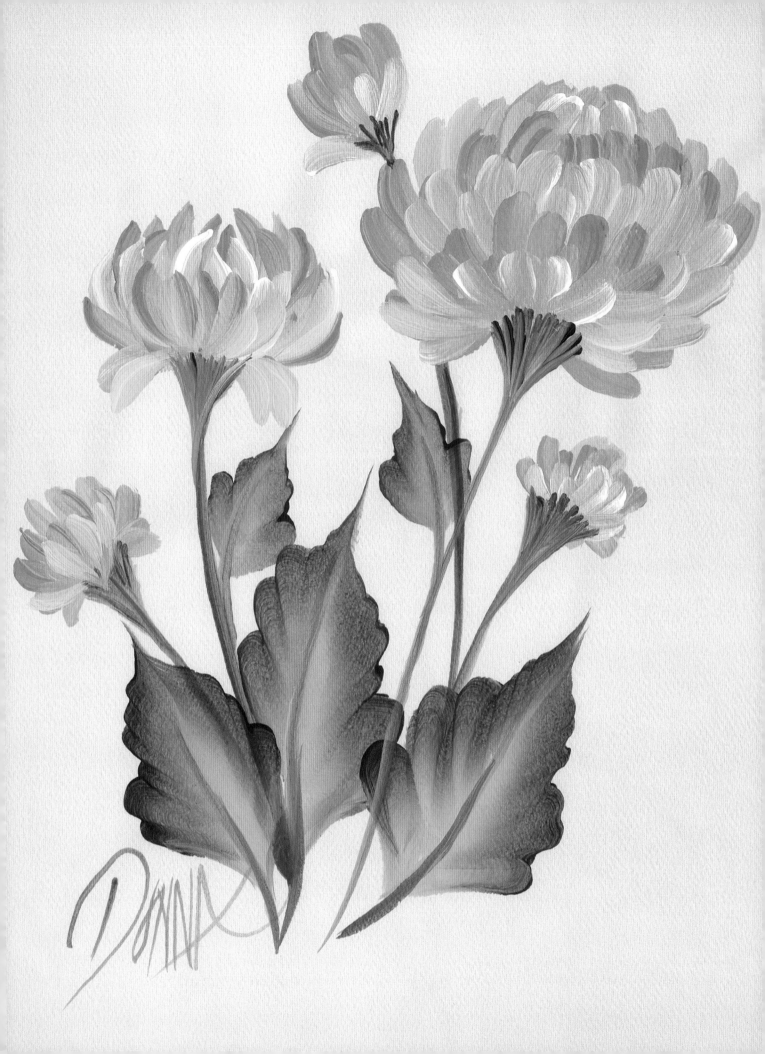

Chrysanthemum

BRUSHES
- ¾-inch (19mm) flat
- no. 12 flat

PAINTS

FOLKART ACRYLICS
- School Bus Yellow
- Thicket
- Wicker White

FOLKART ARTISTS' PIGMENTS
- Yellow Ochre
- Yellow Light

OTHER
- Floating Medium

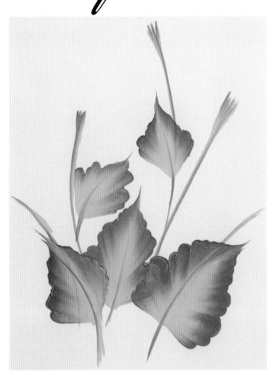

1 Stroke in the stems and leaves with a ¾-inch (19mm) flat double loaded with School Bus Yellow and Thicket (see page 22). Keep the Thicket to the outside edge on the leaves.

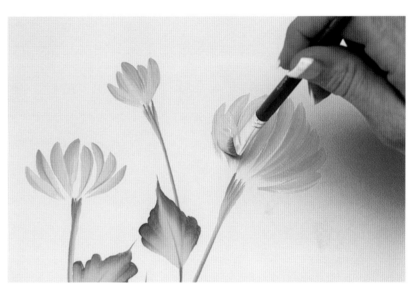

2 All the blossoms are painted with the no. 12 flat. Alternately pick up Yellow Ochre, Yellow Light, School Bus Yellow and Wicker White on your brush. Stroke in the back petals of the small, medium and large flowers. Start forming the shape of the flower; touch, lean toward the stem on the chisel and pull, leading with the lightest color.

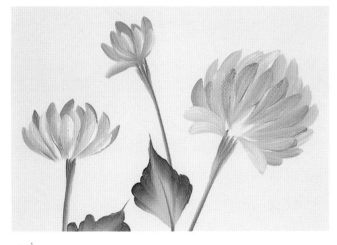

3 For the next layer of petals, lead with the opposite side of the brush using the same colors and brush. Add a few petals coming out from the base and curving downward.

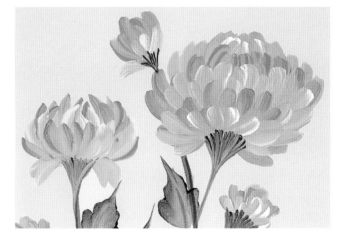

4 Fill in each layer of petals, alternating with the lighter or darker yellows, depending on which you used on the previous layer. See page 15 for petal stroke instructions.

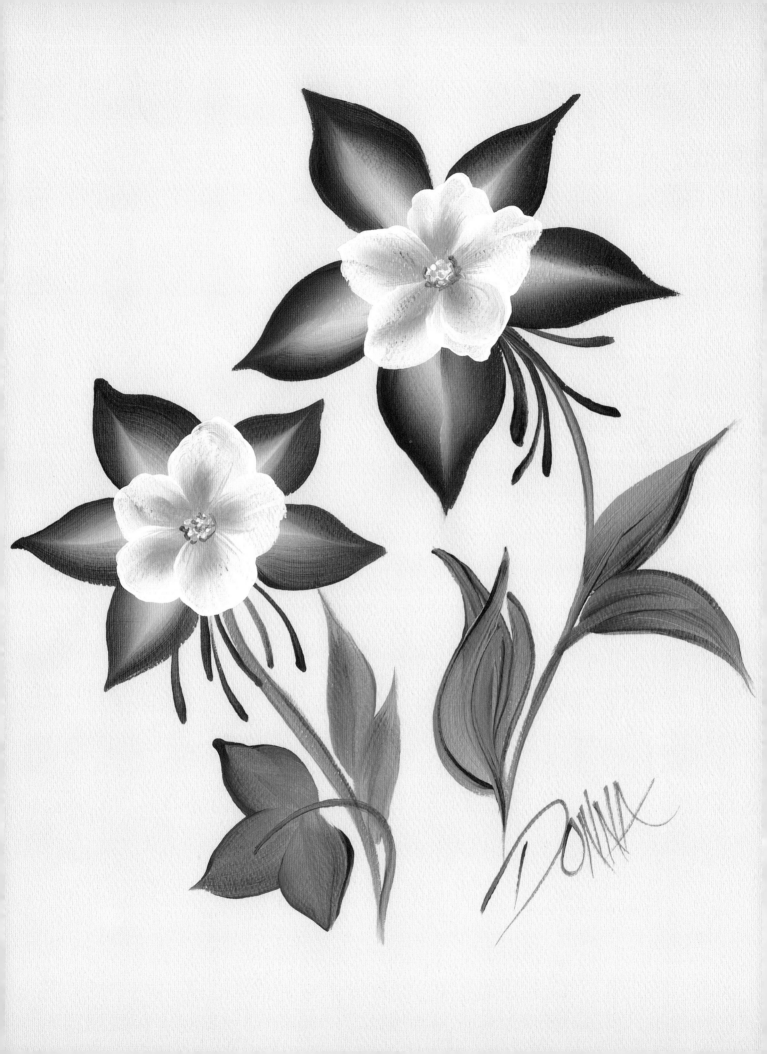

Columbine

BRUSHES
- no. 2 liner
- no. 12 flat

PAINTS
FolkArt Acrylics
- Berry Wine
- Thicket
- Wicker White
- Sunflower

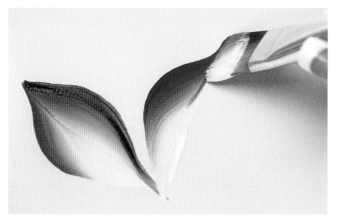

1 Double load a no. 12 flat with Berry Wine and Wicker White. Begin on the chisel, push and slide out to the point of the petal.

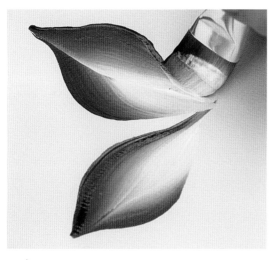

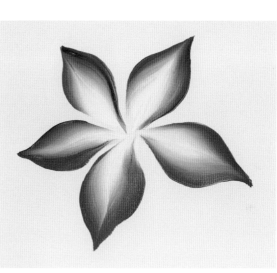

3 The five petals are placed in a star pattern.

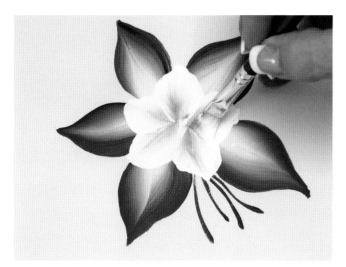

2 Lift up and slide back down the other side, then lift to the chisel. Keep the Berry Wine to the outside.

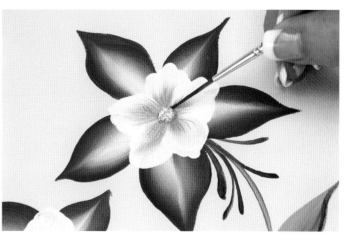

4 Load a no. 2 liner with inky Berry Wine to paint the stamen. Touch and pull in to the center. Load a no. 12 flat with Wicker White and a touch of Berry Wine. Paint the center petals.

5 Double load a no. 12 flat with Thicket and Sunflower and paint the leaves and stems. Load a no. 2 liner with Sunflower and paint the yellow veins coming from the flower's center. Dot in the very center with Wicker White, then use inky Thicket to dot a ring of light green around the center.

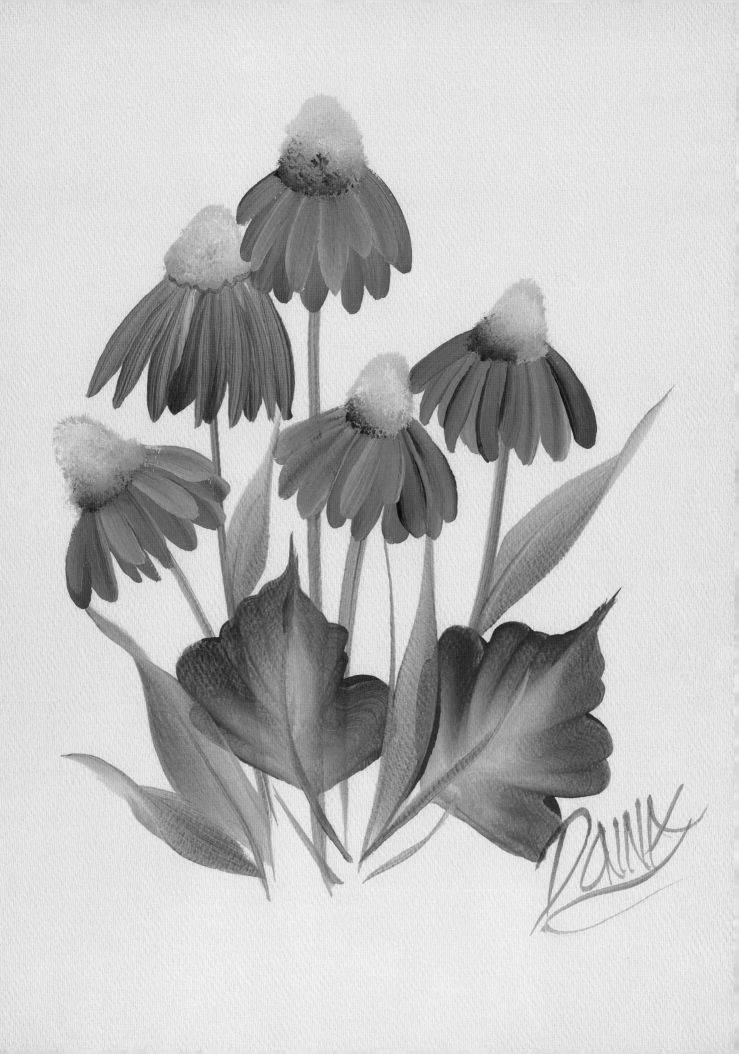

Cone Flower

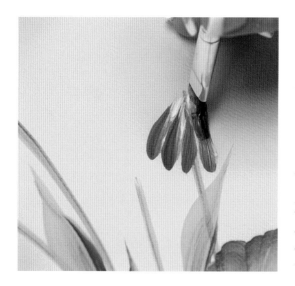

BRUSHES
- ¾-inch (19mm) flat
- no. 12 flat
- medium scruffy

PAINTS
FolkArt Acrylics
- Thicket
- School Bus Yellow
- Night Sky
- Wicker White
- Berry Wine

1 Paint the greenery using your ¾-inch (19mm) flat loaded with Thicket and School Bus Yellow. The greenery is a mixture of long slender leaves and ruffled leaves (see pages 20 and 22). Paint the purple petals using a no. 12 flat with Night Sky and Wicker White. Touch, lean and pull the petals toward the center while leading with the white edge of the brush. Concentrate on the shape and placement of the petals.

2 For the next layer of petals, flip the brush over and lead with the Night Sky edge to create depth.

3 Paint the pink flowers, using the same brush, with Berry Wine and Wicker White. Then go back and layer some of the blue petals over the pink petals.

4 Load a medium scruffy with School Bus Yellow and Wicker White. Dip the School Bus Yellow edge into a little Berry Wine and pounce in the flower centers. Make sure the Berry Wine side is facing the petals. Use a little inky Berry Wine or Thicket and do some line work along the bottom edge of the centers if you want to define them more (as shown on the pink flower).

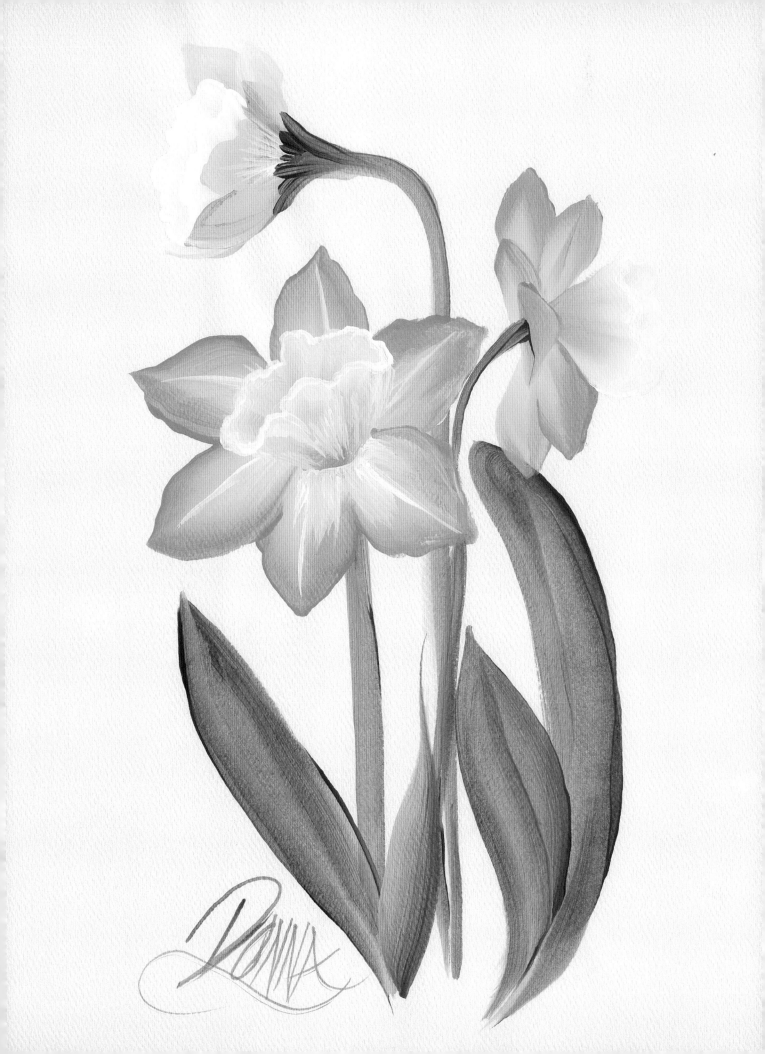

Daffodil

BRUSHES
- ¾-inch (19mm) flat
- small scruffy

PAINTS

FOLKART ACRYLICS
- Thicket
- Sunflower
- Wicker White

FOLKART ARTISTS' PIGMENTS
- Yellow Ochre
- Yellow Light

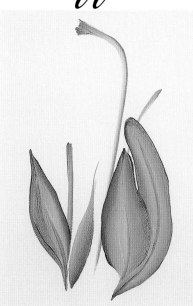

1 Using a ¾-inch (19mm) flat with Thicket and Sunflower, paint the stems and leaves (see page 20).

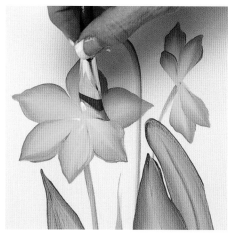

2 Double load the flat with Yellow Ochre and Yellow Light and stroke in the back petals of the center-and right-facing flowers.

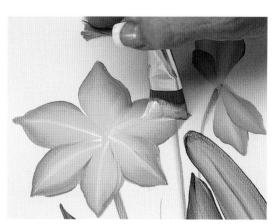

3 Pick up Wicker White on the Yellow Light edge of the brush. Lead with the Yellow Ochre edge of the brush and use the chisel to pull in the white center lines on each petal.

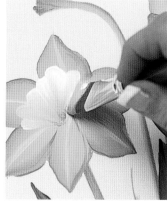

4 Re-load with Yellow Light, Yellow Ochre and Wicker White on the Yellow Ochre side. Ruffle in the back of the trumpet.

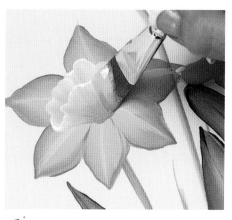

5 Add the front of the trumpet, keeping the Yellow Ochre side of the brush towards the base of the trumpet.

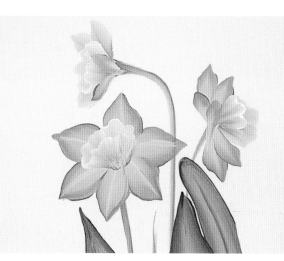

6 Paint the smaller, left-facing flower by flipping the brush over so the Yellow Light side will be on the outside edge. Use the same strokes as for the other flowers. On the trumpet of the large flower, pull in some lines with the chisel. Use the same brush, with Thicket and Sunflower, to connect the base of the flower to the stem.

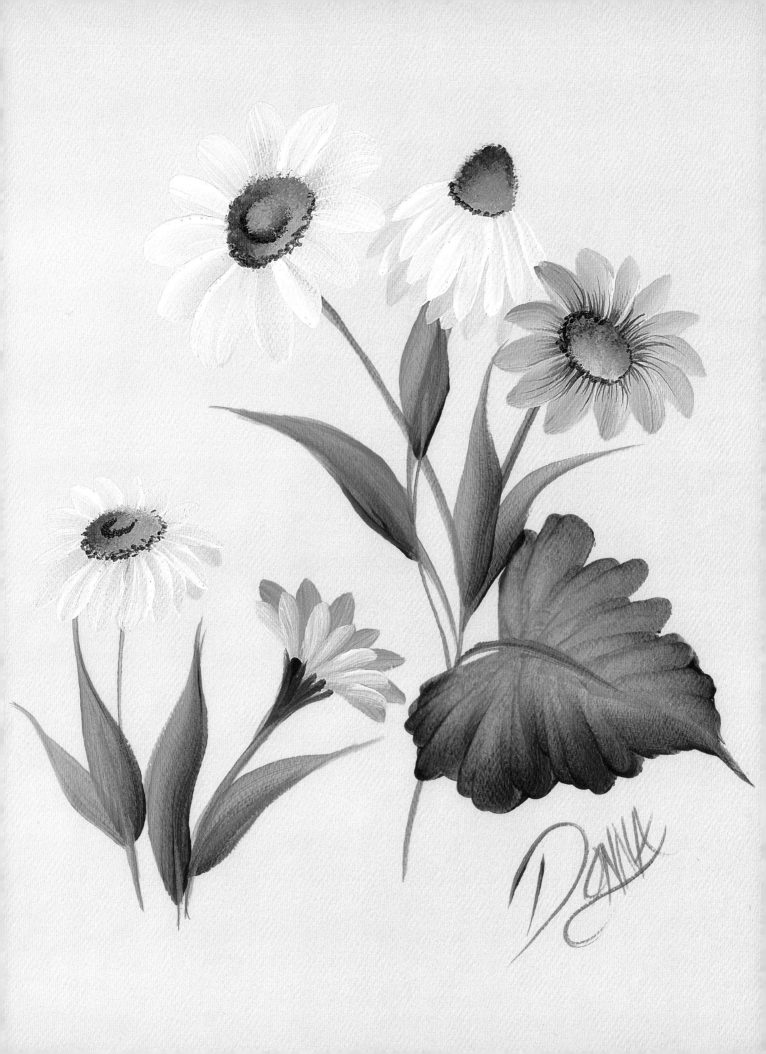

Daisies

BRUSHES
- ¾-inch (19mm) flat
- no. 12 flat
- no. 2 liner
- 2 scruffies (different sizes)

PAINTS

FolkArt Acrylics
- Thicket
- Grass Green
- Wicker White
- Sunflower

FolkArt Artists' pigments
- Yellow Ochre
- Yellow Light
- Burnt Sienna
- Burnt Umber

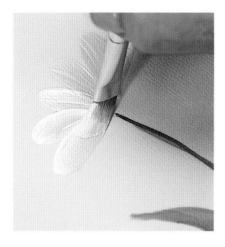

1 When painting daisies, it may help you to think of a clock face and start with four petals at 12, 3, 6 and 9 o'clock. Then fill in between with the rest of the petals. Use Wicker White with a tiny bit of Sunflower to stroke in the petals. Begin on the chisel edge of the no. 12 flat, leading with the white. Touch, lean back and pull, then lift back up to the chisel. The leaves and stems are painted with Thicket, Grass Green and Yellow Light on a ¾-inch (19mm) flat (see pages 20-22).

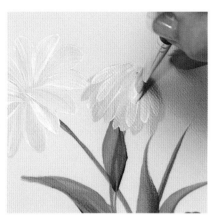

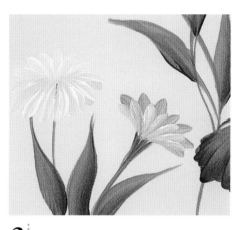

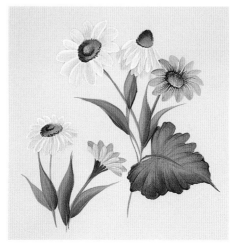

2 Pull in the long back layer of petals on the open daisy. Use the same colors and touch slightly, lean (don't push as hard; you want these petals to be longer and thinner), then lift back up to the chisel. For the next layer, add more Yellow Light and flip the brush. Then lead with the opposite color. Paint the front layer of petals with Wicker White.

3 To make a white daisy look as if it is leaning, make the back petals shorter. This daisy is mostly Wicker White with a little bit of Sunflower; lead with the Sunflower. For the back layer of petals on the yellow, side-view daisy, use the same brush with Yellow Ochre and Yellow Light. The front petals are Yellow Light and Wicker White.

4 Use the scruffy (the size most appropriate to your flower) with Yellow Ochre and Burnt Sienna to pounce in the centers. Add some Yellow Light to make it glow. For the yellow daisy centers, use Yellow Ochre, Burnt Umber and Sunflower to lighten it. The key here is to multi-load the scruffy and keep the darker color to the top and to one side.

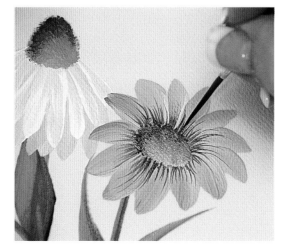

5 Use inky Burnt Umber on a no. 2 liner to touch in the little accent lines on the gold petals.

6 Dot in some little accent touches on the white daisies with Burnt Umber, using the tip of your liner. You can also pounce in some Burnt Umber onto the centers to create some dimension.

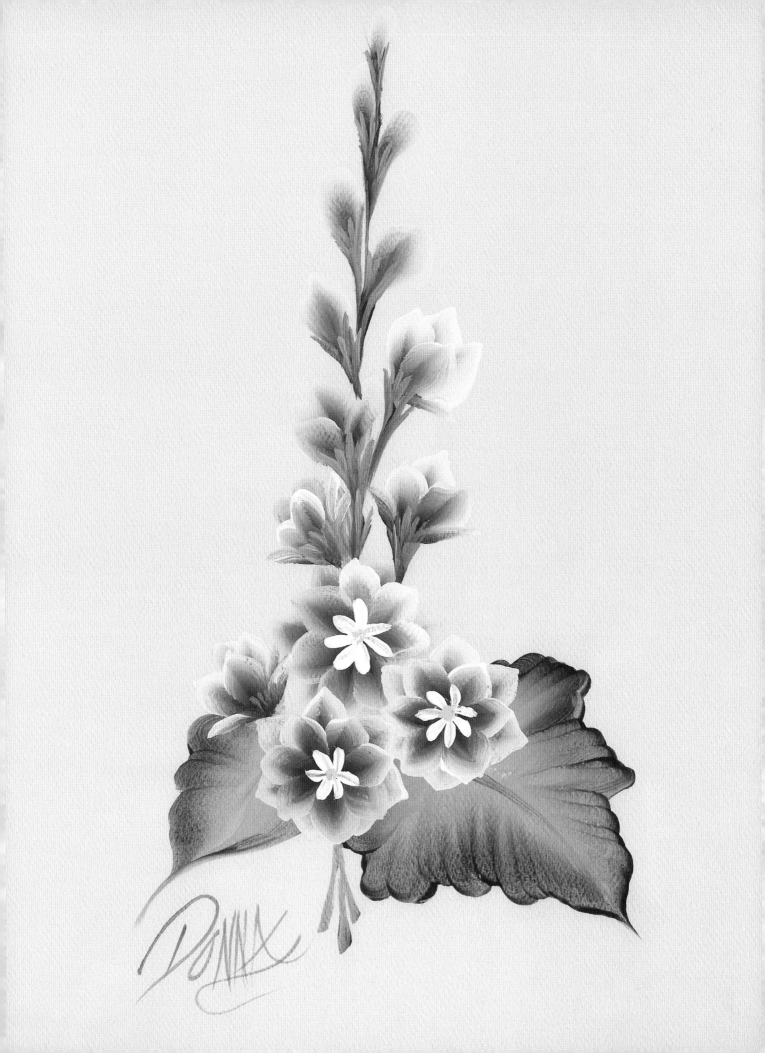

Delphinium

BRUSHES
- ¾-inch (19mm) flat
- no. 10 flat
- no. 12 flat
- no. 1 liner

PAINTS
FolkArt Acrylics
- Thicket
- Sunflower
- Violet Pansy
- Wicker White

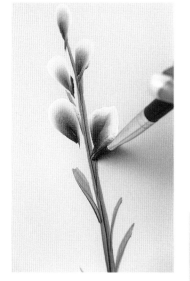

1 Begin by painting the leaves and stems, using your ¾-inch (19mm) flat with Thicket and Sunflower. Then double load no. 12 flat with Violet Pansy and Wicker White and begin at the top of the stem. Paint the buds using a tear-drop shaped stroke, keeping the white to the outside. As you go down the stem make the buds larger and add a wiggle.

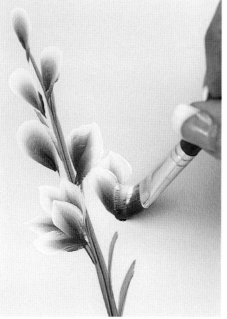

2 Using the same colors and brush, layer the buds by overlapping the front petals. Make the front petals shorter.

3 With a no. 10 flat double loaded with Thicket and Sunflower, use the chisel to attach the buds to the main stem.

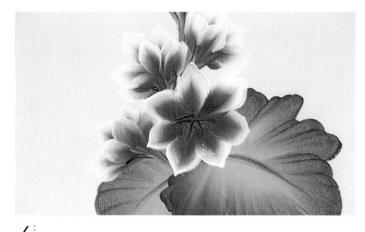

4 Using a no. 12 flat, paint the back layer of the open blossoms with Violet Pansy and Wicker White. Keep the white to the outer edge.

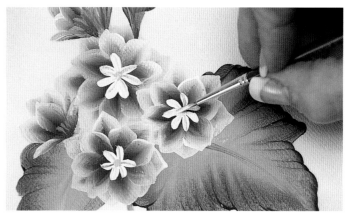

5 Add a second layer of petals in front of the back layer. Then use the no. 1 liner with Wicker White and add the stamen. Dot in the yellow centers with Sunflower.

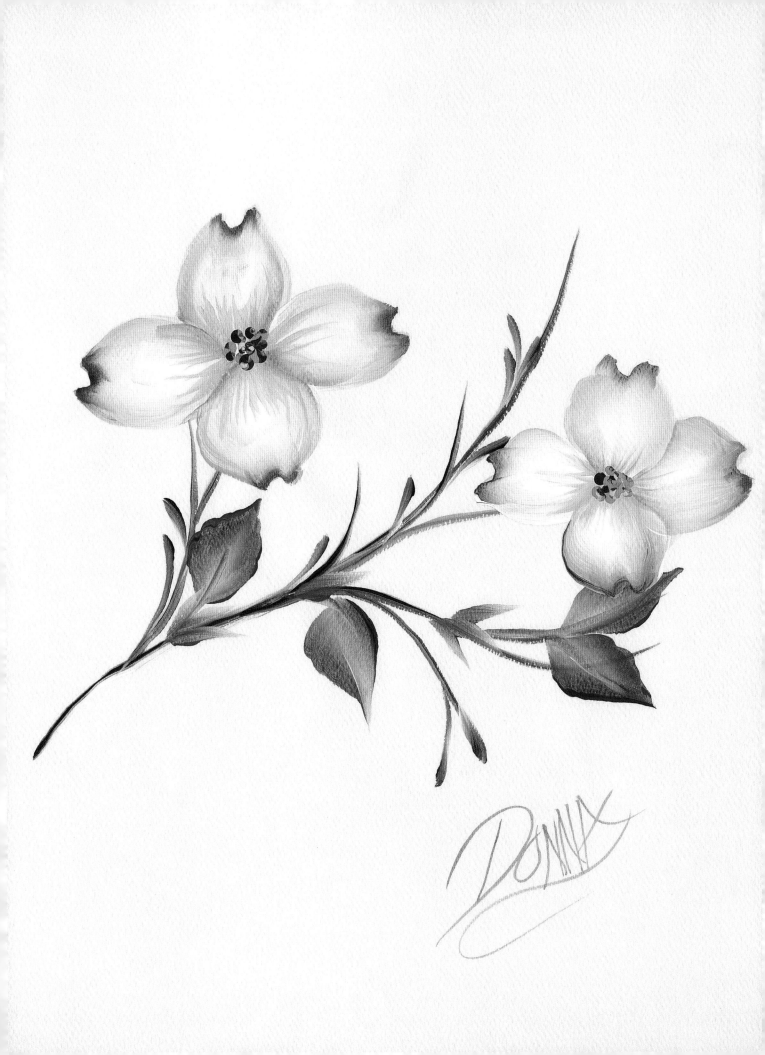

Dogwood

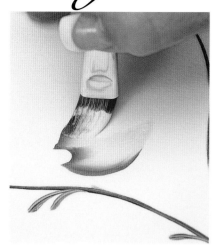

BRUSHES
- no. 6 flat
- no. 12 flat
- no. 2 liner

PAINTS
FOLKART ACRYLICS
- Berry Wine
- Thicket
- Wicker White
- Fresh Foliage

FOLKART ARTISTS' PIGMENTS
- Burnt Umber
- Yellow Light

1 Sketch in the branches using a no. 6 flat loaded with Wicker White and Burnt Umber. Use a no. 2 liner to pull out the buds. Paint the petals with Wicker White side loaded into Berry Wine. Watch the pink edge as you follow the shape of the petal; create a little "U"-shaped dip at the top of each petal. Paint the first side of the petal, go up to the point, come down, go back up to the next point, then slide down the other side.

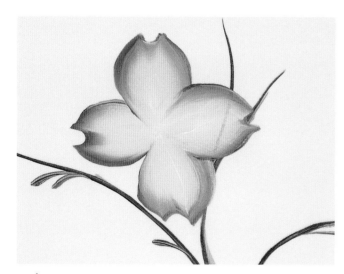

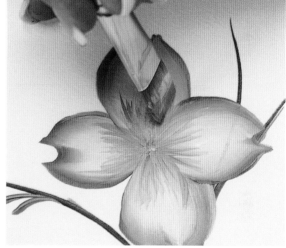

2 Repeat this for all four petals, turning your work to make it easier to stroke and keeping the Berry Wine to the outside edge.

3 Use Fresh Foliage with Yellow Light on a no. 12 flat to chisel in the lines on the petals.

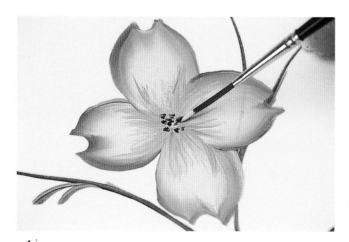

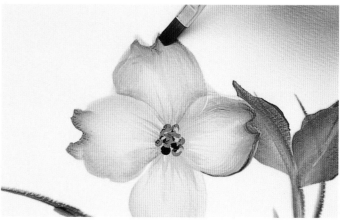

4 Dot the centers with Yellow Light, Thicket and Fresh Foliage using your no. 2 liner. Pick up thick paint and dot it into the center.

5 Use a no. 12 flat with Thicket, Fresh Foliage and Yellow Light to add leaves. Then use the no. 6 flat and accent the dips with a sideload float (see page 14) of Berry Wine.

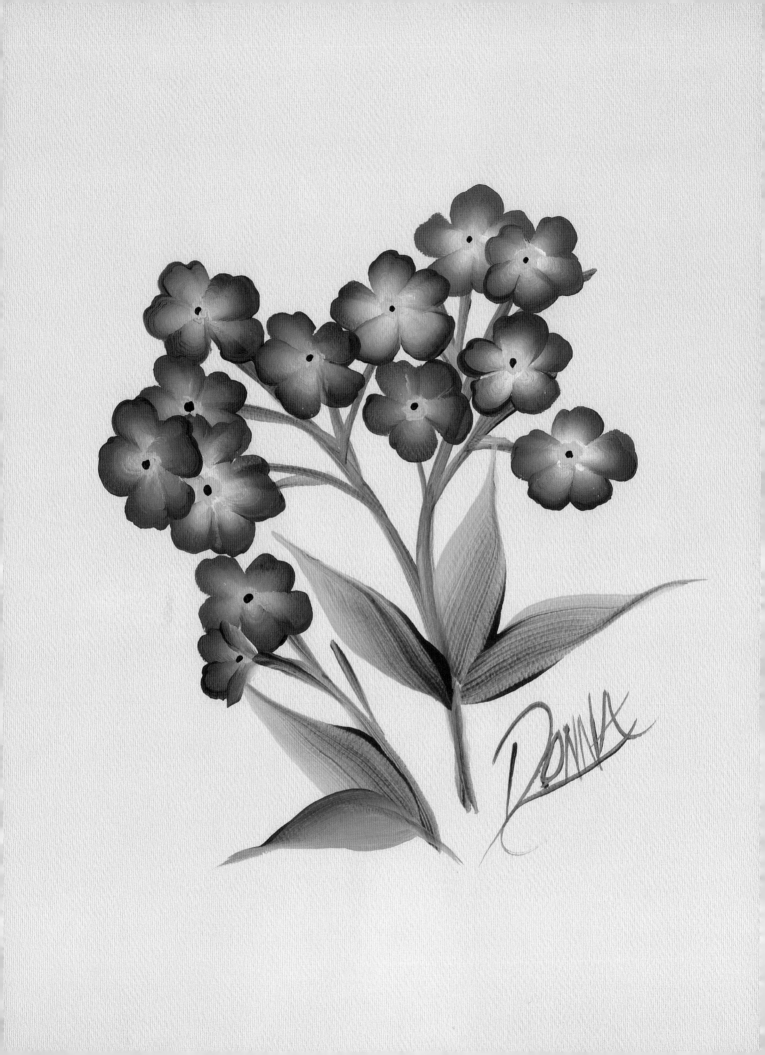

Forget~Me~Nots

BRUSHES

♣ no. 12 flat
♣ no. 2 liner

PAINTS

FOLKART ACRYLICS

♣ Midnight
♣ Thicket
♣ Wicker White
♣ Sunflower
♣ Violet Pansy

FOLKART ARTISTS' PIGMENTS

♣ Yellow Light

1 Stroke in the stems and leaves with Sunflower and Thicket using a no. 12 flat. To paint the petals, double load a no. 12 flat with Midnight and Wicker White and paint a five-petal flower (see page 16). Keep the white side toward the center and wiggle the brush a little as you paint each petal to get a rippled edge.

2 Use the same brush and alternate colors by dipping the Midnight corner into Violet Pansy. The petals will soon transition to all violet, then go back to dark blue.

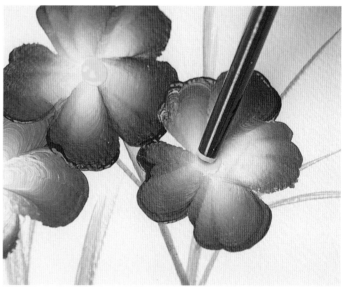

3 Use the end of a small brush to dot Yellow Light into the center of each blossom.

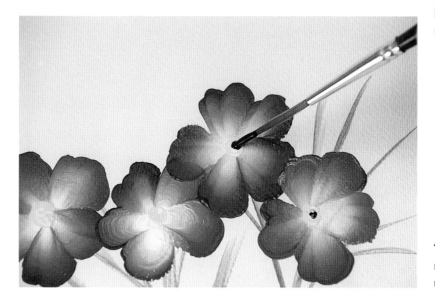

4 Then use the bristles of a no. 2 liner to dot Midnight into the very center of the yellow dots.

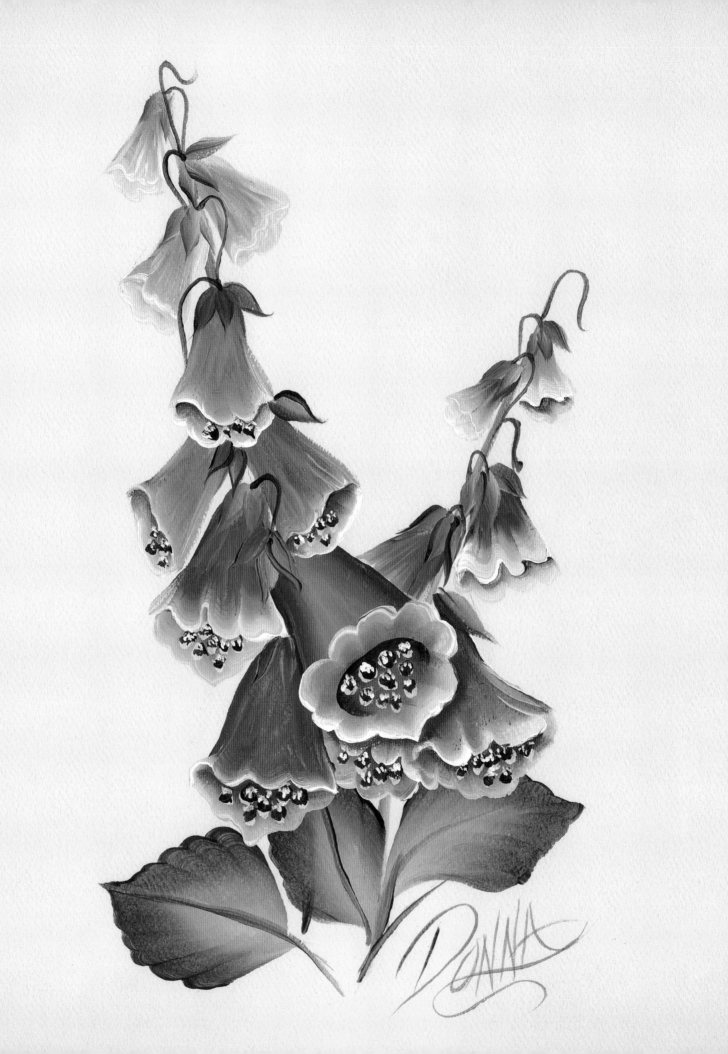

Foxglove

BRUSHES
- ¾-inch (19mm) flat
- no. 6 flat
- no. 12 flat
- no. 1 liner
- no. 2 liner

PAINTS
FOLKART ACRYLICS
- Sunflower
- Thicket
- Wicker White
- Berry Wine

OTHER
- Floating Medium

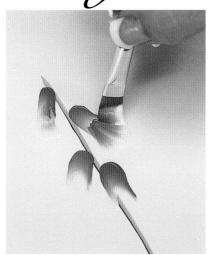

1 Paint the leaves using a ¾-inch (19mm) flat with Thicket and Sunflower. Double load a no. 12 flat with Wicker White and a touch of Berry Wine and paint the small top blossoms. Add more Berry Wine to your brush to darken the pink color as you travel down the stem. Paint the trumpet base using a C-shaped stroke. Then add the back layer of ruffled edges on each trumpet (see page 16 for instructions on painting ruffled-edge petals).

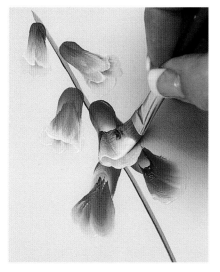

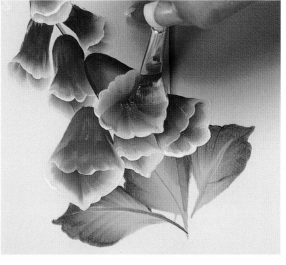

2 Using the same brush and colors, paint the front ruffled edges a little shorter than the back ones.

3 Paint the large back blossoms the same as the small ones. The opening on the front blossom is a ruffled circle.

4 To define the throat of the trumpet, load a no. 12 flat with Berry Wine and floating medium and paint a C-shaped float in the center.

5 With the handle of a small brush, add Sunflower dots into the blossom openings. Next, dot Berry Wine onto the yellow dots. Follow up with tiny touches of Wicker White, using the tip of a no. 1 liner. Go back and add the calyx, using a no. 6 flat and Sunflower and Thicket. Use a no. 2 liner with inky Thicket to add the little vines.

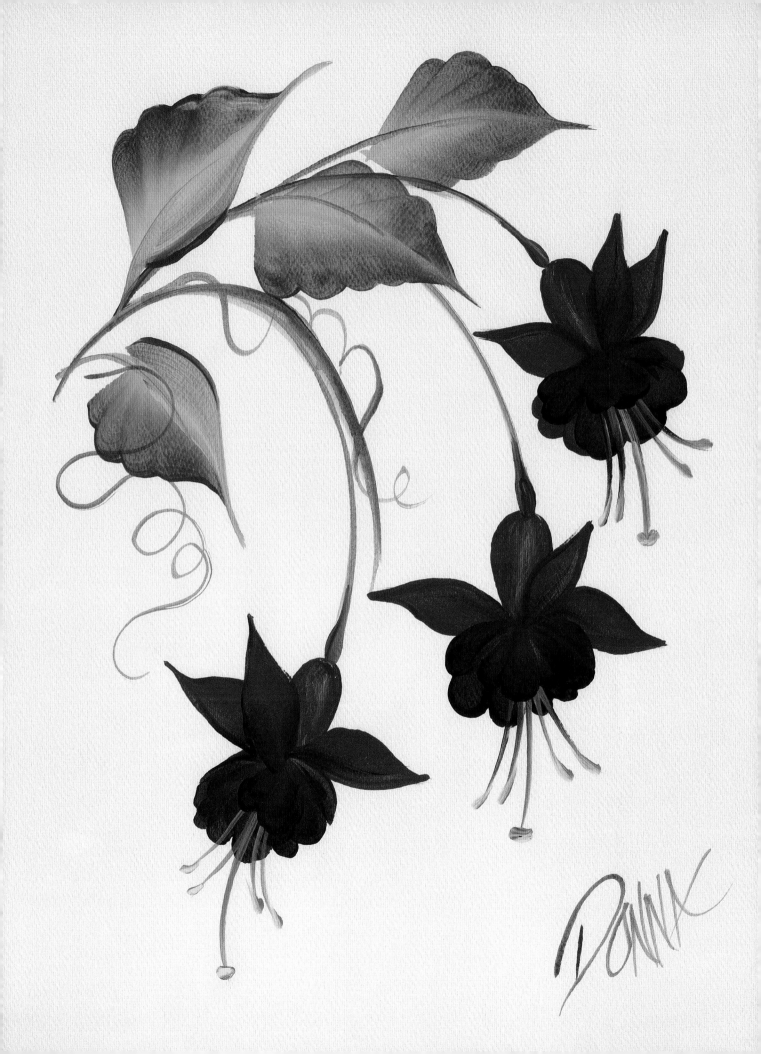

Fuchsia

BRUSHES
- no. 12 flat
- no. 2 liner

PAINTS

FOLKART ACRYLICS
- Engine Red
- Thicket
- Wicker White

FOLKART ARTISTS' PIGMENTS
- Dioxazine Purple
- Yellow Light

1 Using a no. 12 flat with Thicket and Yellow Light, chisel in the stems of the Fuchsia. Load a no. 12 flat with Engine Red and a touch of Wicker White and paint the calyx lobe (the part of the blossom that attaches to the calyx). Paint a little bubble shape; begin on the chisel, push up and slide back down to a point.

2 Now paint the back layer of petals. Some are all Engine Red and the others are Engine Red side loaded with Dioxazine Purple. Using a no. 12 flat, paint a teardrop-shaped stroke without lifting your brush between petals.

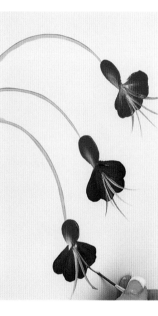

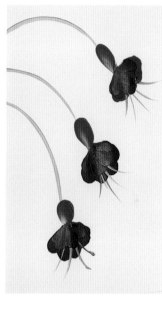

3 Pull in the green stamens with a no. 2 liner loaded with Yellow Light and Thicket.

4 With a no. 12 flat (it should still have paint on it from step 2), pick up more Dioxazine Purple. Paint in the front petals over the stamen.

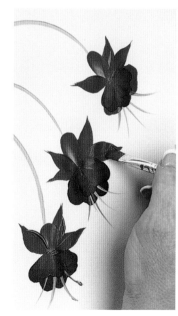

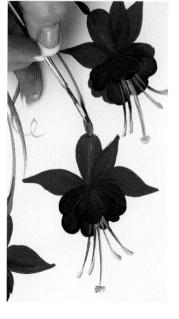

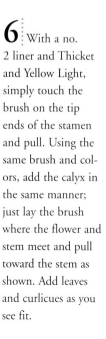

5 Add one-stroke petals (see page 15) where the calyx lobe and petals meet. Use a no. 12 flat and Engine Red side-loaded with Dioxazine Purple. Adjust the color to your liking.

6 With a no. 2 liner and Thicket and Yellow Light, simply touch the brush on the tip ends of the stamen and pull. Using the same brush and colors, add the calyx in the same manner; just lay the brush where the flower and stem meet and pull toward the stem as shown. Add leaves and curlicues as you see fit.

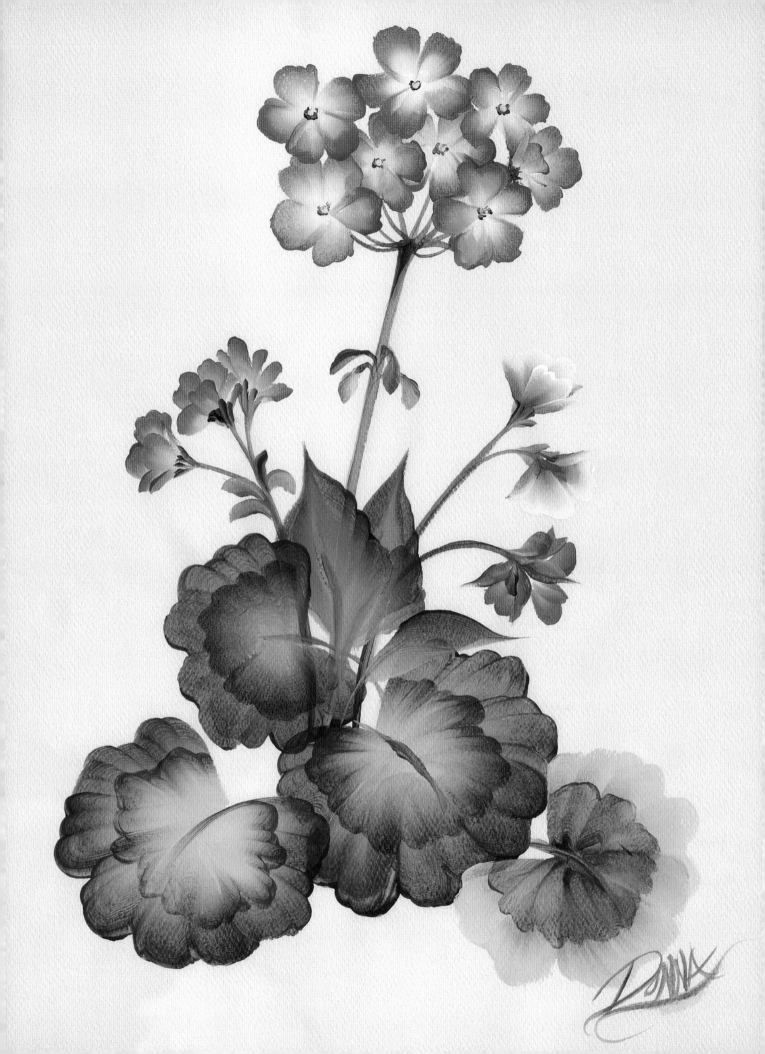

Geranium

BRUSHES
- 1-inch (25mm) flat
- no. 6 flat
- no. 12 flat
- no. 2 liner

PAINTS

FOLKART ACRYLICS
- Sunflower
- Thicket
- Wicker White
- Engine Red
- Magenta

FOLKART ARTISTS' PIGMENTS
- Yellow Light

OTHER
- Floating Medium

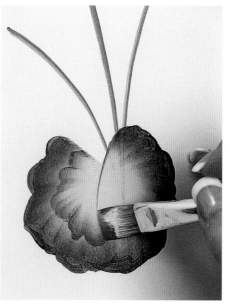

1 Using a 1-inch (25 mm) flat double loaded with Sunflower and Thicket, chisel in the stems. Paint the leaves using the same brush and colors. Ripple the edges, keeping your eyes on the green edge as you form the shape of the leaf.

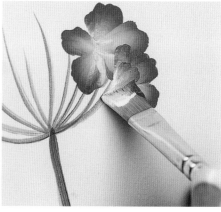

2 When the leaf is dry, load Engine Red and floating medium on a no. 12 flat. Use the same stroke as in step 1 to float in the red stripe around the inside of the leaf.

5 Use a no. 12 flat with Wicker White and Yellow Light, and a sideload of Magenta, to paint the partial side-view blossom. Paint the back petals first, then add the front petals.

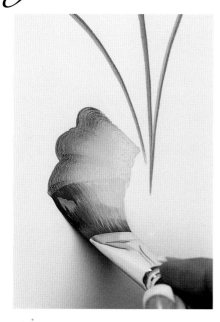

3 Use a no. 12 flat with Sunflower and Thicket to chisel in the base for the geraniums. Load a no. 6 flat with the same colors to paint the little buds on the stem with just a touch and lift.

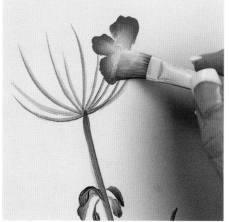

4 Use Wicker White and Yellow Light, with a sideload of Magenta, to paint the ripple-edged five-petal blossoms (see page 16).

6 For the lower side-view buds, flip your brush and use the same stroke to paint the petals. With Sunflower and Thicket on a no. 12 flat, chisel in the connecting calyx on the side-facing buds. Finish by touching in tiny dots into the centers of each blossom with Sunflower and Thicket on a no. 2 liner.

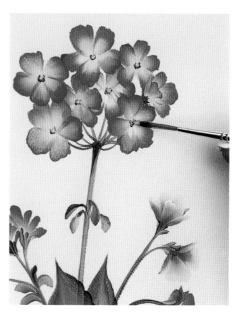

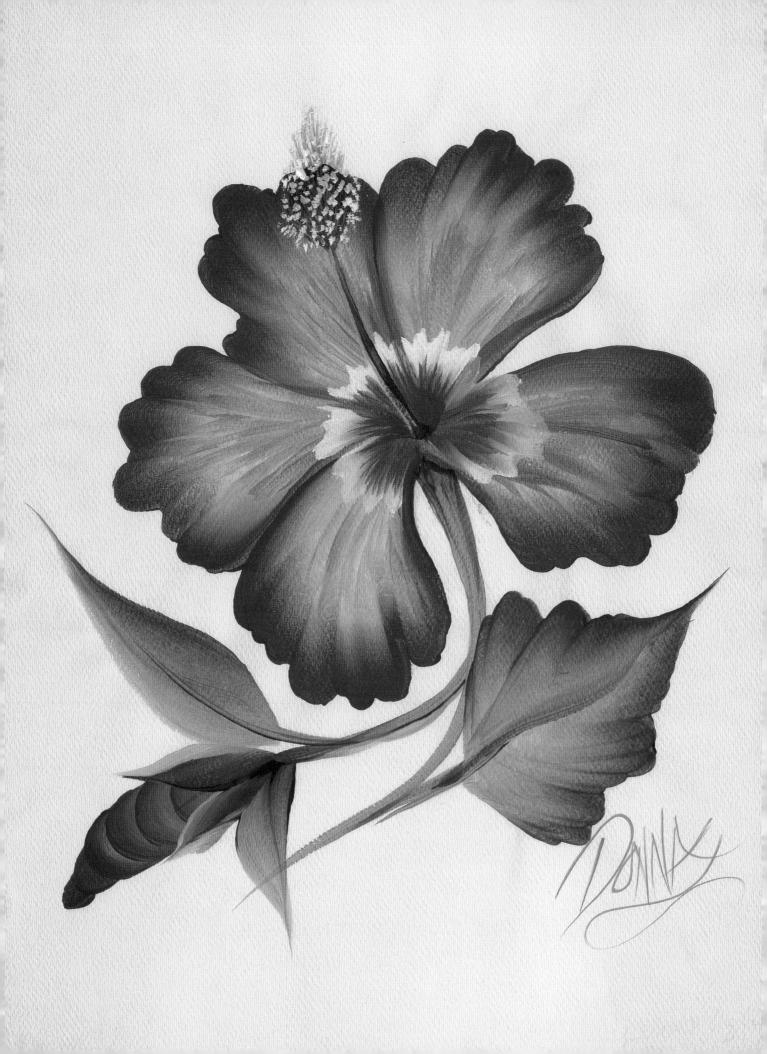

Hibiscus

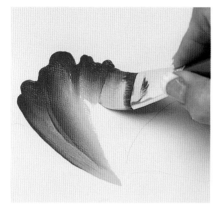

BRUSHES
- 1-inch (25mm) flat
- no. 16 flat
- no. 1 liner
- no. 2 liner

PAINTS

FOLKART ACRYLICS
- School Bus Yellow
- Engine Red
- Wicker White
- Green Forest

FOLKART ARTISTS' PIGMENTS
- Yellow Light

OTHER
- Tracing Paper
- Graphite Paper

1 It's best to trace and make a pattern (on tracing paper) for placement of this large-petaled flower. Use graphite paper to transfer the design onto your surface. Load Engine Red and School Bus Yellow on a 1-inch (25 mm) flat to paint the ruffled-edge petals. Go around the outer edge following the pattern, with the red ruffling the outside petal edges. Follow the red edge of the brush as you form the shape.

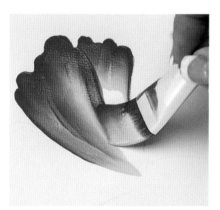

2 Then pull back into the center. Repeat steps 1 and 2 for each of the five large petals. Vary the amount of red and yellow to give a more natural look.

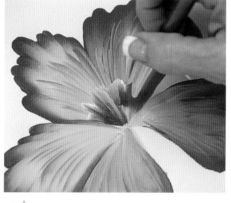

3 Load a no. 16 flat with Engine Red and Wicker White and wiggle in the center area of the petals. The white should face away from the flower center.

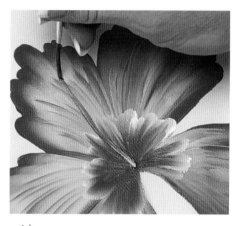

4 Paint the pistil in the center with a no. 2 liner and Green Forest and Yellow Light; touch and pull out from the center.

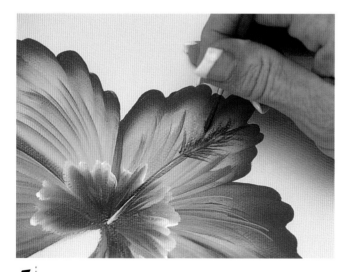

5 Use a no. 1 liner with Green Forest and Yellow Light to pull little stamen from the pistil. Turn your work to make stroking easier.

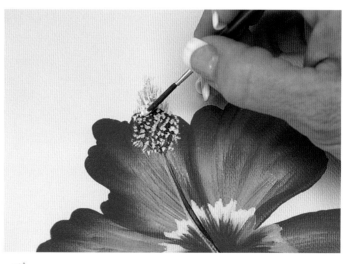

6 With Yellow Light and Wicker White on a no. 1 liner, dot in the pollen. Use a 1-inch (25mm) flat double loaded with Green Forest and Yellow Light to add the stems and large leaves (see page 22).

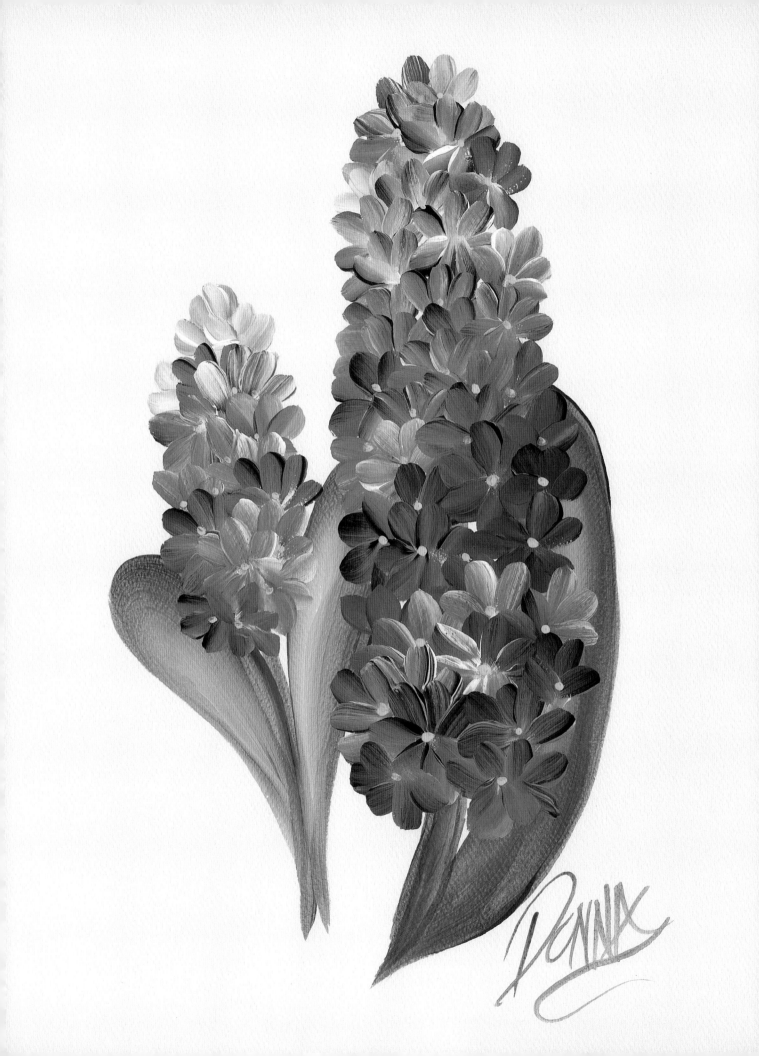

Hyacinth

BRUSHES
- ¾-inch (19mm) flat
- no. 8 filbert
- no. 2 liner

PAINTS

FOLKART ACRYLICS
- School Bus Yellow
- Thicket
- Wicker White

FOLKART ARTISTS' PIGMENTS
- Dioxazine Purple
- Yellow Light

OTHER
- Floating Medium

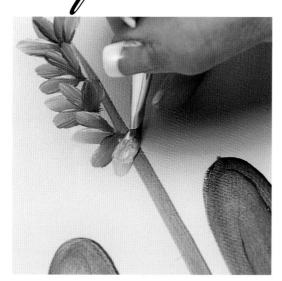

1 Paint the leaves using a ¾-inch (19mm) flat double loaded with Thicket and Yellow Light (see page 20). To paint the petals, double load a no. 8 filbert with Dioxazine Purple and Wicker White. Staying on the chisel edge of the filbert, start at the top and work down the stalk, painting four to five petals at a time, reloading as needed.

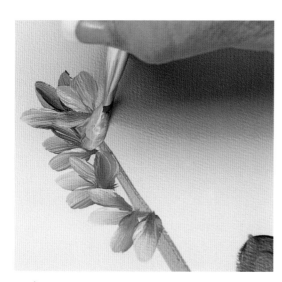

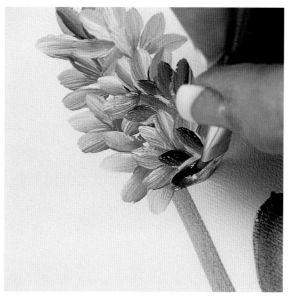

3 Pick up more Dioxazine Purple on the filbert. Lead with the Wicker White to make some darker purple petals. Keep alternating colors as you go down the stem, making some lighter purple and some darker.

2 Pick up a little School Bus Yellow and paint a few petals. The key is to layer these on top of each other.

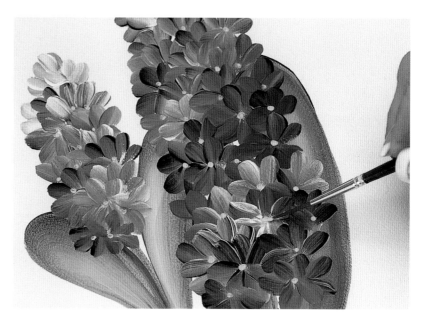

4 Dot in the centers using a no. 2 liner and Yellow Light. Skip the centers that are hidden behind other petals.

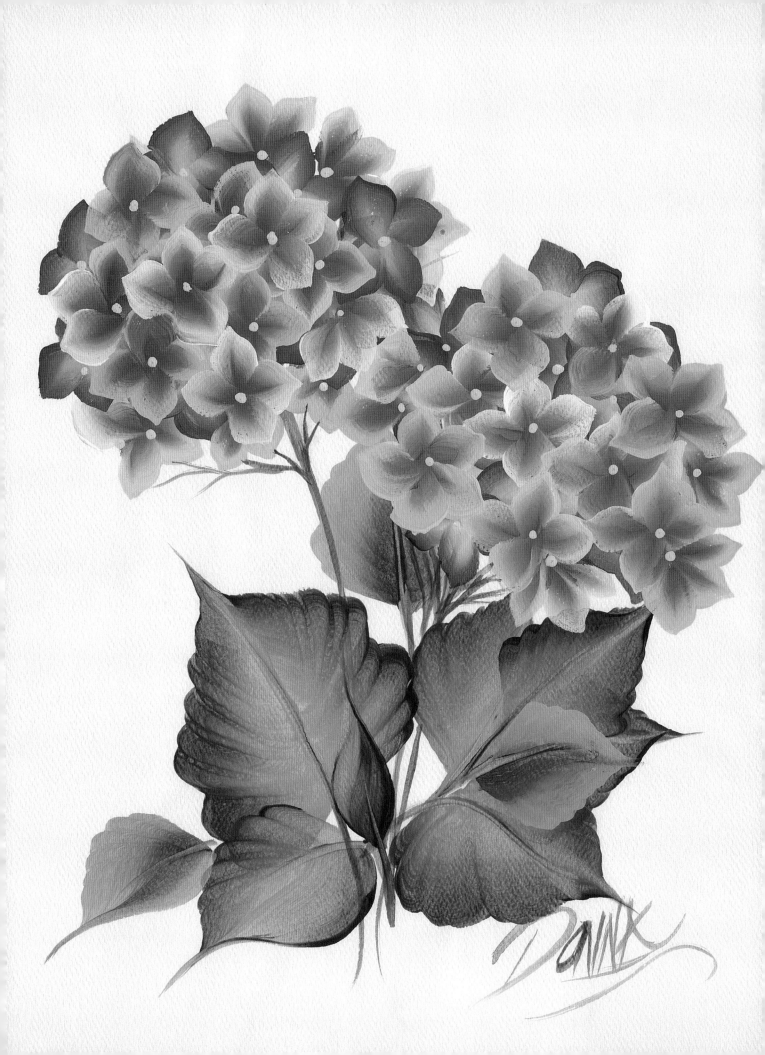

Hydrangea

BRUSHES
- ¾-inch (19mm) flat
- no. 10 flat
- no. 1 liner

PAINTS
FolkArt Acrylics
- Fresh Foliage
- Thicket
- Wicker White
- Violet Pansy
- Sunflower

1 Use a ¾-inch (19mm) flat double-loaded with Thicket and Fresh Foliage to paint the leaves and stems (see page 22). The small stems come off one main stem and sprout out from there as shown.

2 Load a no. 10 flat with Wicker White and Violet Pansy and paint the four petals of each floret. For each petal, begin on the chisel, slide out, lean, then come up to the point. Reverse direction, lean out and lift back up to the chisel to end the stroke. Overlap the florets. Pick up a little Sunflower on your brush for the yellow-centered ones, then flip the brush over and paint another floret with yellow edges and a purple center.

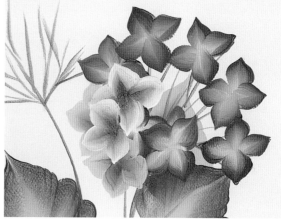

3 Paint the basic round shape. Then with the alternating colors of Wicker White, Violet Pansy and Sunflower, begin filling in the blossoms. You can add more purple, blue or white to the blossoms if you want to vary the colors.

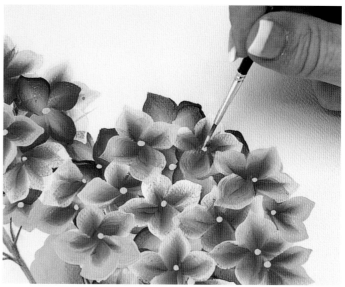

4 Dot in the centers of the florets with Sunflower on a no. 1 liner. Skip the ones that are hidden behind other petals.

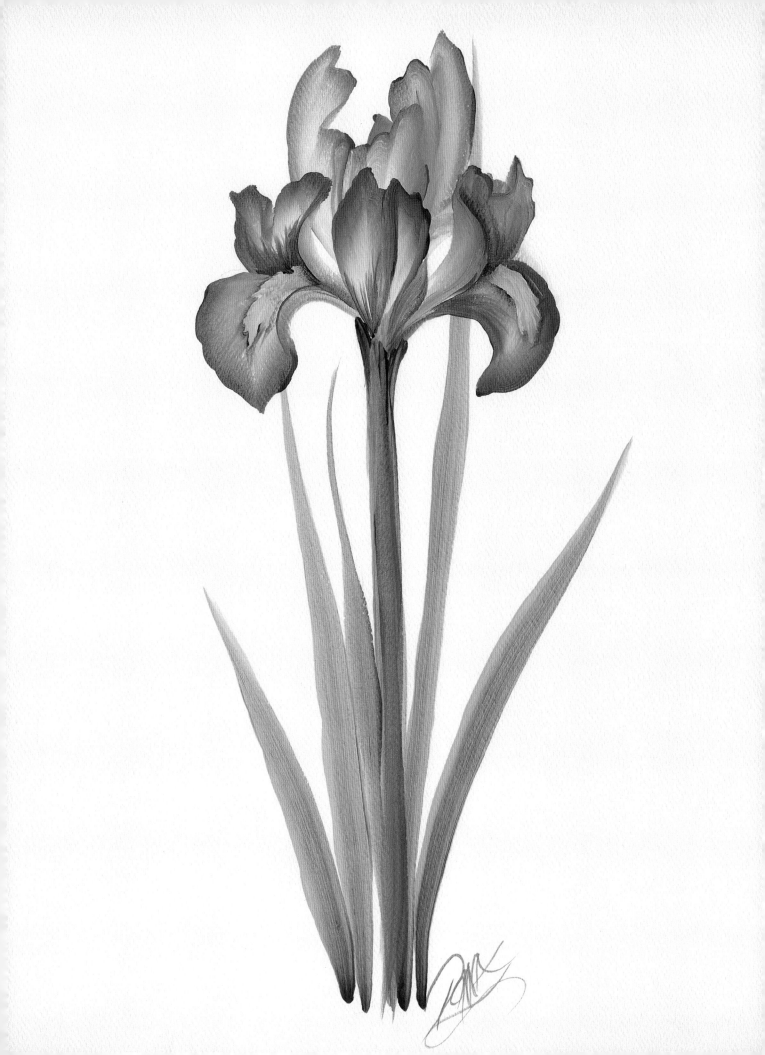

Iris

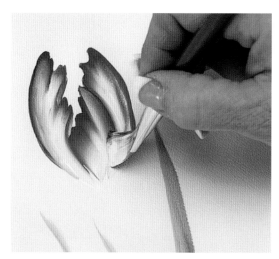

BRUSHES
- ¾-inch (19mm) flat
- no. 8 flat

PAINTS
FOLKART ACRYLICS
- Fresh Foliage
- Thicket
- Wicker White
- Night Sky
- School Bus Yellow

OTHER
- Floating Medium

1 Paint the leaves using a ¾-inch (19mm) flat double loaded with Fresh Foliage and Thicket. Load the same brush with Wicker White, then sideload it into Night Sky. Use the purple edge of the brush to draw the back petals. Slide up and ripple down, watching the shape of the petals (keep your eye on the purple edge) as you form them. Fill in the whole back section.

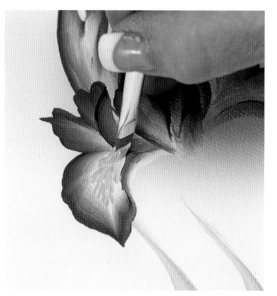

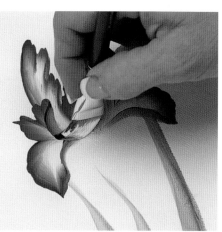

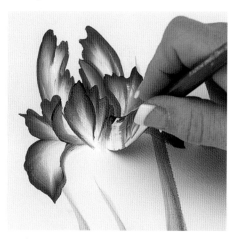

2 Add the bottom petals. Wiggle down to a point, start sliding back, then lift and roll the brush to get the curve in the front.

3 Add the smaller flipped-up petals on the sides. Start at the far-left back side and wiggle forward, rolling the last stroke (as in step 2) as you slide back down in front. The petal on the right side is painted the opposite way.

4 Intensify the color with a little more Night Sky on the edge of your brush. Add the front petals with a wiggle stroke.

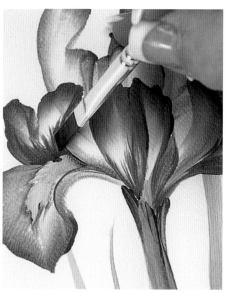

5 Load a no. 8 flat with Wicker White and School Bus Yellow. Lead with the white and fill in the beards on the iris with short strokes.

6 After the beard has dried, use a no. 8 flat to float Night Sky (floating medium sideloaded with Night Sky) around the beard. Also chisel in the little accent marks at the bottom of the petals. Add the stem using the colors and brush you used for the leaves in step 1.

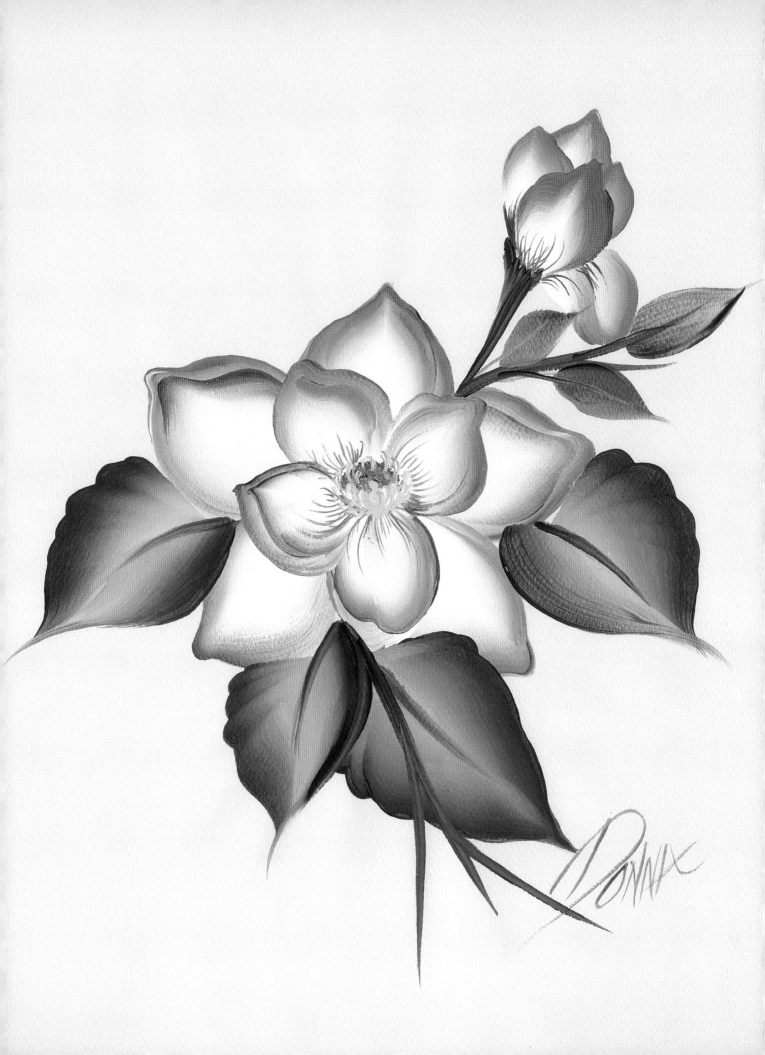

Magnolia

BRUSHES
- ¾-inch (19mm) flat
- no. 2 liner
- medium scruffy

PAINTS
FolkArt Acrylics
- Berry Wine
- Wicker White
- School Bus Yellow
- Thicket
- Sunflower

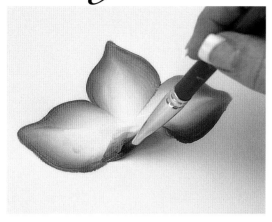

1 Use a ¾-inch (19mm) flat double loaded with Berry Wine and Wicker White to paint the first three petals. Keep your eye on the pink edge of the brush as you form the shape of each petal.

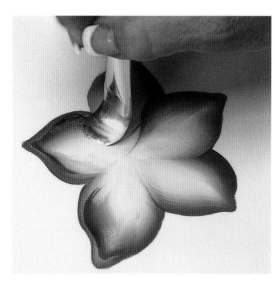

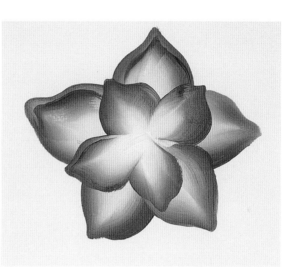

3 Use the same brush and colors to add the four smaller inside petals. Notice how these petals are staggered with the back petals.

2 Paint five petals in a starfish shape. Using the same brush and colors, paint some curled edges, stroking right inside a few of the large petals.

4 Use a no. 2 liner and thinned Berry Wine to add the pink streaks at the base of the inside petals. Load a medium scruffy with School Bus Yellow and Wicker White and pounce in the center area. With Wicker White and School Bus Yellow on the liner, touch and pull stamens around the center.

Paint the magnolia bud with Berry Wine and Wicker White. Use Thicket and Sunflower to chisel in the bud's calyx and to pull the stem. Finish with some large ruffled leaves and a few one-stroke leaves to fill in around the open blossom and the bud.

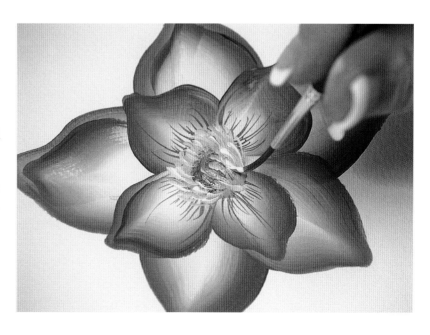

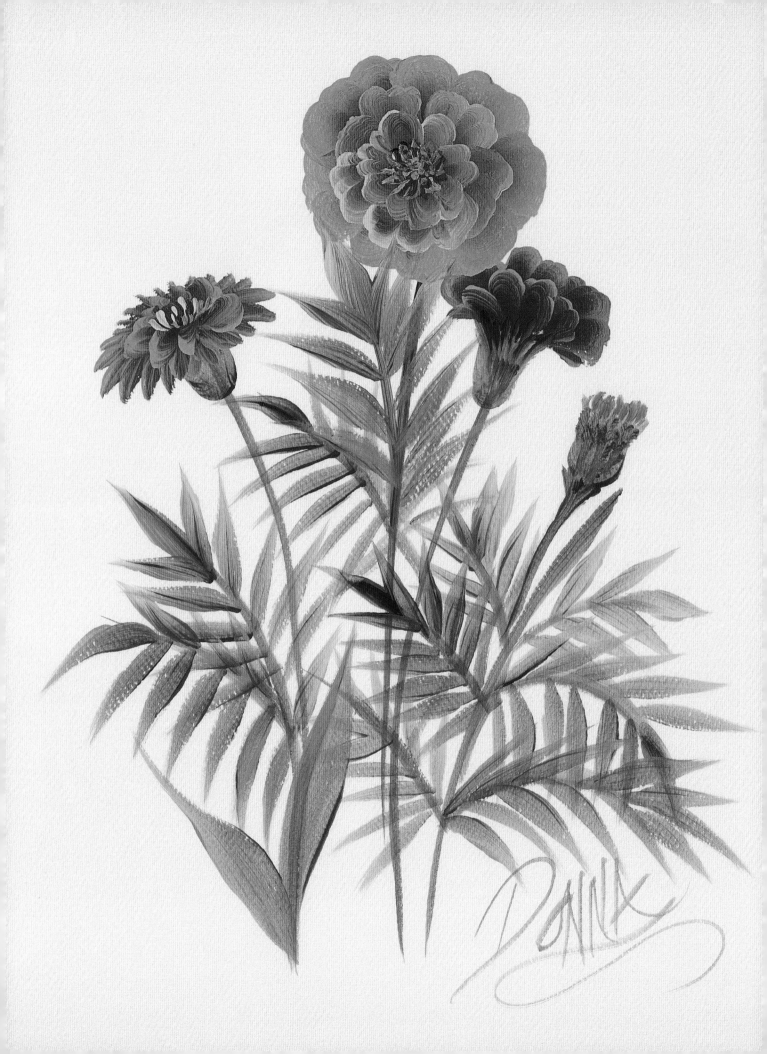

Marigold

BRUSHES
- no. 10 flat
- no. 2 liner

PAINTS

FOLKART ACRYLICS
- School Bus Yellow
- Engine Red
- Thicket

FOLKART ARTISTS' PIGMENTS
- Yellow Light

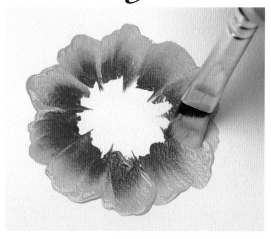

1 Paint the marigold's outer skirt with a bit of a ruffle, using a no. 10 flat with School Bus Yellow and Engine Red. Keep the yellow to the outer edge.

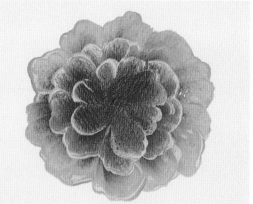

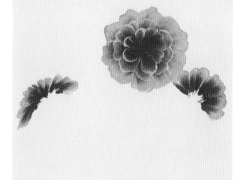

2 Add the second and third layers of ruffled petals using the same brush and colors.

3 Paint the side flowers. The back petals on the left side flower are short and get longer toward the sides. The back petals on the right side flower are painted the same as the center flower.

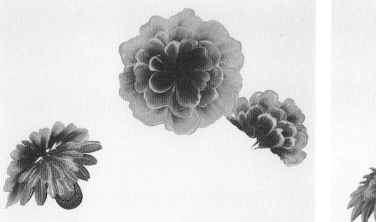

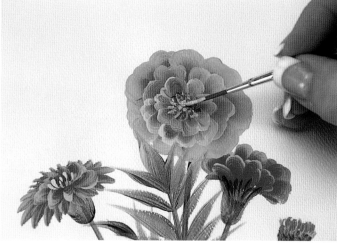

4 Before adding more layers to the left side flower, paint in a U-shaped base using a no. 10 flat with Thicket and Yellow Light. To add layers to the side flowers, use a no. 10 flat with the yellow and red. Chisel in the petals on the left flower, leading with the red. This will give a curved effect to the blossom.

5 Add the greenery. The leaves are an outward chisel-edge stroke using a no. 10 flat with Thicket and Yellow Light. Use a no. 2 liner with Thicket and Yellow Light to touch in the stamens.

Meadow Rue

BRUSHES
- ¾-inch (19mm) flat
- no. 12 flat

PAINTS

FOLKART ACRYLICS
- Thicket
- Wicker White
- Magenta

FOLKART ARTISTS' PIGMENTS
- Yellow Light

1 Paint the two main stems and the smaller branching stems using Thicket and Yellow Light on a ¾-inch (19mm) flat.

2 Using the same brush and colors, add the long, slender bottom leaves (see page 20).

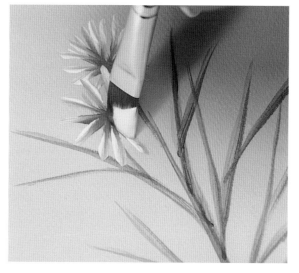

3 Double load a no. 12 flat with Wicker White and a touch of Magenta. Pull in the petals toward the center, staying up on the chisel edge. For variation, pull some petals while leading with the white edge, and pull others while leading with the Magenta edge.

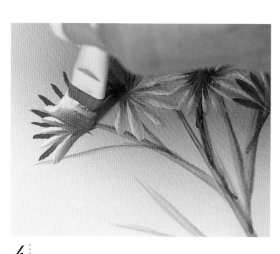

4 For the side-facing flowers, paint the back layer of petals while leading with the white edge. Paint the front layer of petals by leading with the pink edge.

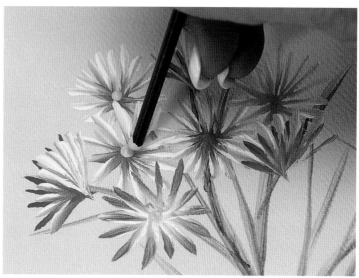

5 Take a small brush handle and dot Yellow Light onto the centers.

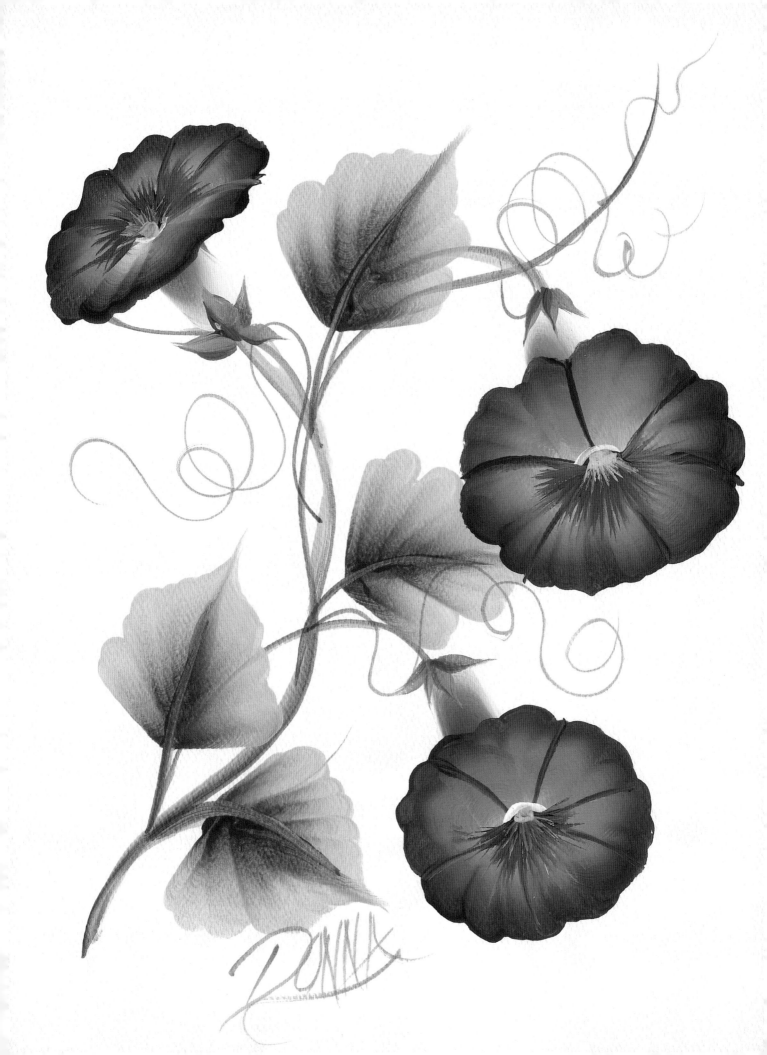

Morning Glory

BRUSHES
* ³⁄₄-inch (19mm) flat
* no. 16 flat
* no. 2 liner

PAINTS

FOLKART ACRYLICS
* Thicket
* Sunflower
* Wicker White
* Berry Wine

FOLKART ARTISTS' PIGMENTS
* Dioxazine Purple
* Yellow Light

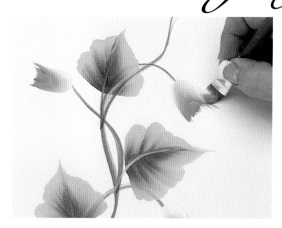

1 Paint the leaves and vines with Thicket and Sunflower and a little Yellow Light on the outside edge, using a ³⁄₄-inch (19mm) flat. Paint the C-shaped trumpet (see page 16) of the blossom using a no. 16 flat with Wicker White sideloaded with a small amount of Dioxazine Purple (working it into the brush on your palette really well).

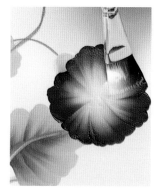

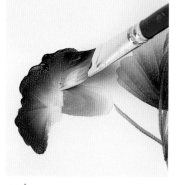

2 Double load a ³⁄₄-inch (19mm) flat with Wicker White and Dioxazine Purple, then pick up a little Berry Wine on the purple side. Paint five separate sections of petals using a sea shell stroke (see page 15) to create a ruffled look.

3 For the side-facing blossom, use the same brush and colors, painting the back layer first. Then staying up on the chisel, make the front petals shorter than the back.

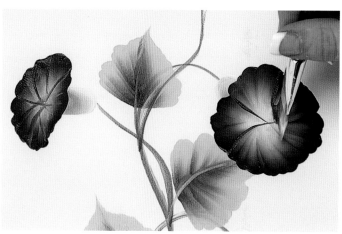

4 Pick up more Berry Wine on the Dioxazine Purple edge and, leading with the white, pull in the rib lines between the petals.

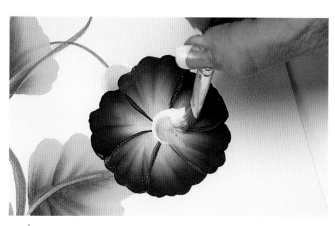

5 Use a no. 16 flat with Wicker White and floating medium and paint a C-shaped stroke to define the throat of the blossom.

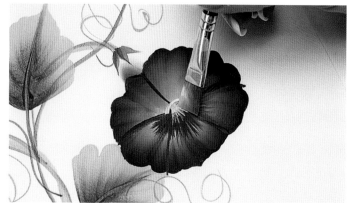

6 With your no. 16 flat, chisel in the purple lines on the petals. Use the handle of your brush to dot Yellow Light into the center. Then use the chisel to pull out the yellow stamen. Add the calyx with a no. 16 flat and the curlicues with a no. 2 liner, using the same colors you used in step 1 for the leaves and vines.

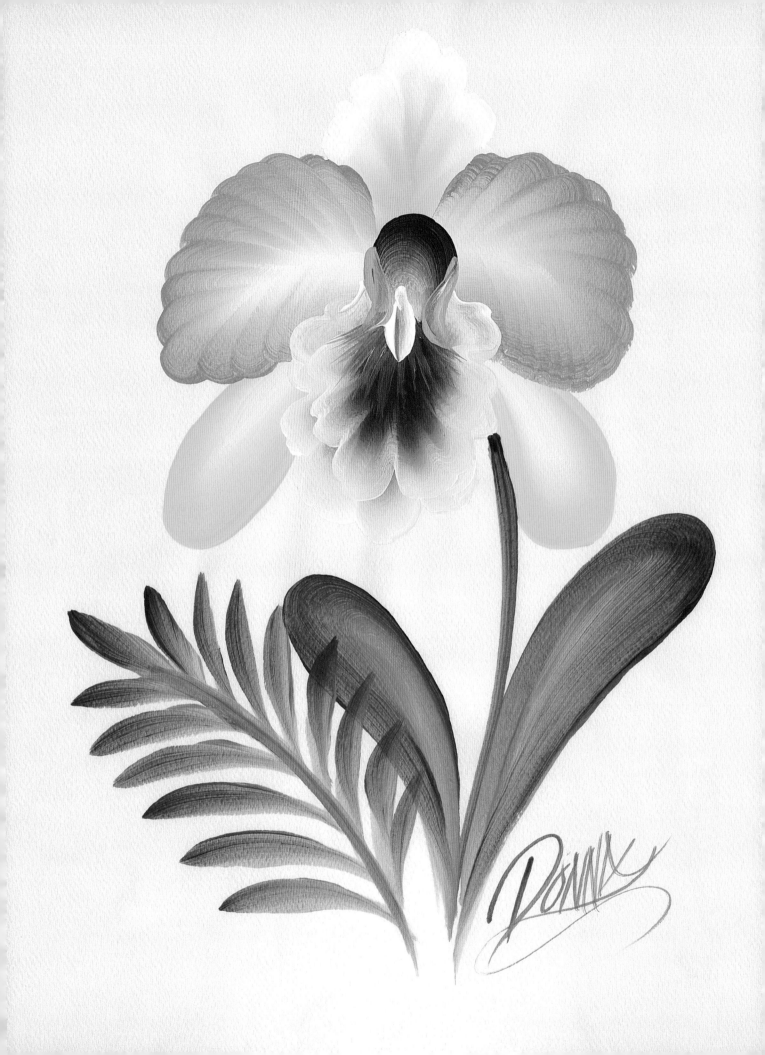

Orchid

1 Look at the orchid you want to paint, and decide how wide you want the back petal. This is the basis for how big the flower will be. Double load a ¾-inch (19mm) flat with Yellow Light and Wicker White and paint a ruffled petal (see page 17). Watch the white edge while you form the ruffled shape.

BRUSHES
- ¾-inch (19mm) flat
- no. 8 flat

PAINTS

FOLKART ACRYLICS
- Berry Wine
- Green Forest
- Wicker White
- Sunflower

FOLKART ARTISTS' PIGMENTS
- Yellow Ochre
- Yellow Light
- Burnt Carmine

2 For the two lower back petals, use the same colors and brush. Just flip the brush over, keeping your eye on the outside yellow edge. These look like two big, long teardrops (see page 17).

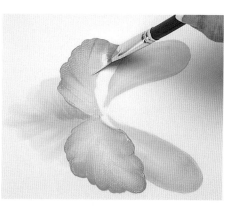

3 Add the upper petals using Yellow Ochre, Yellow Light and Wicker White (keep the yellow to the outside). These are ruffly teardrops, the same as the back center petal but hanging down to the sides a bit.

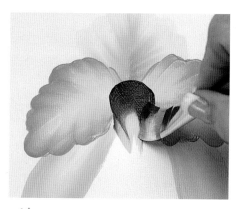

4 With Burnt Carmine and Yellow Light on the same brush, add the center of the throat. Begin on the chisel, slide up and paint a C-shape and slide back down, lifting to the chisel.

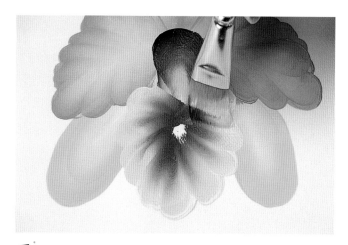

5 Add the back ruffled layer on the bottom, using the same brush and colors. If you want to brighten up the colors, add some Berry Wine to the Burnt Carmine side of the brush.

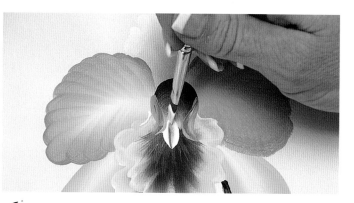

6 Still using the same brush and colors, add a second layer of ruffled petals. Then add connecting side petals with the chisel of a no. 8 flat and Yellow Ochre. With the same brush and Wicker White, add a center chisel stroke (stroke upward). Add a stem, leaves and the fern using a ¾-inch (19mm) flat with Green Forest and Sunflower (see pages 20-21).

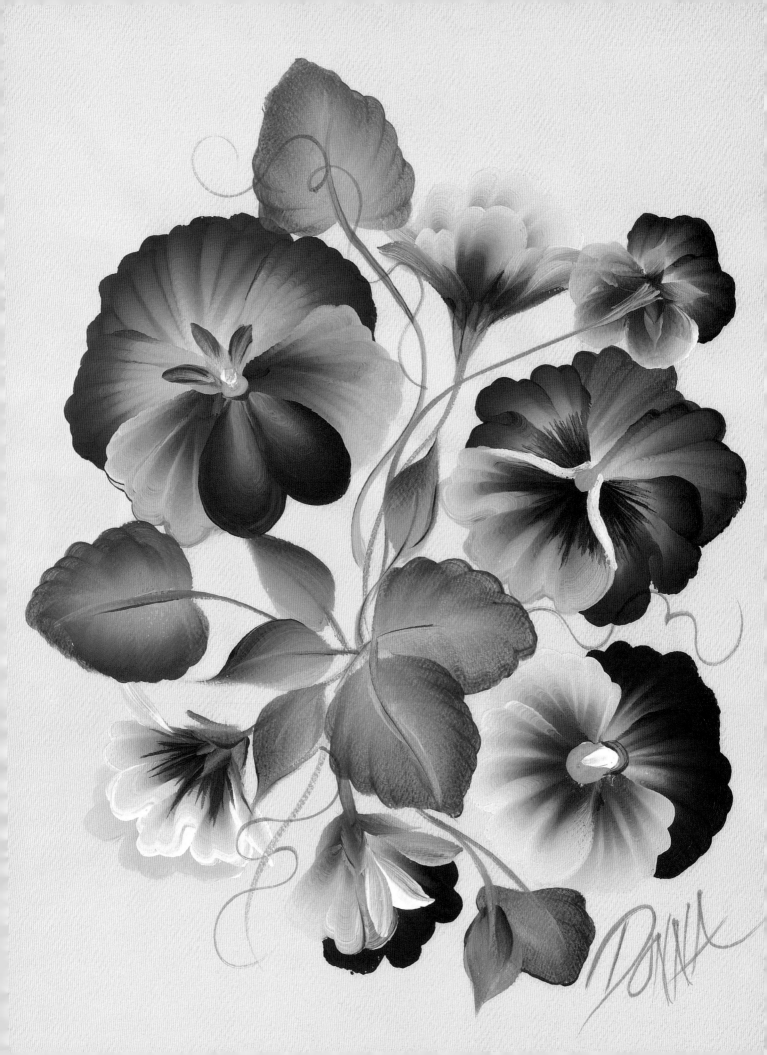

Pansy

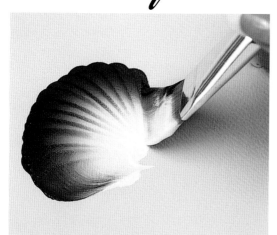

1 Paint the purple pansy with a ³⁄₄-inch (19mm) flat loaded with Wicker White and a side-load of Dioxazine Purple (blend well on your palette). Paint the large back petal using a sea shell stroke (see page 15). Keep the purple to the outside edge.

BRUSHES
- ³⁄₄-inch (19mm) flat
- nos. 8 and 12 flats
- no. 1 script liner
- no. 2 liner

PAINTS

FolkArt Acrylics
- Wicker White
- School Bus Yellow
- Thicket
- Sunflower

FolkArt Artists' pigments
- Dioxazine Purple
- Yellow Light

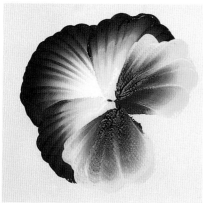

2 With the same brush, pick up some Yellow Light on the white edge and stroke in two side petals. Let dry. Flip the brush over so the yellow is toward the outside edge and paint two more petals.

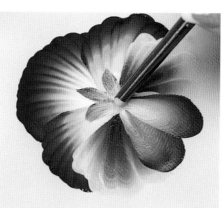

3 Still with the same brush, pick up School Bus Yellow on the light edge and paint two teardrop-shaped strokes. Keep your eye on the purple edge as you form the shape of the stroke. Using a no. 8 flat with Thicket and Yellow Light, chisel in three green strokes in the center. Dot the center with School Bus Yellow using the handle of your brush.

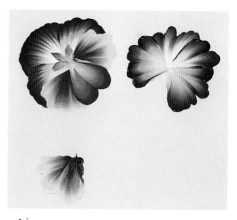

4 Use Wicker White and Dioxazine Purple to ruffle in the back petals of the other purple pansies. Add Yellow Light to the white edge of the brush and ruffle in the side petals. Flip the brush and paint the back layer of the bud.

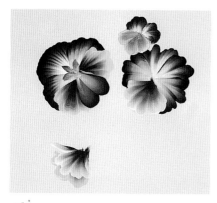

5 The lower petal of the open pansy is large and very ruffly. Add a little more white to the brush and paint the front layer of the bud shorter than the back.

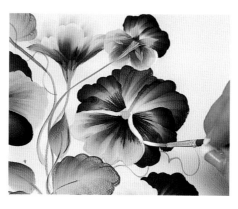

6 Use a no. 12 flat with floating medium and Dioxazine Purple to chisel out streaks on the petals and the bud. Dot in the centers with School Bus Yellow. Use a no. 1 script liner to accent the petals with Wicker White. Add leaves and stems using Thicket and Sunflower on a ³⁄₄-inch (19mm) flat (see page 22). Load inky Thicket on a no. 2 liner and add curlicues here and there (see page 23).

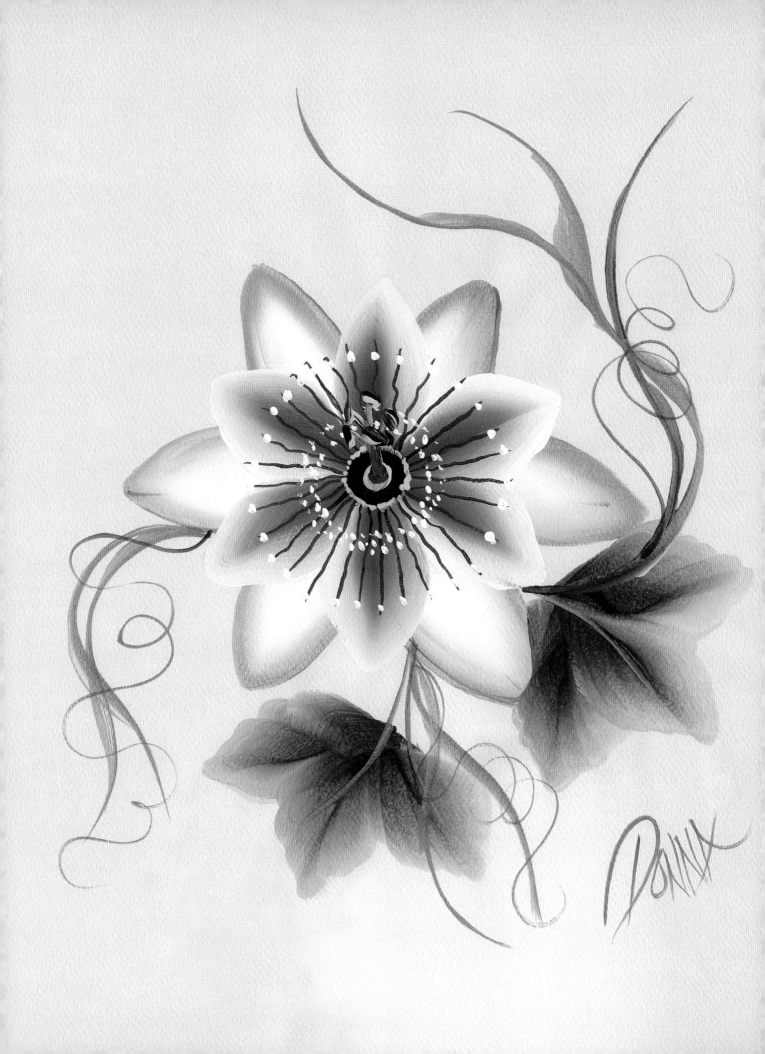

Passion Flower

BRUSHES
- ¾-inch (19mm) flat
- no. 2 liner
- no. 1 script liner

PAINTS

FOLKART ACRYLICS
- Wicker White
- Thicket
- Berry Wine
- Sunflower

FOLKART ARTISTS' PIGMENTS
- Dioxazine Purple
- Yellow Light

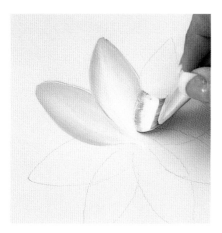

1 Load the ¾-inch (19mm) flat with Wicker White and, just tipping the edge, sideload with Thicket. Keep your eye on the green edge while painting the back leaves. Touch, push and slide up to a rounded point; reverse direction and slide back down the other side. Repeat this for each back leaf.

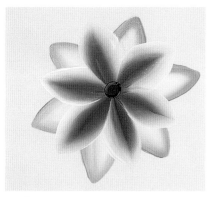

2 Double load Dioxazine Purple and Wicker White, working it into the brush really well. With the same stroke as for the leaves, paint six smaller flower petals in a circle. Be sure the petal tips are rounded and keep your eye on the white edge of the brush. Dip the handle of the brush into Dioxazine Purple and make a large dark circle in the center.

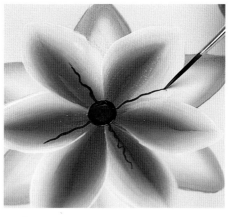

3 Use a no. 2 liner and thinned Dioxazine Purple to paint the corona fringe. Think of the flower as a clock face and paint four wiggly lines at 12, 3, 6 and 9 o'clock. Then fill in with more lines in between.

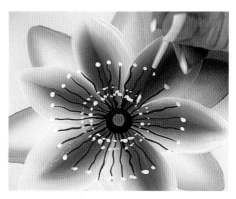

4 Dip the handle of your brush into Berry Wine and Wicker White and dot in the pink center. Tip the fringe with dots of Wicker White using a no. 2 liner. Perfectly place the outside row at the line ends, then randomly dot the inside two rows.

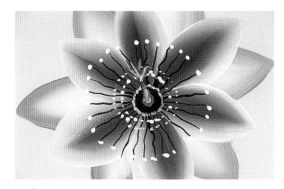

5 With the tip of a liner brush and Yellow Light, dot around the purple center. Load a no. 1 script liner with Thicket streaked through Wicker White and pull the stem up from the center.

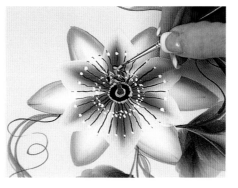

6 Add the stamen with a no. 1 script liner loaded with Thicket and streaked through Yellow Light. These are little slashes at the tops of the stalks. Stroke in leaves and stems using a ¾-inch (19mm) flat double loaded with Thicket and Sunflower. Use a no. 2 liner with inky Thicket for the curlicues.

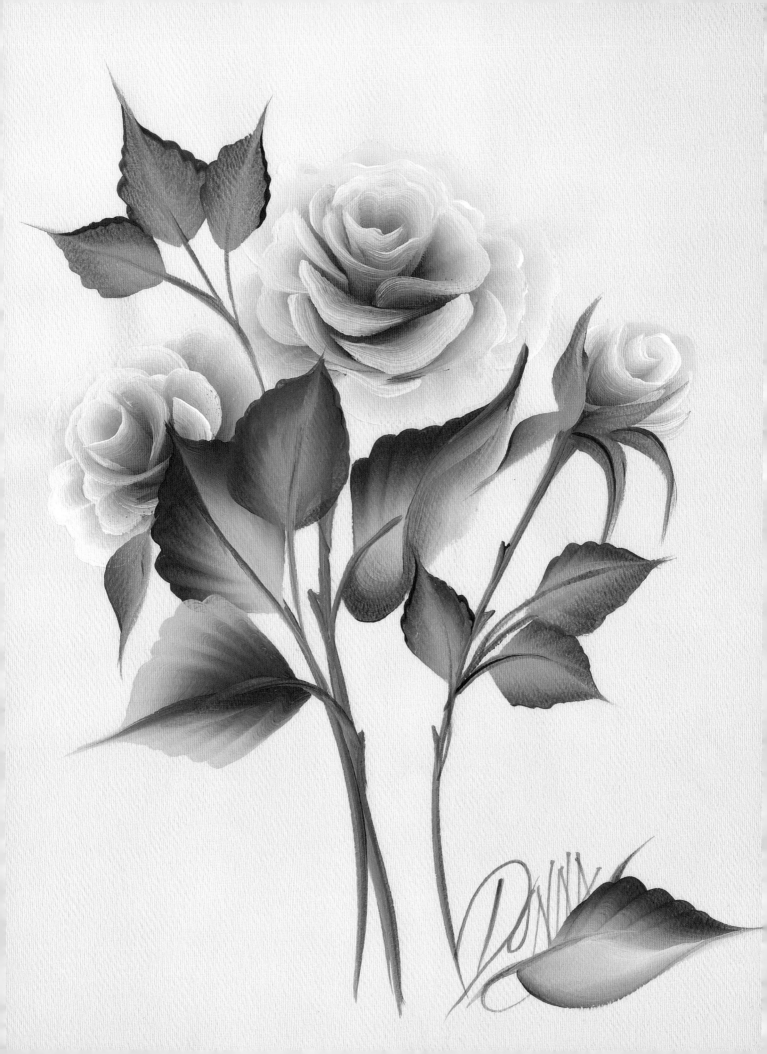

Peace Rose

BRUSHES

♣ ¾-inch (19mm) flat
♣ no. 16 flat
♣ ⅝-inch (16mm) angular

PAINTS

FOLKART ACRYLICS

♣ Wicker White
♣ Berry Wine
♣ Thicket

FOLKART ARTISTS' PIGMENTS

♣ Yellow Light

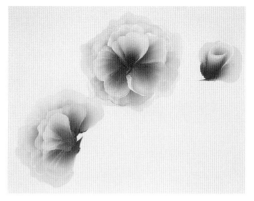

1 Load a ¾-inch (19mm) flat with Yellow Light and Wicker White on one side and Berry Wine on the other. Paint the outer skirt. Use the same colors on a no. 16 flat to paint the outer petal of the rosebud (see pages 18-19 for step-by-step directions on painting a rose and a rosebud).

2 Paint three layers of petals, varying the amount of white and yellow on the brush. Add the center back petal on the full roses and on the closed bud.

3 *(left)* Paint the center petal strokes on the open rose. Then begin to chisel in the side petals. Use a ⅝-inch (16mm) angular brush and lean the lighter color out.

4 *(right)* Now pull across the front, rolling the brush and fingers and pivoting on the heel of the brush (darker color).

5 *(left)* Chisel in the last petals, keeping your eye on the light edge. Lead with the heel of the brush.

6 *(right)* Use Thicket and Yellow Light with the ⅝-inch (16mm) angular to paint the leaf that covers part of one rose. Start with the toe down and wiggle the green edge of the brush to the tip of the leaf. Repeat on the other side. Finish by adding the rest of the leaves and stems, using the same colors and brush.

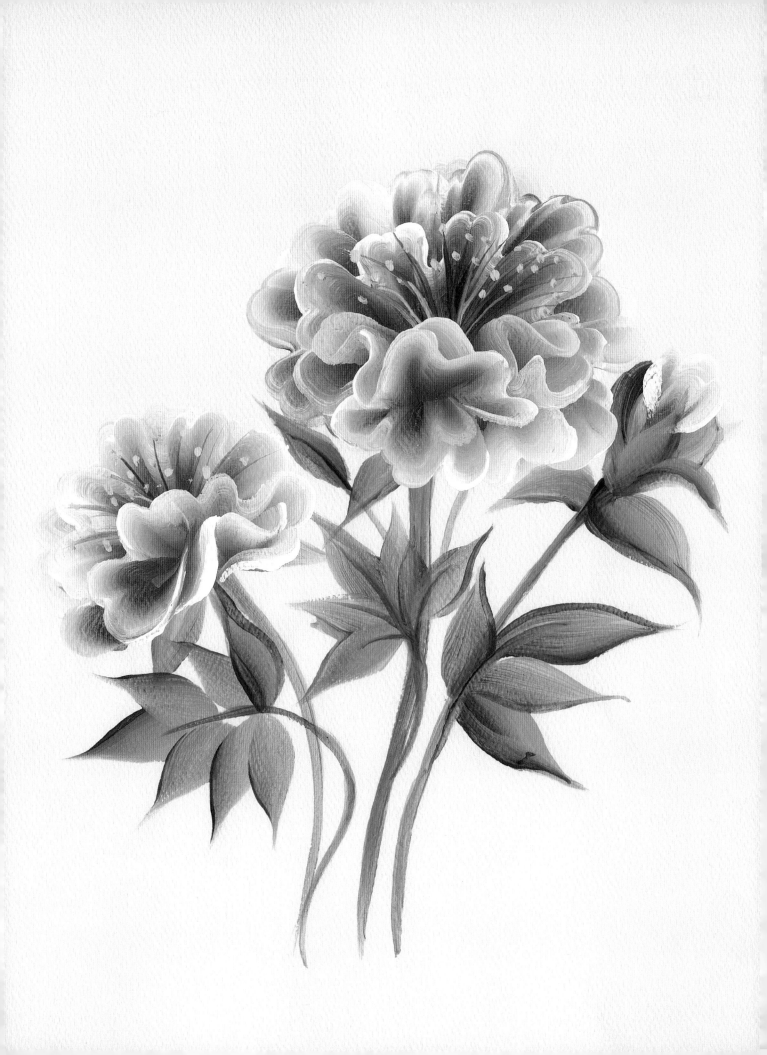

Peony

BRUSHES
- ¾-inch (19mm) flat
- no. 2 liner
- no. 1 script liner

PAINTS
FolkArt Acrylics
- Berry Wine
- Wicker White
- Thicket
- Sunflower

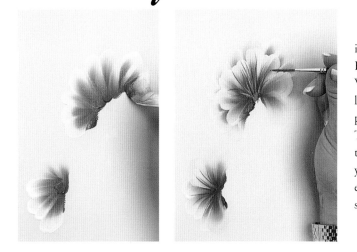

1 *(far left)* Use a ¾-inch (19mm) flat with Berry Wine and Wicker White to paint the back layer of petals. Peony petals are very ruffly. The white should face the outer edge; keep your eye on the white edge as you form the shape of the petals.

2 *(top right)* Add more ruffled layers. Pull the stamen using inky Thicket and a touch of Sunflower on a no. 2 liner.

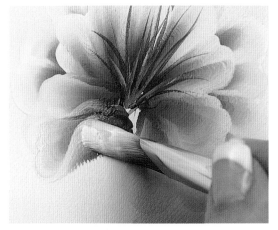

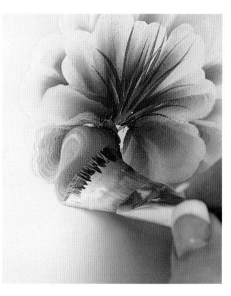

3 *(left)* Using the same brush and colors as in step 1, begin painting the front rolled petals that fold in over on themselves (see page 17 for instructions on painting rolled petals).

4 *(right)* Without lifting the brush, pull it back over to form the second fold.

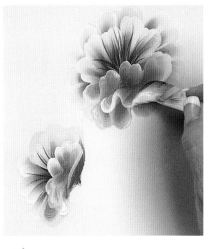

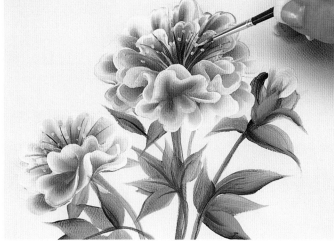

6 Use a no. 1 script liner with Sunflower to dot in the stamen. Add leaves and stems using a ¾-inch (19mm) flat double loaded with Thicket and Sunflower (see page 21).

5 Add more ruffled or rolled petals to fill in any empty areas.

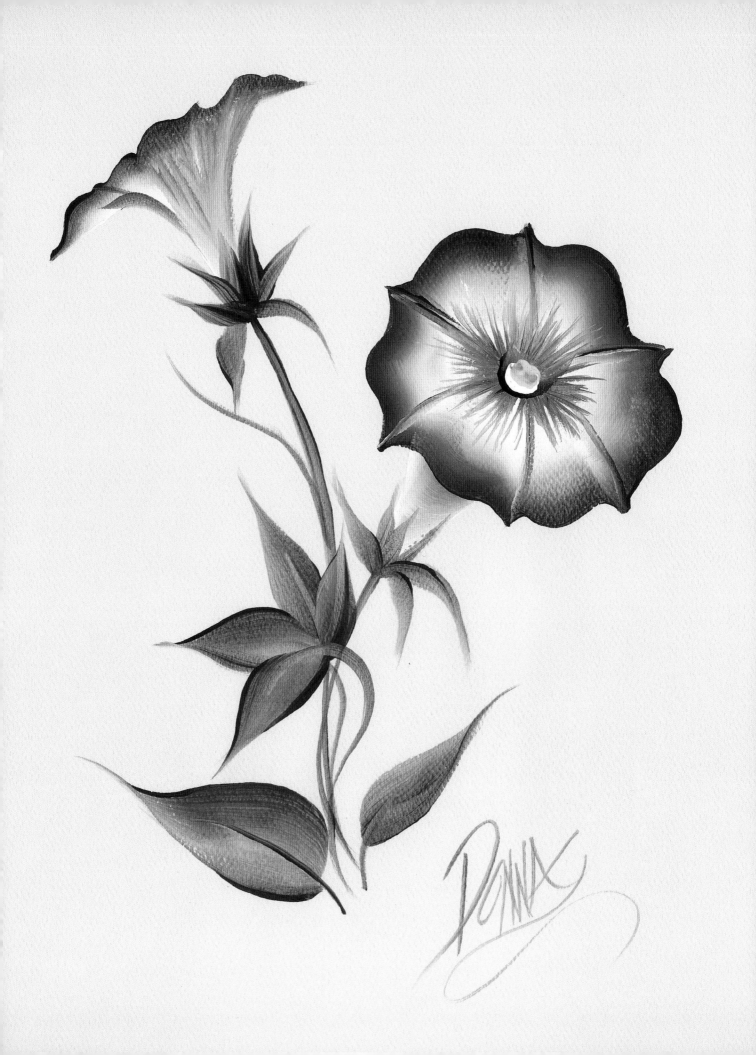

Petunia

BRUSHES
- ¾-inch (19mm) flat
- no. 12 flat

PAINTS
FOLKART ACRYLICS
- Wicker White
- Thicket

FOLKART ARTISTS' PIGMENTS
- Dioxazine Purple
- Yellow Light

1 Paint the C-shaped trumpets using a ¾-inch (19mm) flat loaded with Wicker White, then sideloaded with Dioxazine Purple. Keep your eye on the white edge of the brush as you form the trumpet shape.

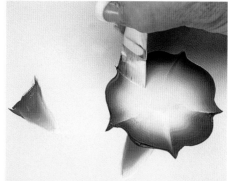

2 Beginning on the chisel at the petal's peak, scoop in, make a scallop, back up to the peak and back out to the chisel. Repeat for each section of the petunia.

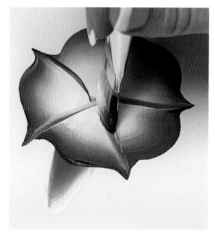

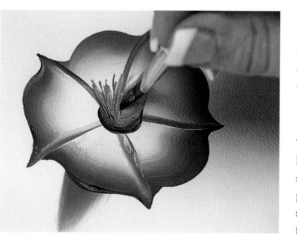

3 *(far left)* Add rib lines at each peak; curve in to the center on the chisel, leading with the white edge of the brush.

4 *(left)* Using a no. 12 flat loaded with Wicker White and sideloaded with Dioxazine Purple, add the throat with a C-shaped stroke. Pull out little lines from the center on the chisel.

5 Still using a ¾-inch (19mm) flat and Wicker White sideloaded with Dioxazine Purple, paint the side-view petunia. Scallop the edges, then slide down into the trumpet. Use the chisel to add rib lines.

6 Dot the flower center with Yellow Light. Also add the calyxes using a no. 12 flat with Thicket and Yellow Light. With the same brush and colors, add the stems and leaves (see pages 20-21).

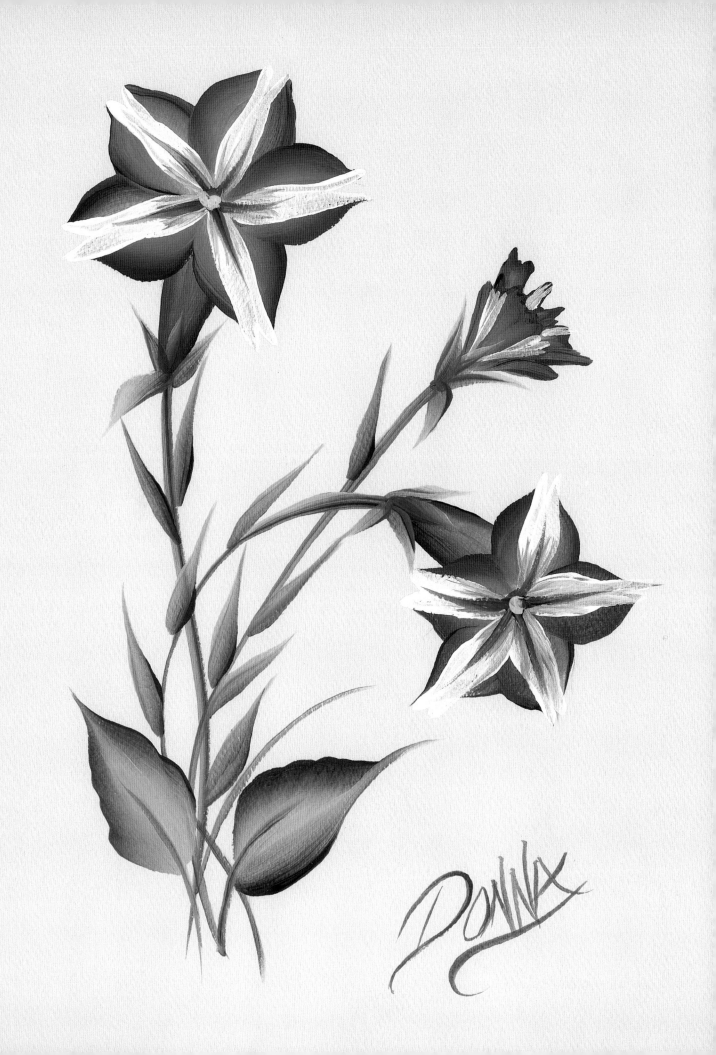

Petunia *(striped)*

BRUSHES
- no. 16 flat
- no. 12 flat
- no. 6 flat

PAINTS

FOLKART ACRYLICS
- Wicker White
- Green Forest

FOLKART ARTISTS' PIGMENTS
- Dioxazine Purple
- Yellow Light

1 Paint the trumpet using a no. 16 flat double-loaded with Dioxazine Purple and Wicker White.

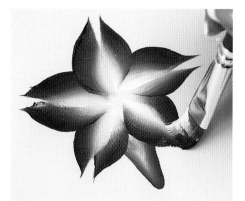

2 Paint the petals using the same brush and colors. Start on the chisel, push down and lift, pulling out from the center.

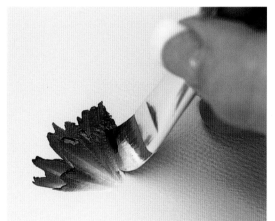

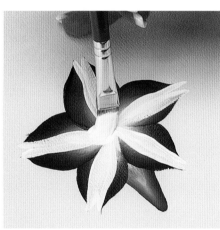

3 *(far left)* The side-view petunia that is just starting to unfurl is painted with a ruffled-edge stroke (see page 16). Turn your work so it's easier to move your brush in a zig-zagging motion.

4 *(left)* Add the white stripes to the open petunias using the chisel of a no. 12 flat. Pull the stripes out from the center.

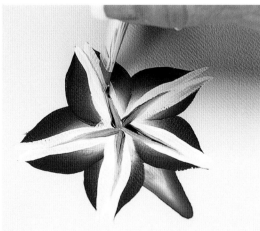

5 Add green stripes with the chisel of a no. 12 flat loaded with Yellow Light and Green Forest.

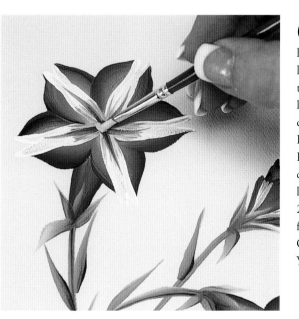

6 Chisel in the little wispy green lines on each side of the center green lines. Add the center dot with Yellow Light on a no. 6 flat. Finish with the calyxes, stems and leaves (see pages 20-21), using a no. 16 flat loaded with Green Forest and Yellow Light.

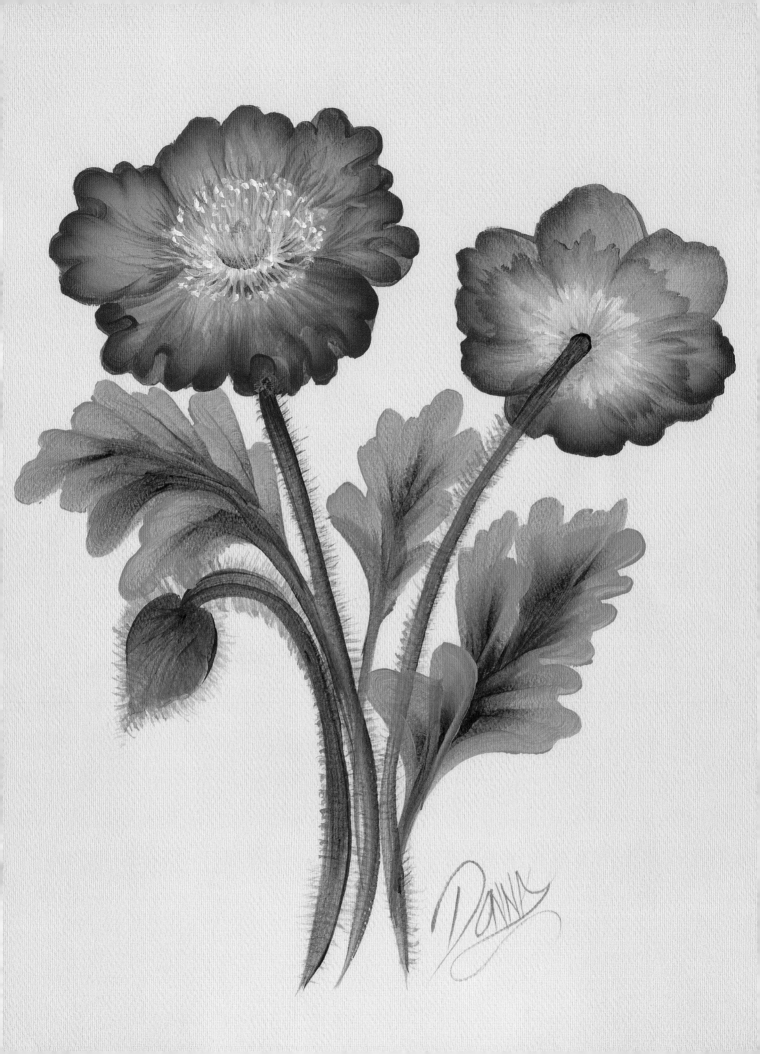

Poppy

BRUSHES
- ¾-inch (19mm) flat
- no. 12 flat
- no. 2 liner

PAINTS
FolkArt Acrylics
- Grass Green
- Thicket
- School Bus Yellow
- Engine Red
- Wicker White
- Fresh Foliage

1 Paint the leaves and small stems with Grass Green and Thicket on a ¾-inch (19mm) flat. Use the same brush with School Bus Yellow and Engine Red to paint ruffled petals. Keep the red to the outside and paint around in a circle.

2 Stay up on the chisel edge and add tiny lines on the petals. Lead with the yellow.

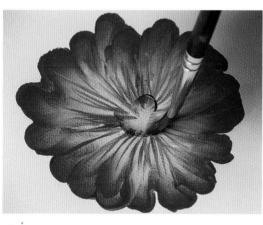

3 Use School Bus Yellow sideloaded into Thicket to add the center green area (a small C-shaped stroke and a larger U-shaped stroke under the small stroke). You will be pulling the stamens into this area.

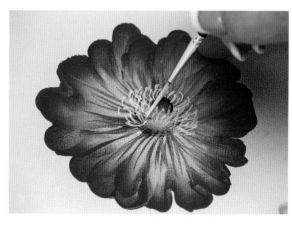

4 Load a no. 2 liner with Wicker White. Touch and pull down stamens into the center. Keep them light and airy.

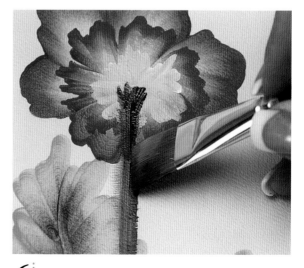

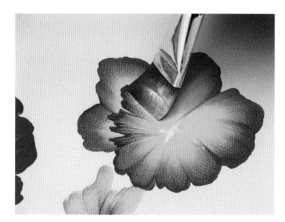

5 With a ¾-inch (19mm) flat, paint the back of the back-facing poppy. Make the bottom petals shorter than the top petals. Come back in and add a wiggly layer inside of the outer petal layer.

6 Load School Bus Yellow with Wicker White on a no. 12 flat and add a wiggly layer of white. Using the same brush, chisel in the stem with Fresh Foliage and Thicket. Take the chisel edge of the brush and touch on the wet stem, then pull tiny little "hairs" out of it.

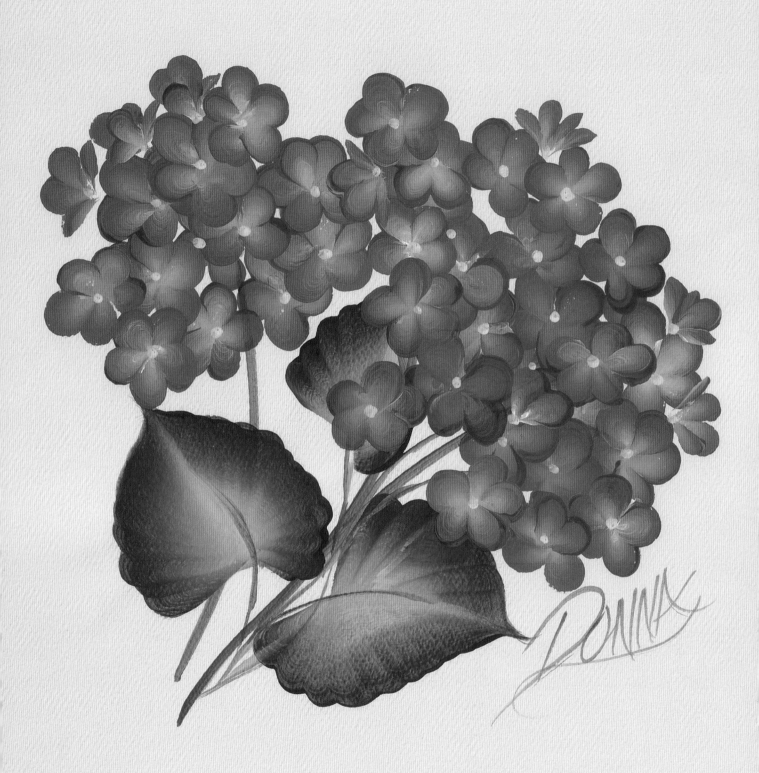

Ruby Glow

BRUSHES
- ¾-inch (19mm) flat
- no. 8 flat
- no. 2 liner

PAINTS

FOLKART ACRYLICS
- Thicket
- Sunflower
- Engine Red
- Wicker White

FOLKART ARTISTS' PIGMENTS
- Yellow Light

1 Paint the leaves and stems with Thicket, Yellow Light and Sunflower using a ¾-inch (19mm) flat (see page 22).

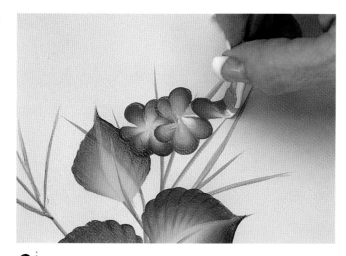

2 Double load a no. 8 flat with Engine Red and Wicker White. Stroke in five-petal florets, overlapping them as you go (see page 16). Watch the red edge of the brush as you form the shape of each petal. You want to form a ball shape of blossoms.

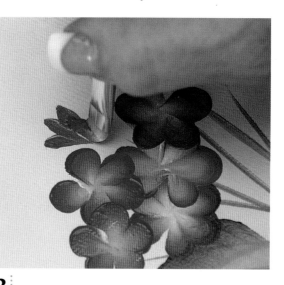

3 Pull in the strokes on the bud, using the same colors and the chisel of the same brush.

4 Dot in the centers with the end of a small brush dipped in Sunflower.

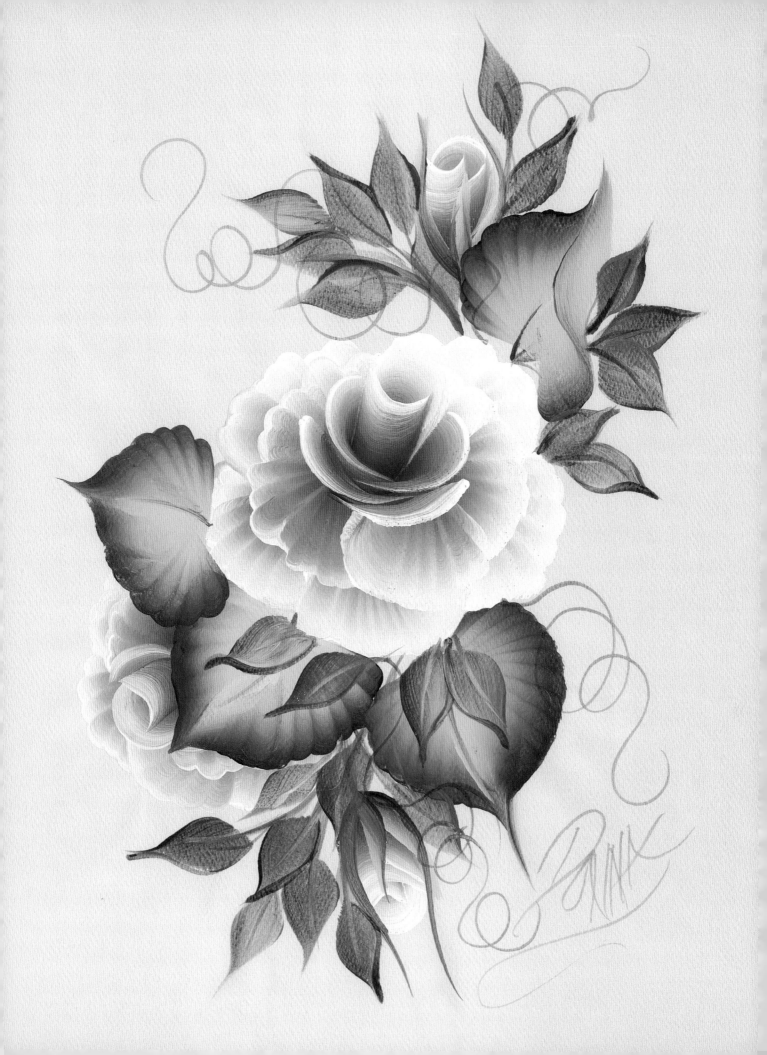

Signature Rose

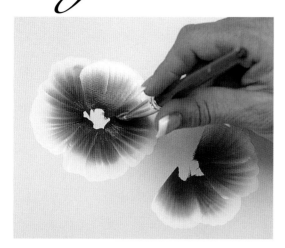

BRUSHES
- ¾-inch (19mm) flat
- ¾-inch (19mm) angular
- ⅝-inch (16mm) angular
- no. 2 liner

PAINTS
FOLKART ACRYLICS
- Berry Wine
- Wicker White
- Thicket
- Sunflower

1 Use a ¾-inch (19mm) flat loaded with Berry Wine and Wicker White, and keep your eye on the white edge as you form the shape of the petal. For the open roses, paint the back layer of petals with a sea shell stroke (see page 15). Turn your work to make stroking easier, and form a complete circle for the main center rose, and half a circle for the other open rose.

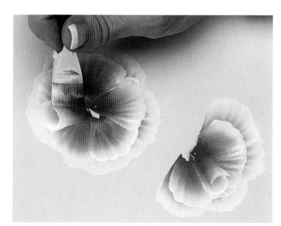

2 Paint the second layer of petals. Then add the buds, or closed petals, in the center (see pages 18-19). Make sure the buds don't go higher than the outer layers.

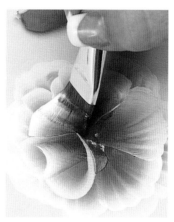

3 Load the toe of a ¾-inch (19mm) angular with Wicker White. Paint two petals surrounding the bud. Start the stroke leaning out.

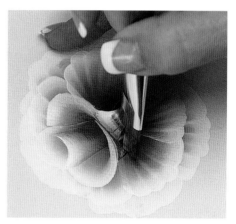

4 Then pull around and across the front.

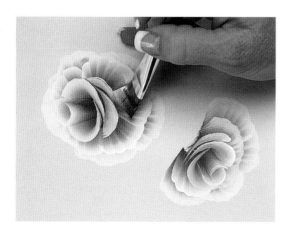

5 Leading with the Berry Wine side, slice in some petals in front of and right below the bud.

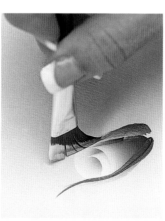

6 The rosebud is an up-and-over curved stroke in back, and in front it's a U-shaped stroke stopped short of completion (see page 19). To paint the calyx, load a ⅝-inch (16mm) angular with Thicket on the toe and Sunflower on the heel. Leading with the heel, touch, lean forward and lift as you come around to form the point of the leaf.

Using the same colors and brush, add large wiggle leaves and small one-stroke leaves (see pages 21 and 22). Load a no. 2 liner with inky Thicket to add curlicues (see page 23).

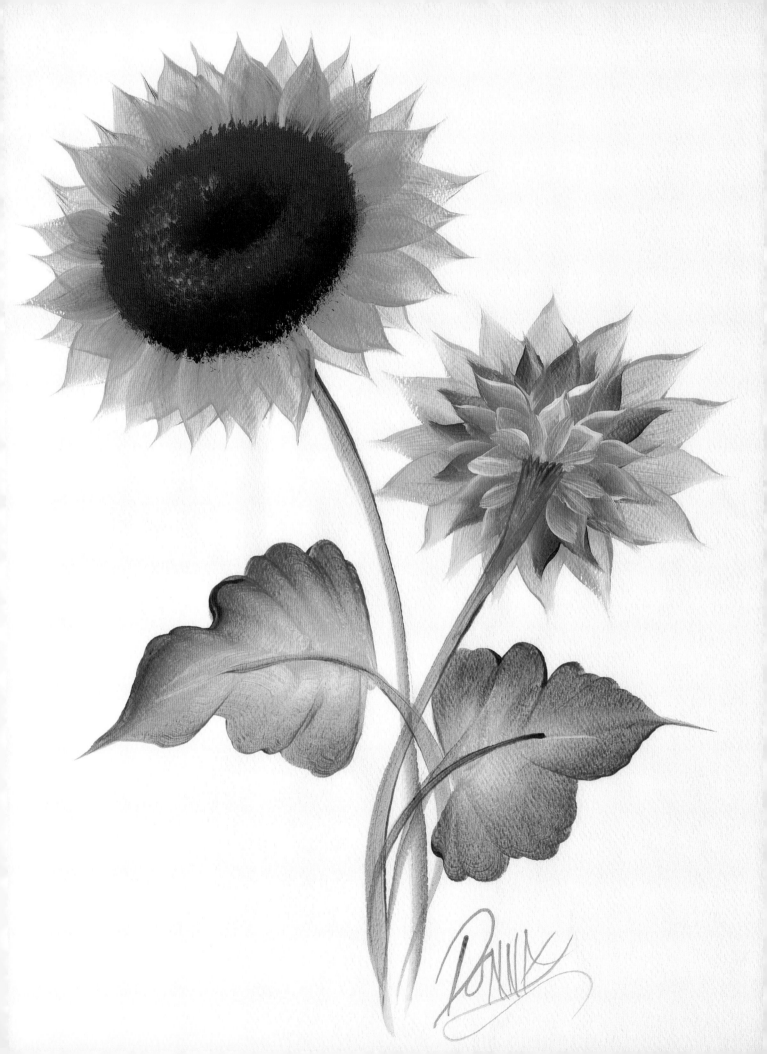

Sunflower

BRUSHES
- ¾-inch (19mm) flat
- large scruffy
- no. 12 flat

PAINTS

FOLKART ACRYLICS
- Licorice
- School Bus Yellow
- Green Forest

FOLKART ARTISTS' PIGMENTS
- Burnt Sienna
- Yellow Ochre
- Yellow Light

1 Double load the large scruffy with Burnt Sienna on one half and Licorice on the other half. Notice the position of the colors in the photo. Paint the sunflower's center by pouncing the scruffy in a C-shape, keeping the Burnt Sienna facing upward. Don't turn or rotate the brush. When you're finished it will look like a chocolate doughnut.

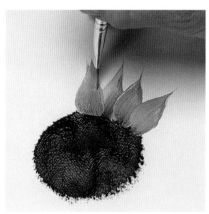

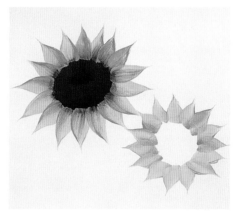

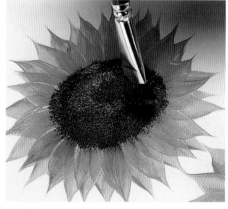

2 Using a no. 12 flat with Yellow Ochre and School Bus Yellow, grab the still-wet "doughnut" edges and pull out the back layer of petals. These are simple one-stroke petals: push, turn, and lift.

3 Paint a circle of one-stroke petals for the back-facing sunflower, using the same colors and brush.

4 Pull out a second layer of petals, then re-pounce the center to clean it up, adding Yellow Ochre to the scruffy for highlights.

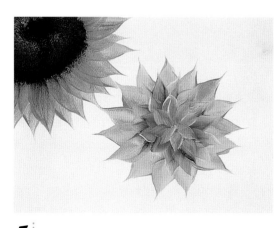

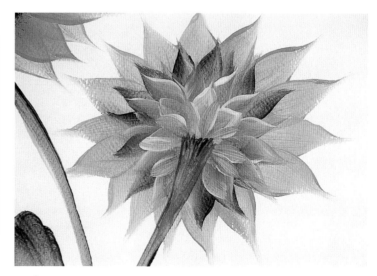

5 Using a no. 12 flat with Yellow Light and Green Forest, add three layers of green calyx on the back-facing flower. This is the same stroke as the one-stroke petals.

6 With a ¾-inch (19mm) flat, pull the stem into the center of the calyx. Finish with the other stem and some ruffled-edge leaves (see page 22).

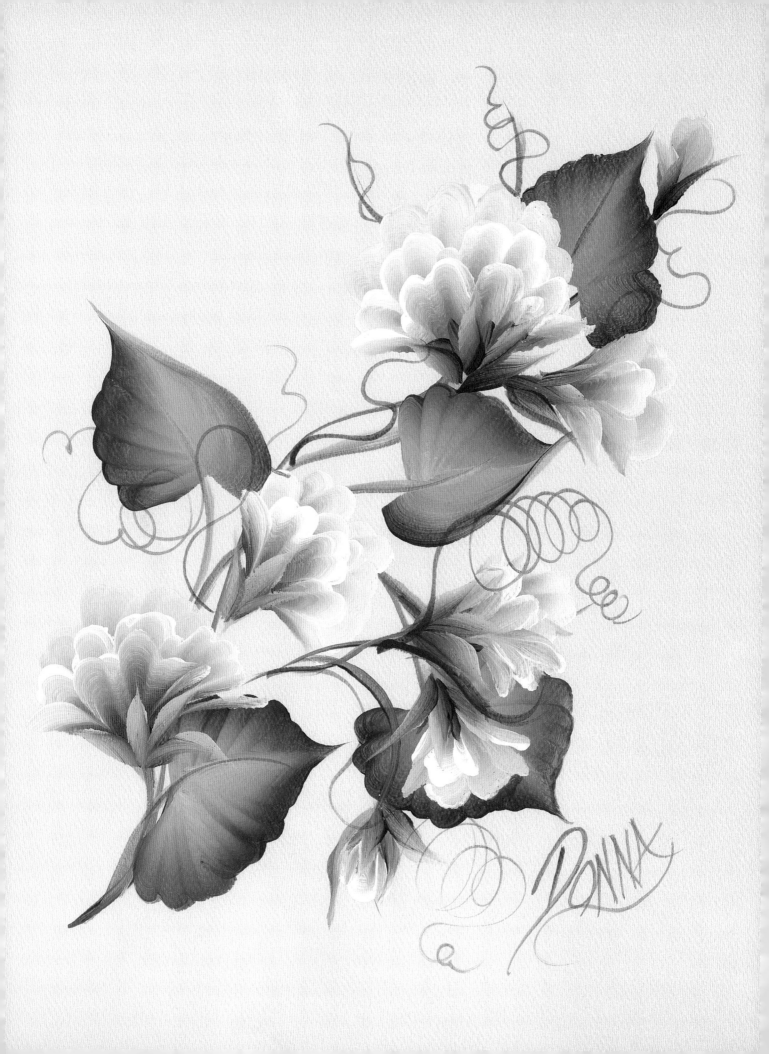

Sweet Pea

BRUSHES
- ¾-inch (19mm) flat
- no. 12 flat
- no. 2 liner

PAINTS
FolkArt Acrylics
- Thicket
- Sunflower
- Purple Lilac
- Wicker White
- Berry Wine

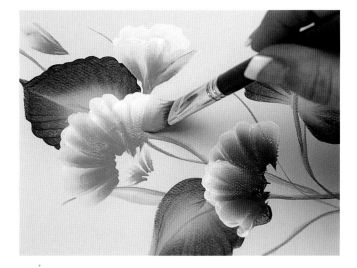

1 Begin by painting the leaves and stems with a ¾-inch (19mm) flat double-loaded with Thicket and Sunflower. Double load the same brush with Purple Lilac and Wicker White and paint the back petals on the lilac sweet peas with a ruffled sea shell stroke (see page 15). Use Berry Wine and Wicker White to paint the back petals on the pink sweet peas.

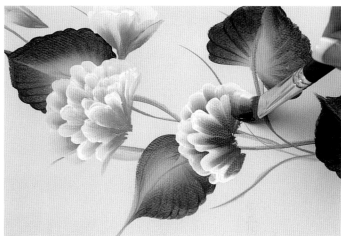

2 Paint the front layers of petals on all the sweet peas using the same colors on a no. 12 flat. Make these layers shorter and smaller.

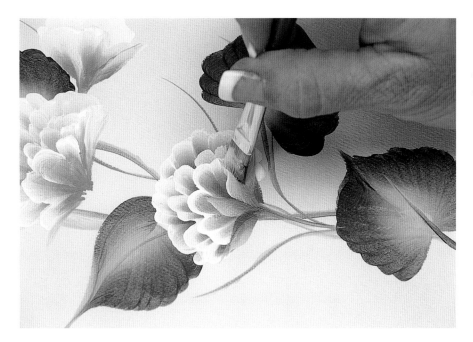

3 Load the same brush with Thicket and Sunflower and add the calyxes. The curlicues are painted with inky Thicket on a no. 2 liner.

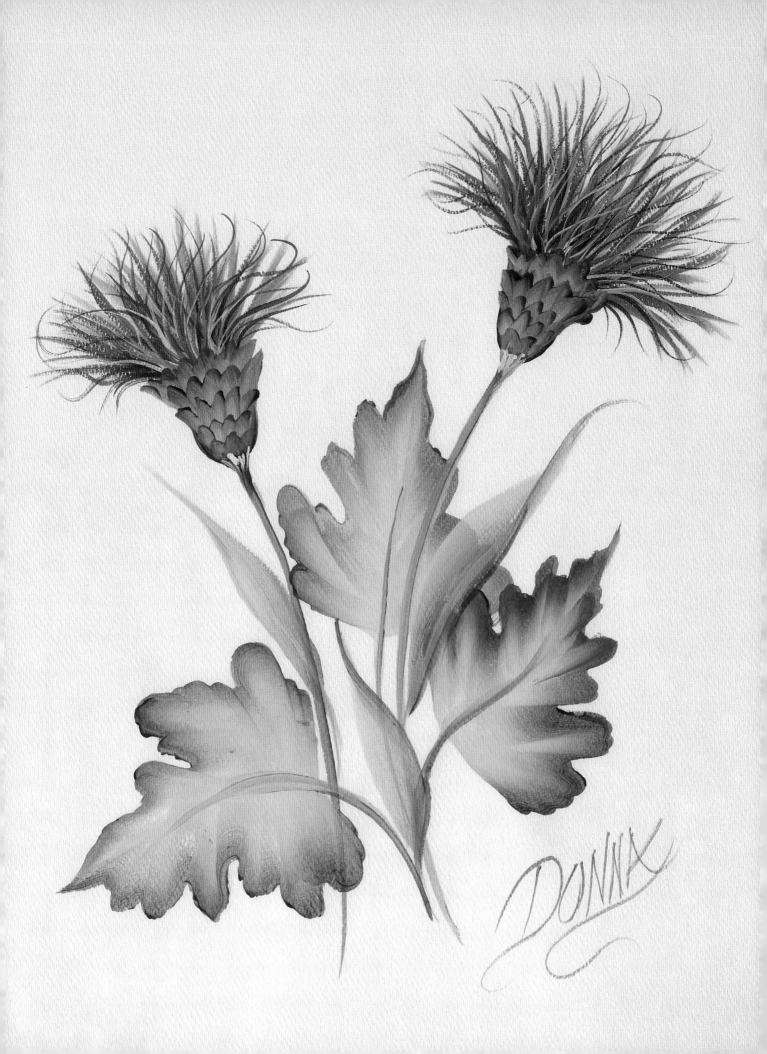

Thistle

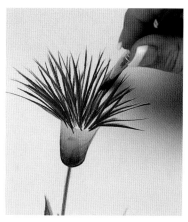

BRUSHES
- ¾-inch (19mm) flat
- no. 12 flat
- no. 6 flat
- no. 2 liner
- no. 1 script liner

PAINTS

FOLKART ACRYLICS
- Thicket
- Sunflower
- Wicker White

FOLKART ARTISTS' PIGMENTS
- Dioxazine Purple

1 Use a ¾-inch (19mm) flat with Thicket and Sunflower to paint the ruffled-edge leaves (see page 22), keeping the green to the outside. Also paint the long, slender leaves, the stems, and the U-shaped bases for the thistle flowers.

2 Double load a no. 12 flat with Dioxazine Purple and Wicker White, and chisel in the long, thin background petals, leading with the white edge of the brush.

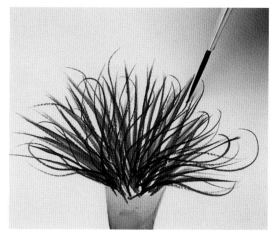

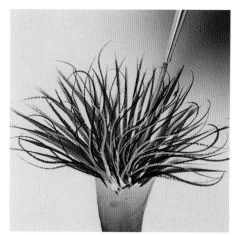

3 *(far left)* Use a no. 2 liner and thinned Dioxazine Purple to add wispy tendrils in the front.

4 *(left)* Thin out Wicker White and add some to your liner. Then paint more tendrils in front.

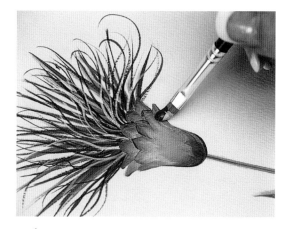

5 Use a no. 6 flat with Sunflower and Thicket and paint rows of pointed shapes on the base. Take these rows all the way down the base.

6 Load a no. 1 script liner with Sunflower, then streak it through Thicket. Connect the thistle base to the stem.

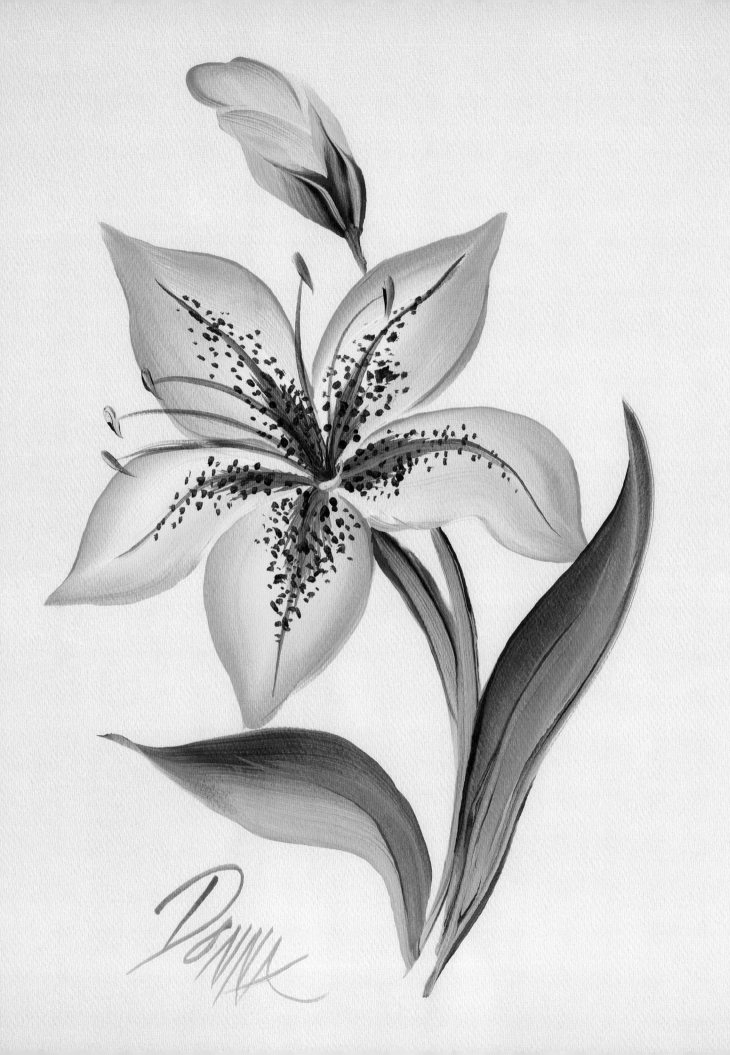

Tiger Lily

BRUSHES
- ¾-inch (19mm) flat
- no. 16 flat
- no. 2 liner

PAINTS

FOLKART ACRYLICS
- Thicket
- Wicker White
- Berry Wine
- Sunflower

FOLKART ARTISTS' PIGMENTS
- Yellow Ochre
- Yellow Light

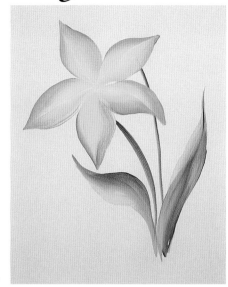

1 Use a ¾-inch (19mm) flat with Yellow Light and Thicket to stroke in the leaves and stems (see page 20). Then use a lot of Yellow Light, Wicker White and Yellow Ochre on a ¾-inch (19mm) flat to stroke in the five large lily petals. Keep the Yellow Ochre to the outside edge. Slide up and lift to the tip, reverse direction, and keeping your eyes on the yellow edge, slide back down to the center. Vary the width of the petals to make them appear to be turning.

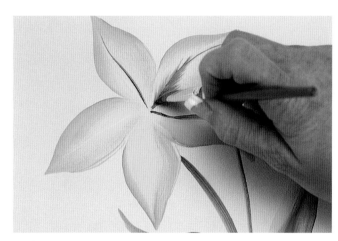

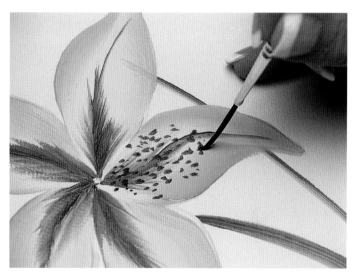

2 Using a no. 16 flat with Yellow Light and Berry Wine, chisel in the center lines and pull out the wispy shading.

3 Use your little finger to steady your hand as you add little dots to the petals with a no. 2 liner and inky Berry Wine.

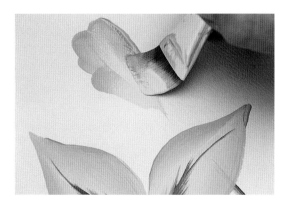

4 Stroke in the closed bud using the same colors and brush used in step one. Instead of forming a point, go up smoothly, and then go back down and lift to the chisel. Overlap the petals to create a bud effect (see page 17 for instructions on painting overlapping bud petals).

5 Use a no. 2 liner with Thicket and Sunflower to pull stamens from the center.

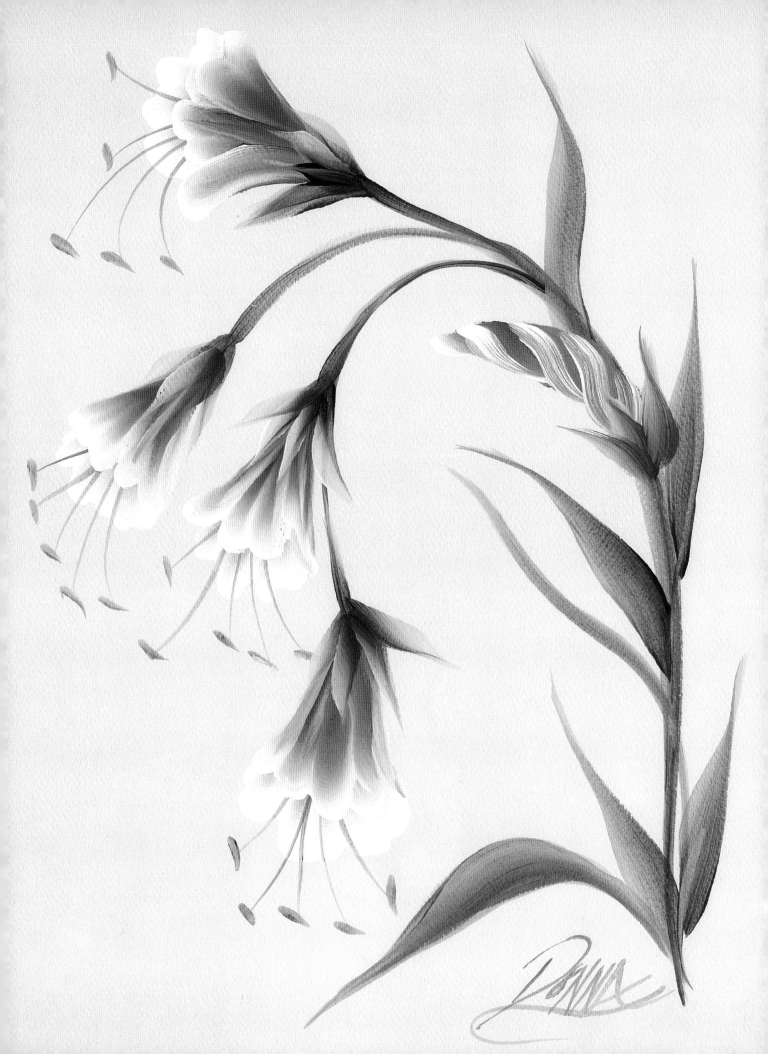

Trumpet Flower

BRUSHES
- ¾-inch (19mm) flat
- no. 1 script liner

PAINTS
FolkArt Acrylics
- Thicket
- Magenta
- Wicker White

FolkArt Artists' pigments
- Yellow Light

1 Paint the stems and leaves using a ¾-inch (19mm) flat loaded with Thicket and Yellow Light. The calyxes will be painted later using the same colors and brush.

Double load a ¾-inch (19mm) flat with Magenta and Wicker White and paint all the trumpets using a C-shaped stroke (see page 16). Watch the pink edge of the brush—you want the trumpets to have a nice shape right from the start.

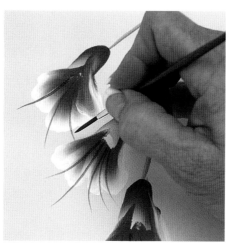

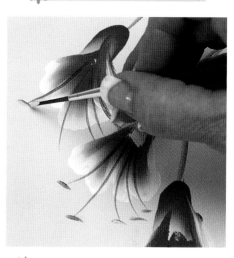

2 Paint the back layer of ruffled petals on the flower, using the same colors and brush. Slide out, wiggle, slide back in and wiggle (see page 16 for instructions on painting ruffled-edge petals).

3 Load a no. 1 script liner with inky Thicket and pull out the stamens from the throat of the trumpet. Steady your hand, using your little finger as a brace.

4 Using the same brush, pick up a little Yellow Light and touch the anthers onto the end of each stamen.

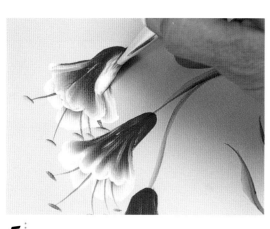

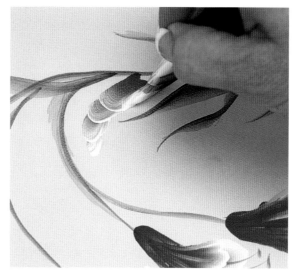

5 Add the top layer of ruffled petals to each trumpet, using the same colors as for the bottom layer. Just pull back to the base between each ruffle.

6 Paint the bud with little C-shaped strokes. Start small and get a little bit bigger as you go down the bud. Pick up more Wicker White on the brush and add a few S-shaped strokes to give the appearance of a tightly furled bud. Finish with calyxes over the base of the trumpets.

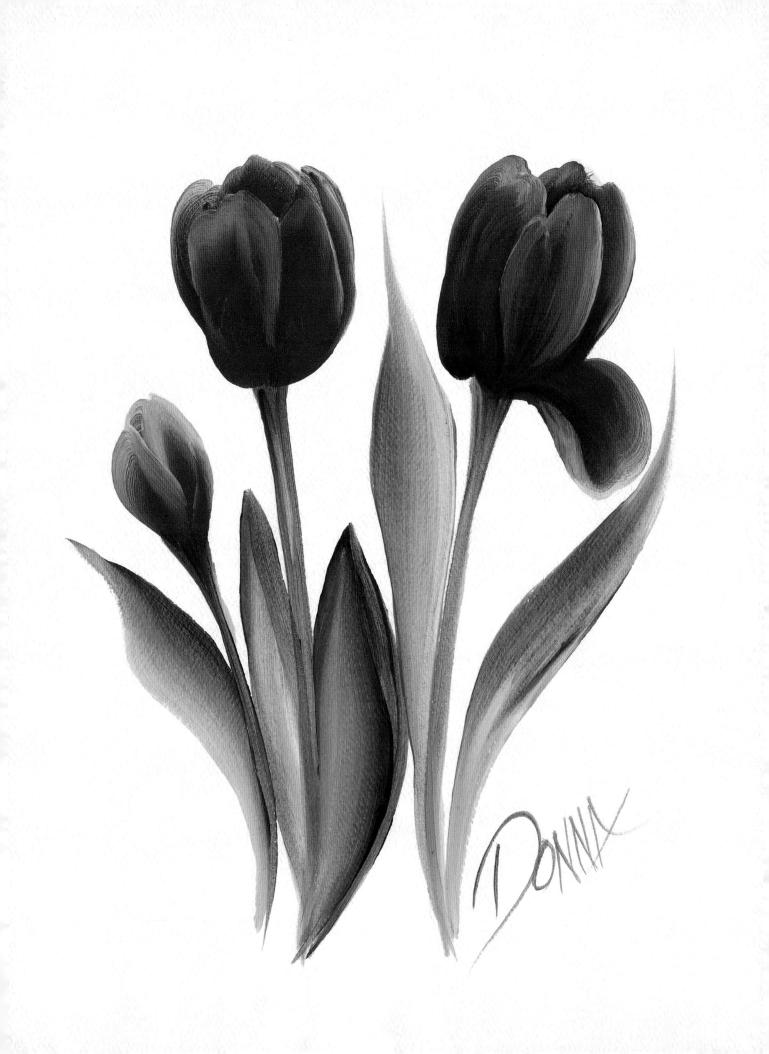

Tulip

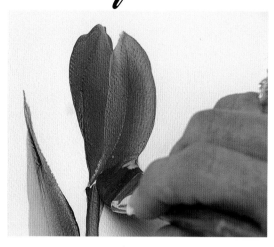

BRUSHES
- ¾-inch (19mm) flat
- no. 12 flat

PAINTS
FolkArt Acrylics
- Thicket
- Engine Red
- School Bus Yellow

FolkArt Artists' pigments
- Yellow Light
- Burnt Carmine

1 Paint the stems and leaves with Thicket and Yellow Light, using a ¾-inch (19mm) flat (see page 20).

Double load the same brush with Engine Red and School Bus Yellow. Begin painting the back petals, keeping the School Bus Yellow to the outer edges of each petal.

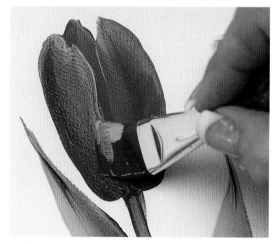

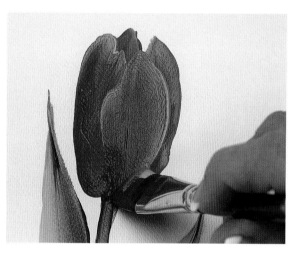

3 Add the final front petal, using the same brush and colors.

2 Paint the front petals with the same colors and brush. Touch, push, slide up, ripple and slide back down, concentrating on the yellow edge while forming the shape of each petal.

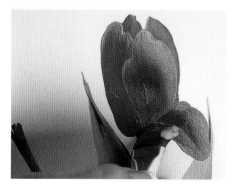

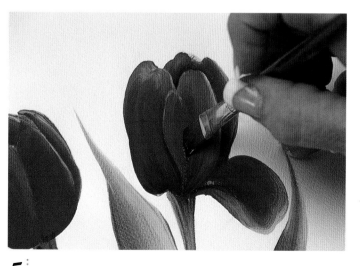

4 Add the open petal. With your eye on the yellow edge, touch, push, slide down, and curve around—keeping the bristles flat. Then lift and slide back up on the chisel.

5 Use a no. 12 flat with Burnt Carmine and floating medium to define, shade and separate the petals. The other tulip and the bud are painted using the same strokes and colors. Just leave off the open petal and the Burnt Carmine shading.

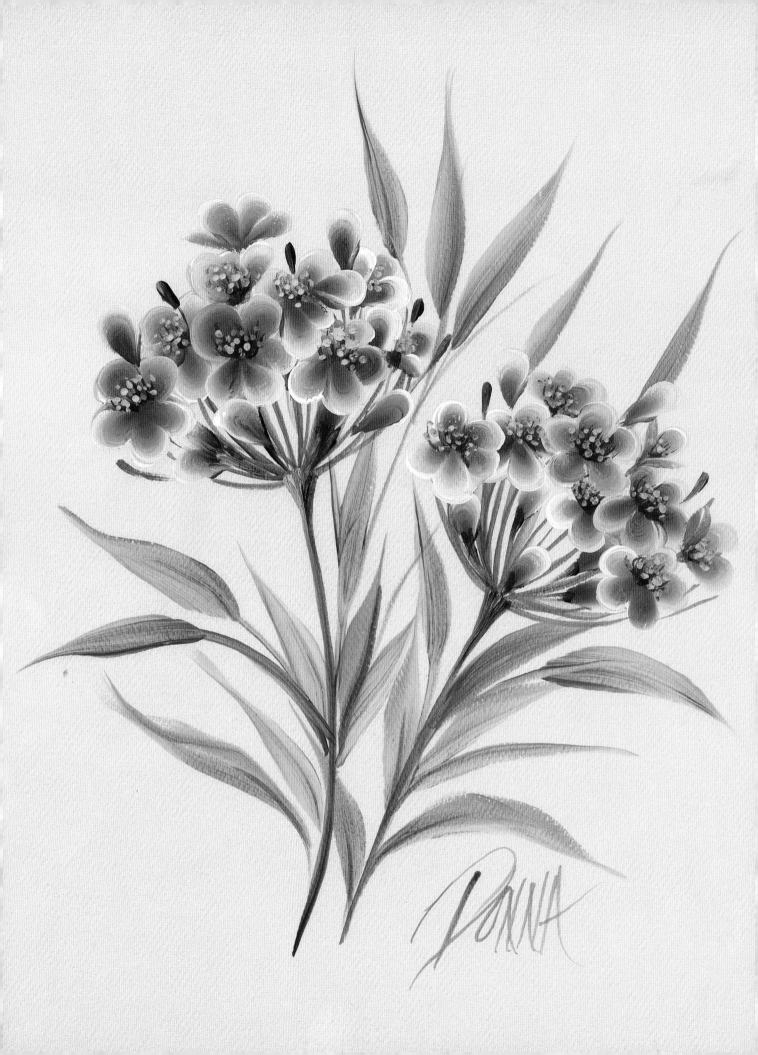

Umbrella Plant

BRUSHES
- ¾-inch (19mm) flat
- no. 8 flat
- no. 1 script liner
- no. 2 liner

PAINTS
FolkArt Acrylics
- Thicket
- Sunflower
- Berry Wine
- Wicker White

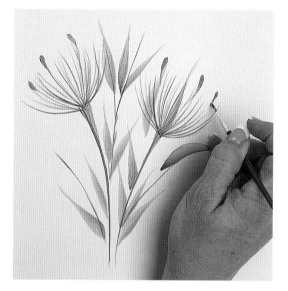

1 Using a ¾-inch (19mm) flat, paint the main stems and leaves (see page 20) with Thicket and Sunflower. Load a no. 1 script liner with the same colors, and touch and pull wispy stems down to the main stems in an umbrella shape. Add a few buds here and there at the tops of some of the small stems.

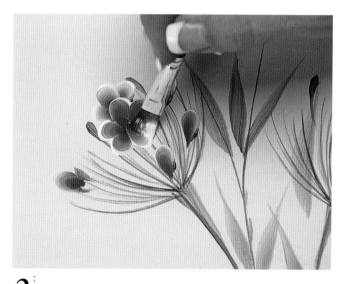

2 Load a no. 8 flat with Berry Wine and ever-so-lightly side-load it with Wicker White. Paint some five-petal flowers and add a few single buds here and there. These are teardrop shaped strokes: touch, push down, and lift back up to the chisel, keeping the white to the outside.

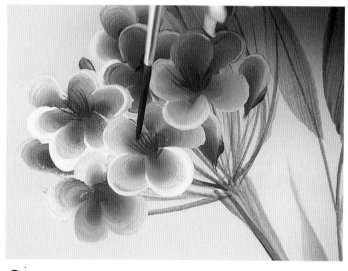

3 Use inky Berry Wine on a no. 2 liner to pull the stamen from the center of each flower.

4 Load a no. 2 liner with Sunflower and dot pollen onto the stamens. Use the same brush and inky Thicket to attach the bottoms of the flower clusters to the main stems.

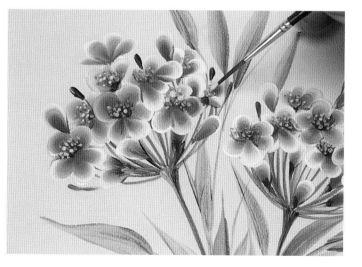

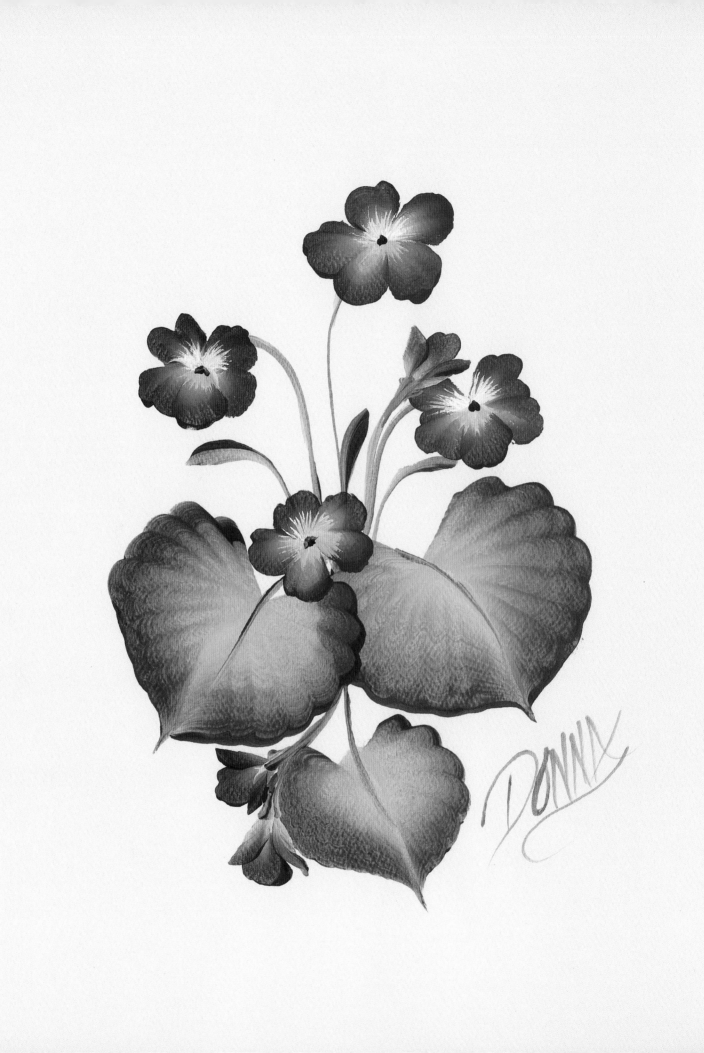

Violet

1 Paint the leaves and stems using Thicket and Sunflower on a ¾-inch (19mm) flat (see page 22). Paint the two back petals of the violets with a no. 12 flat double-loaded with Dioxazine Purple and Wicker White. Keep the white to the center. These are teardrop shaped petals with a slight ruffled edge.

BRUSHES
- ¾-inch (19mm) flat
- no. 12 flat
- no. 2 liner

PAINTS

FolkArt Acrylics
- Thicket
- Sunflower
- Wicker White
- School Bus Yellow

FolkArt Artists' pigments
- Dioxazine Purple

2 Use the same brush and colors to paint the bottom three petals.

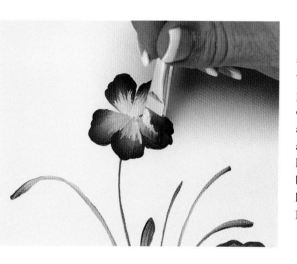

3 Again, using the same brush and colors, chisel in the tiny white lines on the top two petals, leading with the purple edge. With Dioxazine Purple and Wicker White on the brush, add a touch of School Bus Yellow on the white edge of the brush and chisel in the yellow lines on the bottom three petals. Lead with the purple edge.

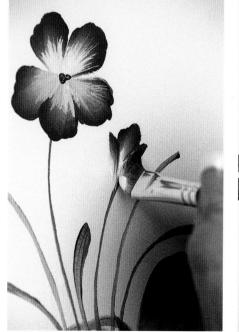

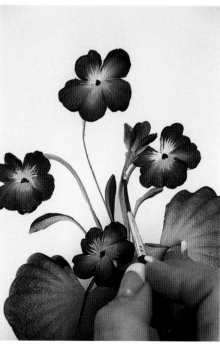

4 *(far left)* Dot in the flower centers with Thicket. Double load a no. 12 flat with Dioxazine Purple and Wicker White and paint the smaller, closed violets. The center petal is a small teardrop shaped petal as shown in step 1, and the two side petals are just chiseled in, leading with the white.

5 *(left)* Paint the calyx and attach it to the stem with Thicket and Sunflower on a no. 2 liner.

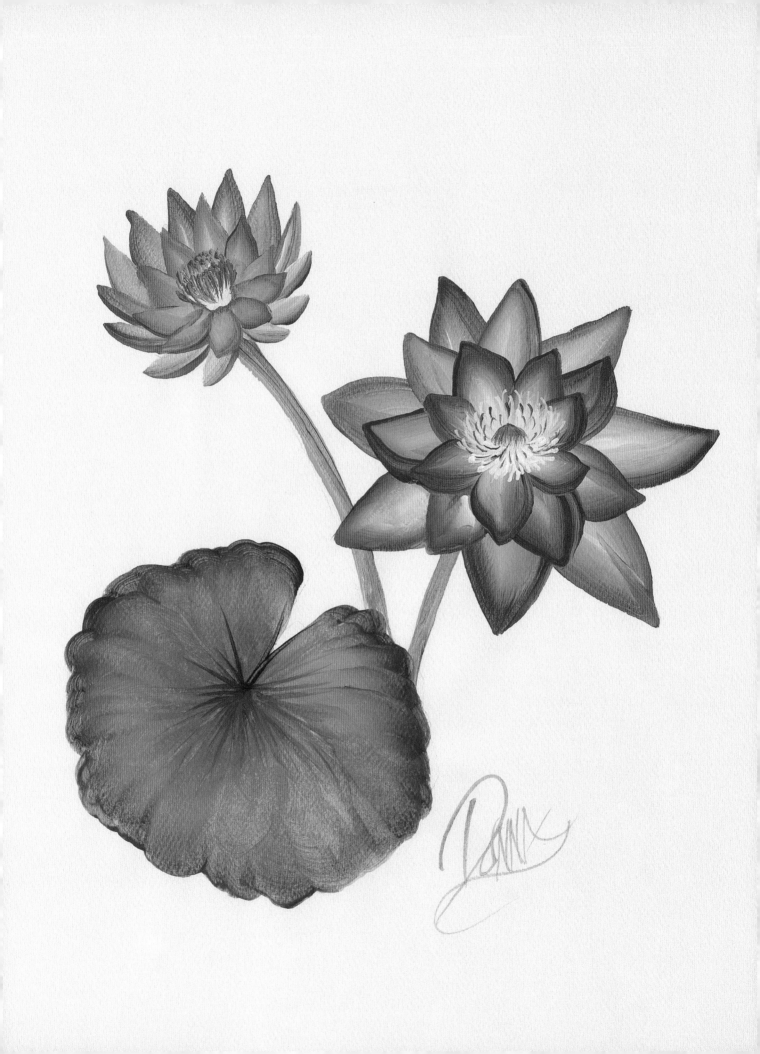

Water Lily

1 Stroke in the stems and the outer edge of the leaf using a 1-inch (25mm) flat with Thicket, Grass Green and Yellow Light. This is a large, circular wiggle leaf (see page 22). Work Magenta into the Yellow Light side of the brush (see page 14) and fill in the center section of the leaf. Pull out green vein lines radiating from the center using the chisel edge of the brush and leading with the light side.

BRUSHES
- 1-inch (25mm) flat
- no. 12 flat
- no. 2 liner

PAINTS

FOLKART ACRYLICS
- Thicket
- Grass Green
- Magenta
- Wicker White

FOLKART ARTISTS' PIGMENTS
- Yellow Light

OTHER
- Floating medium

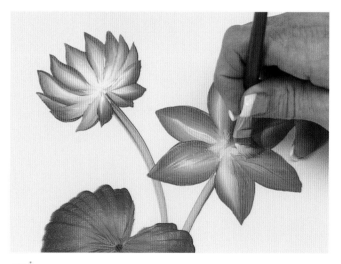

2 Double load a no. 12 flat with Magenta and Wicker White and stroke in the back petals (first layer) on each flower. With your eyes watching the Magenta edge and without lifting the brush, begin on the chisel: push, slide up to the tip, reverse direction and slide back down, ending on the chisel.

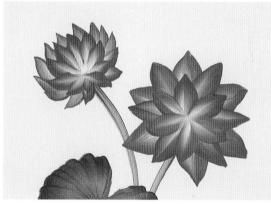

3 With the same brush and colors, add the second layer of petals to both blossoms. Stagger these petals between the petals of the first layer. Then add the third layer of smaller petals on the large open flower.

4 Use a no. 2 liner with Yellow Light and Wicker White to pull in the stamens on the large flower. For the small flower use the same brush with Magenta and a touch of Yellow Light.

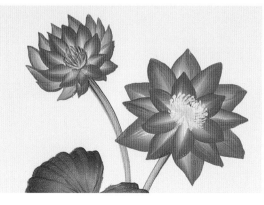

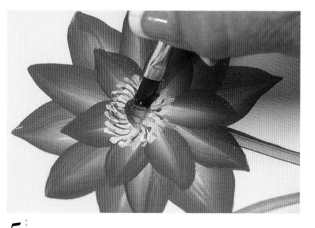

5 Touch the liner into a little Magenta and accent the stamens on the large flower. Load a no. 12 flat with Magenta and floating medium (see page 14) and float in a cone shaped center. Watch the Magenta edge as you form the shape. Chisel in from the outside edge down to create the little lines.

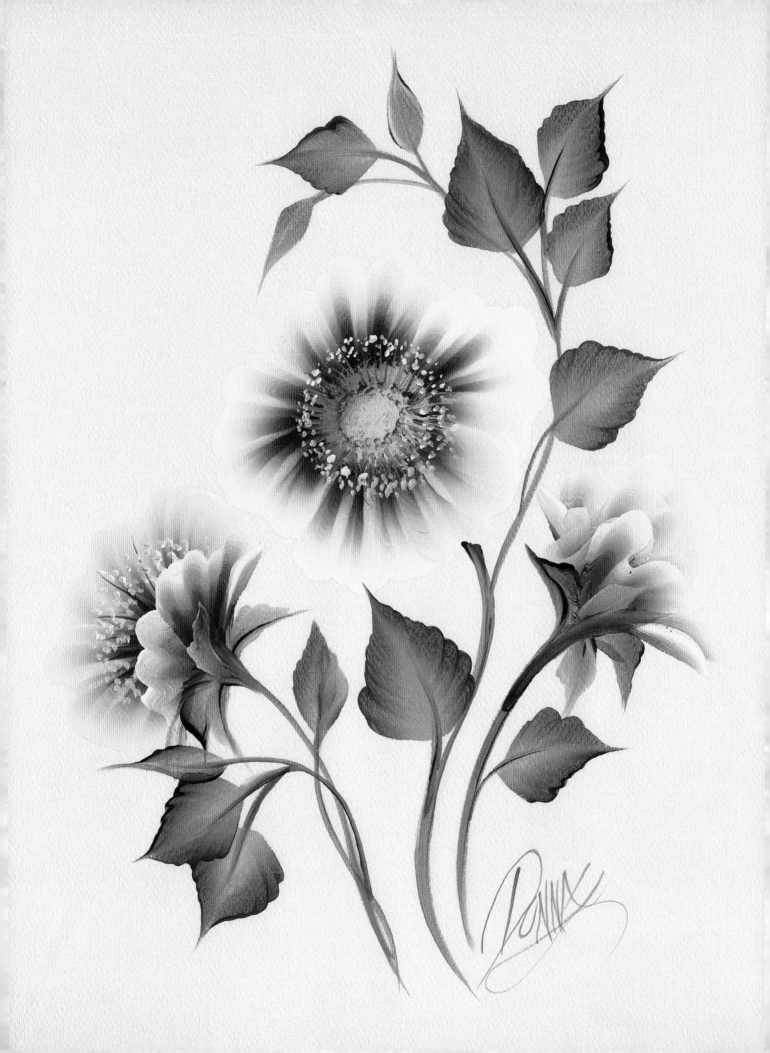

Wild Rose

BRUSHES
- ¾-inch (19mm) flat
- no. 16 flat
- large scruffy
- no. 1 script liner
- no. 2 liner

PAINTS

FOLKART ACRYLICS
- Berry Wine
- Wicker White
- Thicket
- Sunflower

FOLKART ARTISTS' PIGMENTS
- Yellow Light
- Yellow Ochre

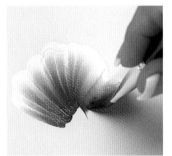

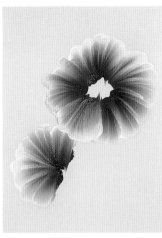

1 Double load Berry Wine and Wicker White on a ¾-inch (19mm) flat. Start the main rose by painting a ruffly circle of petals using a sea shell stroke (see page 15).

2 Finish painting the whole skirt. Paint the left-facing flower in the same manner, but make just half a circle. You can adjust the color of your rose by how much Berry Wine you load on your brush. More will give you a deeper pink as shown here.

3 Double load the large scruffy with Yellow Light and Yellow Ochre and pounce in the center. Go back in with a touch of Wicker White on the lighter side of the bristles to add some highlighting on the upper side of the center.

4 Load a no. 2 liner with inky Thicket and a touch of Yellow Light. Dot a circle of Thicket with the tip of the liner, then pull little stamens outward from the circle. For the left-facing rose, pull stamens out from the center.

5 Load a ¾-inch (19mm) flat with Berry Wine and Wicker White and stroke in the second layer of petals on the left-facing blossom.

6 Load a no. 16 flat with Berry Wine and Wicker White and paint the rolled petal bud (see page 17). Use the same brush with Thicket and Sunflower to paint the calyx, stems and leaves (see page 22). Load a no. 1 script liner with Yellow Light, tip it into Wicker White, and dot in the pollen on the tips of the stamens.

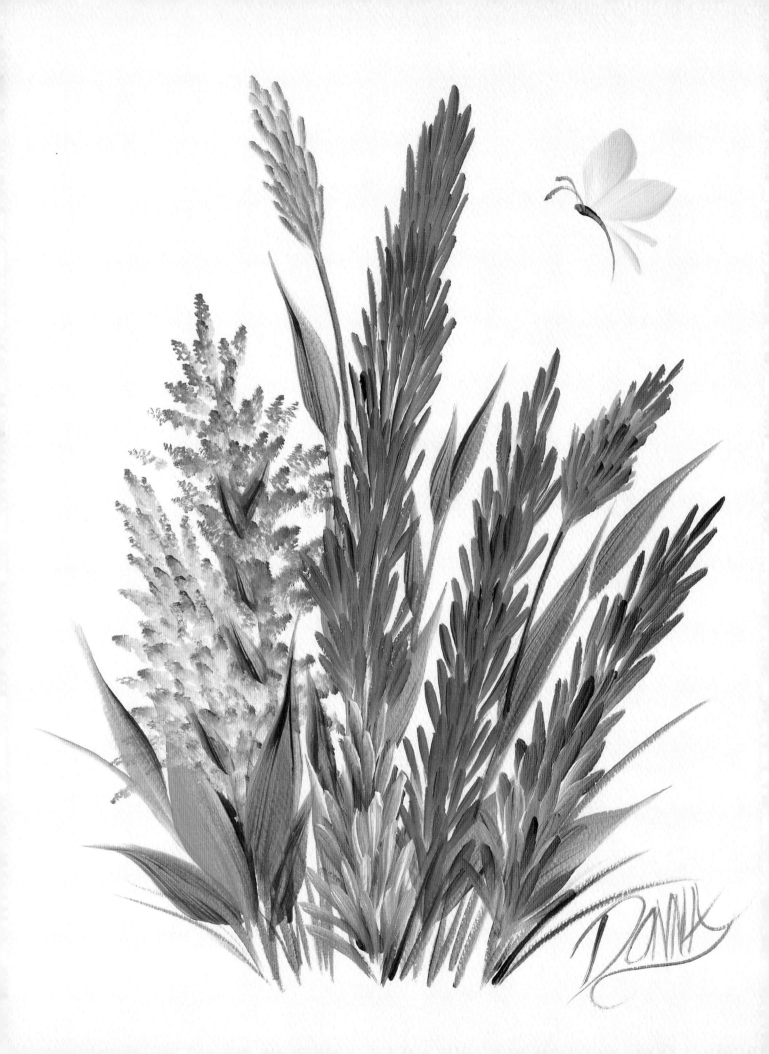

Wildflowers

BRUSHES
- no. 12 flat
- no. 2 liner

PAINTS

FOLKART ACRYLICS
- Sunflower
- Thicket
- Violet Pansy
- Wicker White
- Berry Wine
- School Bus Yellow

FOLKART ARTISTS' PIGMENTS
- Yellow Light
- Dioxazine Purple

1 Use a no. 12 flat with Sunflower, Yellow Light and Thicket to stroke in the leaves and stems.

Using the same brush with Violet Pansy and Wicker White, chisel in the lavender blossoms. Touch on the chisel, lean and pull, and then lift. The pulling motion makes the streaks. Start at the top of the lavender, painting one stroke in the center and two at the sides. Make the lavender a little fuller as you go down the stem.

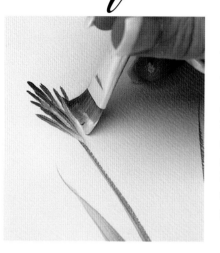

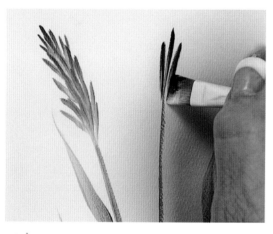

2 Load a no. 12 flat with Dioxazine Purple and Wicker White and chisel in the purple Veronica. Start at the top, painting one stroke in the center and two at the sides.

3 Work down the stem, overlapping and filling out as you go.

Use the same brush loaded with Berry Wine and Wicker White to chisel in the pink Veronica. The Veronica on the right is painted leading with the white edge of the brush. The shorter one in front is painted leading with the pink edge.

4 Double load a no. 12 flat with School Bus Yellow and Berry Wine and dab in the blossoms on the Butterfly Bush. Hold the brush vertically for the top blossoms, and lean the brush slightly side-to-side as you go down the stem, filling in the petals.

5 To paint the butterfly, start with School Bus Yellow and Berry Wine on a no. 12 flat. Lean on the chisel, push down and pull. Add a second wing. The bottom two wings are the same touch-and-pull strokes as on the flowers.

6 Load a no. 2 liner with Thicket and paint the body. This is just a long, thin comma stroke: lay the bristles down and then lift and pull to a point. Then touch in two little antennae.

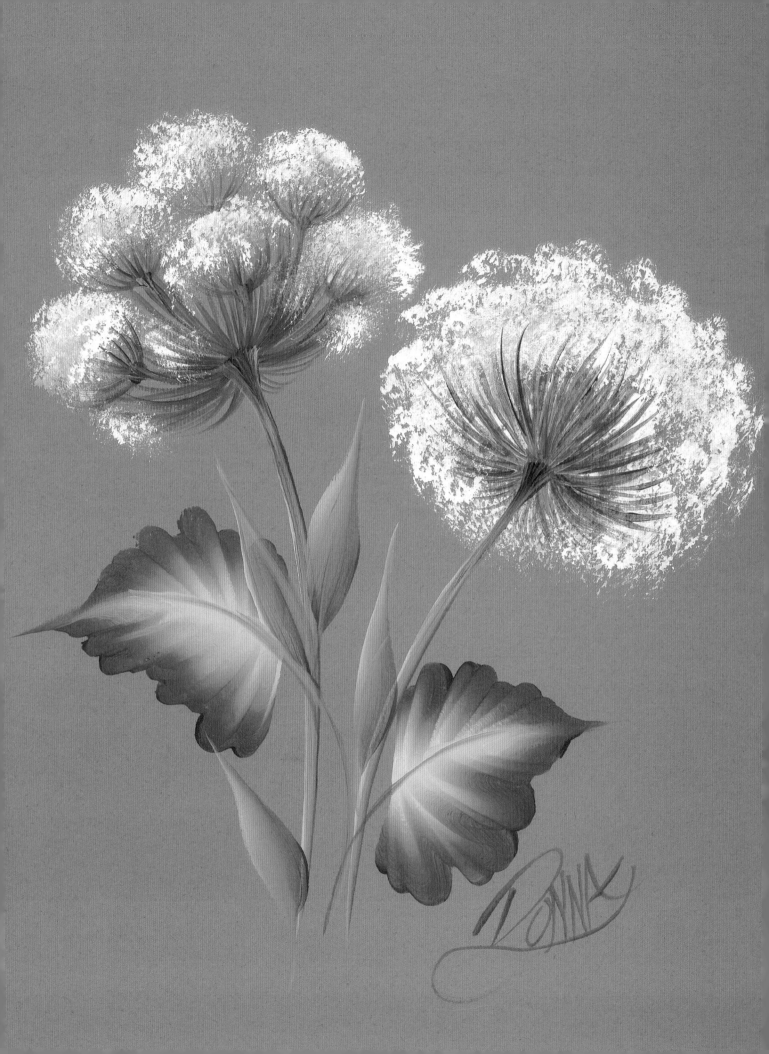

Yarrow

BRUSHES
- ¾-inch (19mm) flat
- medium scruffy
- no. 2 liner

PAINTS

FOLKART ACRYLICS
- Sunflower
- Thicket
- Wicker White
- Green Forest

FOLKART ARTISTS' PIGMENTS
- Yellow Ochre

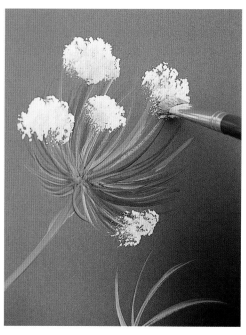

1 Double load a ¾-inch (19mm) flat with Sunflower and Thicket. Stroke in the two main stems for placement using the chisel edge of your brush. Add the smaller branching stems, leading with the green side of the brush.

2 Load a no. 2 liner with Thicket and tip it into Sunflower. Stroke in the wispy stems of the side-facing flower (on the left). Double load a medium scruffy with Wicker White and Yellow Ochre and pounce in the blossoms.

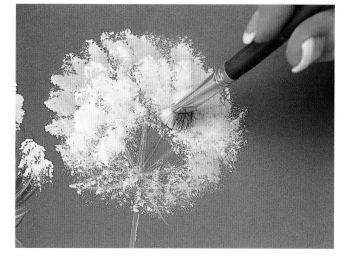

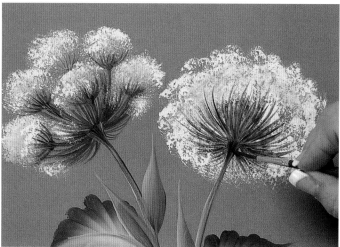

3 With the same brush and colors, pounce in the back-facing flower (on the right). You will pounce over the stem placement lines, but that's okay. Those lines will help you keep the rounded shape of the blossom.

4 Use a no. 2 liner with inky Thicket and Yellow Light to pull in fine stems under the back-facing flower and under the separate sections of the side-facing flower. For shading at the main stem's connection point, pick up a little Green Forest on the liner and pull toward the stem. To paint the large leaves, double load a ¾-inch (19mm) flat with Sunflower and Thicket. Stroke in a couple of wiggle leaves and a few long, slender leaves (see pages 20 and 22).

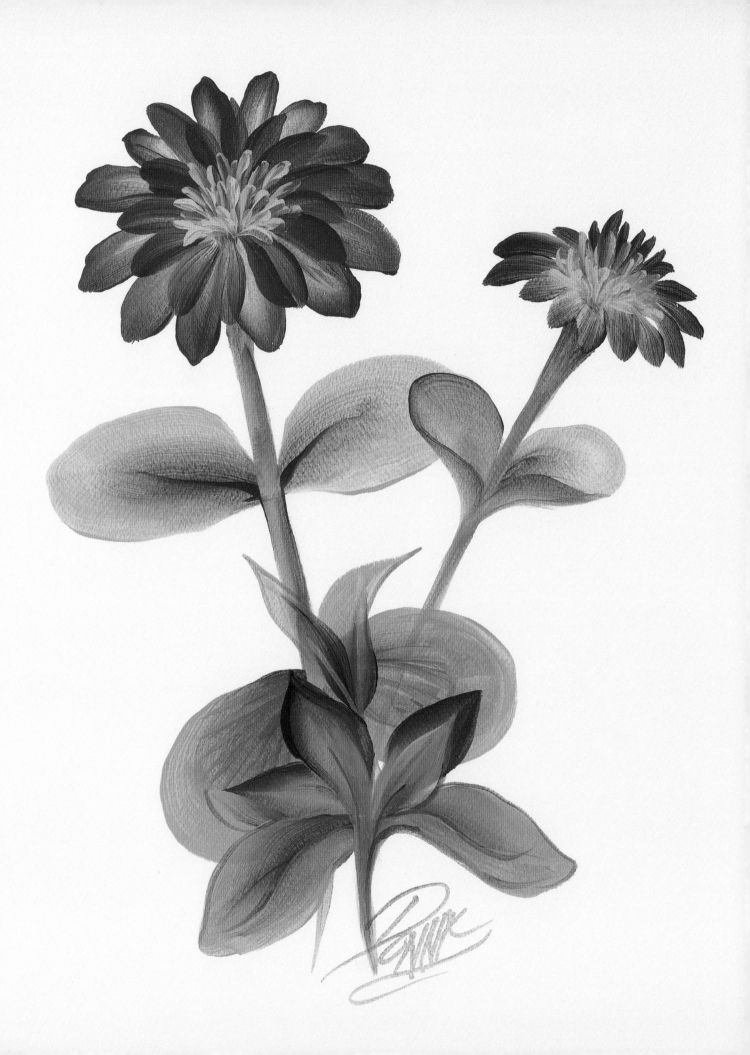

Zinnia

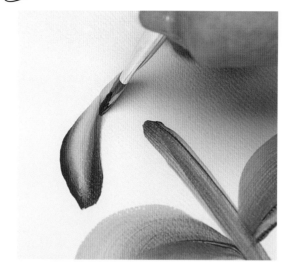

BRUSHES
- ¾-inch (19mm) flat
- no. 6 flat
- no. 12 flat

PAINTS
FOLKART ACRYLICS
- Grass Green
- Thicket
- School Bus Yellow
- Engine Red

1 Double load a ¾-inch (19mm) flat with Grass Green and Thicket to paint the stems and leaves (see page 20). Begin painting the flower petals using a no. 12 flat. Load the whole brush with School Bus Yellow, then sideload just the tip with Engine Red. Start the strokes on the chisel edge, push down and pull to the tip, wiggle slightly at the tip, reverse and lay down, and pull back into the center. Repeat this for each petal.

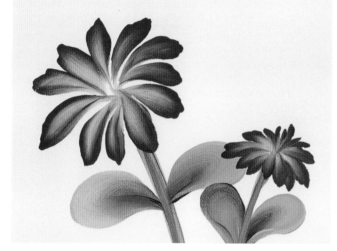

2 Finish the outer layer of petals on both blossoms, using the same brush and colors.

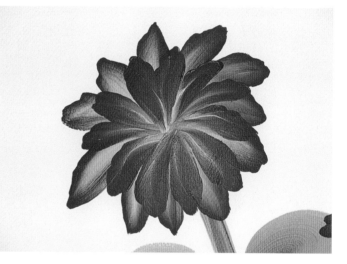

3 Paint the front layers of petals in the same manner, varying the amount of yellow and red you load onto your brush.

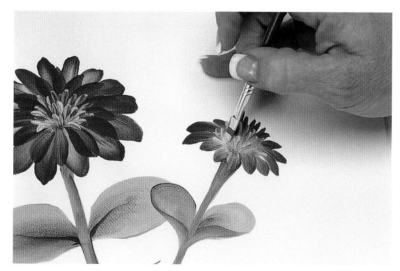

4 Load a no. 6 flat with School Bus Yellow. Use the chisel edge of the brush to stroke in some very small center petals and a few stamens. These should stand up straighter, not as curved as the flower petals. Pull the strokes toward the center.

FILLER FLOWERS

Filler flowers can be used to fill in any areas where you may see gaps or holes in your composition. Keep them simple and airy so they don't compete with the main flowers. Here are examples of some of my favorites.

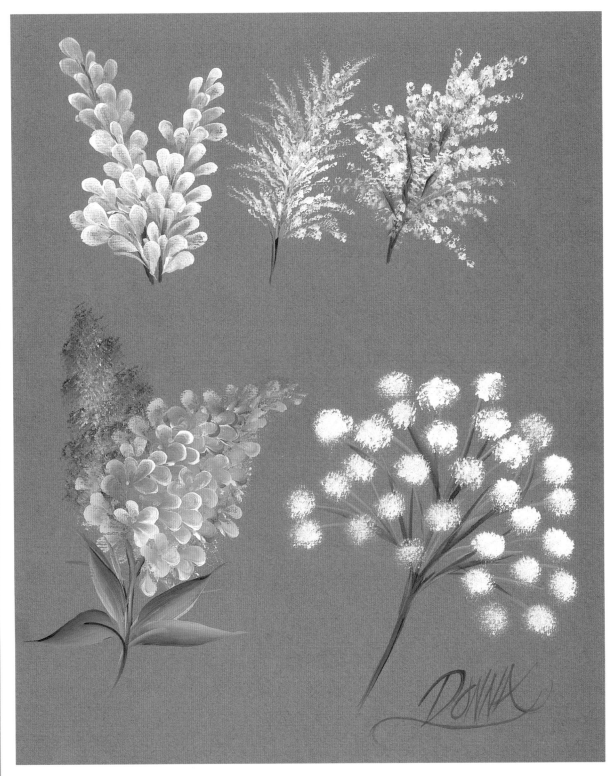

SHADOW LEAVES

Shadow leaves are another of my favorite ways to fill in areas of my floral and fruit paintings. They can be as simple as one-stroke leaves or more intricate like ferns and vining leaves. Shadow leaves used as backgrounds should be painted with colors thinned with water or floating medium.

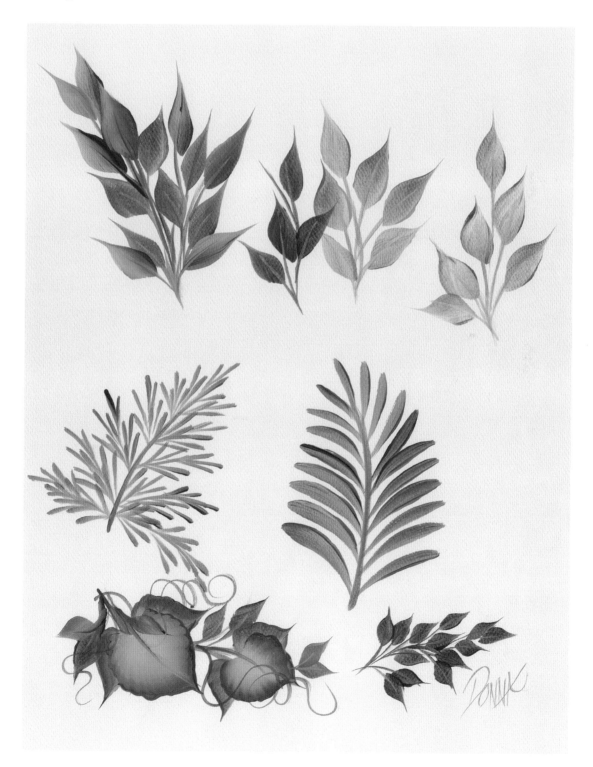

FLORAL DESIGN & COMPOSITION

*P*eople always want to know about design. Without a pattern or exact directions, they struggle with where to start and how to know what to choose for their specific project.

I hope to help you solve this problem with my simple design plan. I have come up with a plan to empower you to jump right in and begin designing your own floral compositions.

When planning a design, it helps to think of flower arranging. Generally, flower arranging begins with the main flowers. I've found that an odd number usually works best. The next thing a florist would add is greenery, usually a variety of large leaves. And finally the fillers are added, such as baby's breath, small leaves, ferns, etc. These fill in sparse areas and help to keep the desired shape.

As you begin, here are the main points to keep in mind as you view the floral compositions on the following pages and begin to take designing into your own hands.

- Decide on the shape you need for the project you are painting. This is also the time to consider the colors you will need.

- Choose the main flowers according to how their shape and color fit on the surface you are painting.

- Add the main leaves to the design. They can beautifully enhance the flowers and help to form the shape you desire.

- Finally, add fillers. They can be small one-stroke leaves, vines, curlicues, baby's breath or whatever else you choose.

Step back often and look at your overall composition. Most of us know instinctively when a design is pleasing. Go with that feeling, begin to trust your natural ability and let it shine!

Now go and create—just jump right in and paint. You'll make mistakes but don't let that discourage you. You may create something better than you ever expected. That's the fun and exciting part of the creative process.

On the following pages I have included five basic design shapes that can help you get started. Each is designed by following the steps listed above and using the shapes as a starting point. The shapes are: vertical, C-shape, L-shape, triangle and round.

This chapter does not have step-by-step instructions for painting the flowers; it simply describes the layering of each design, or the order in which the elements are to be painted. All the flowers are from this book, and painting directions can be found by specific flower name.

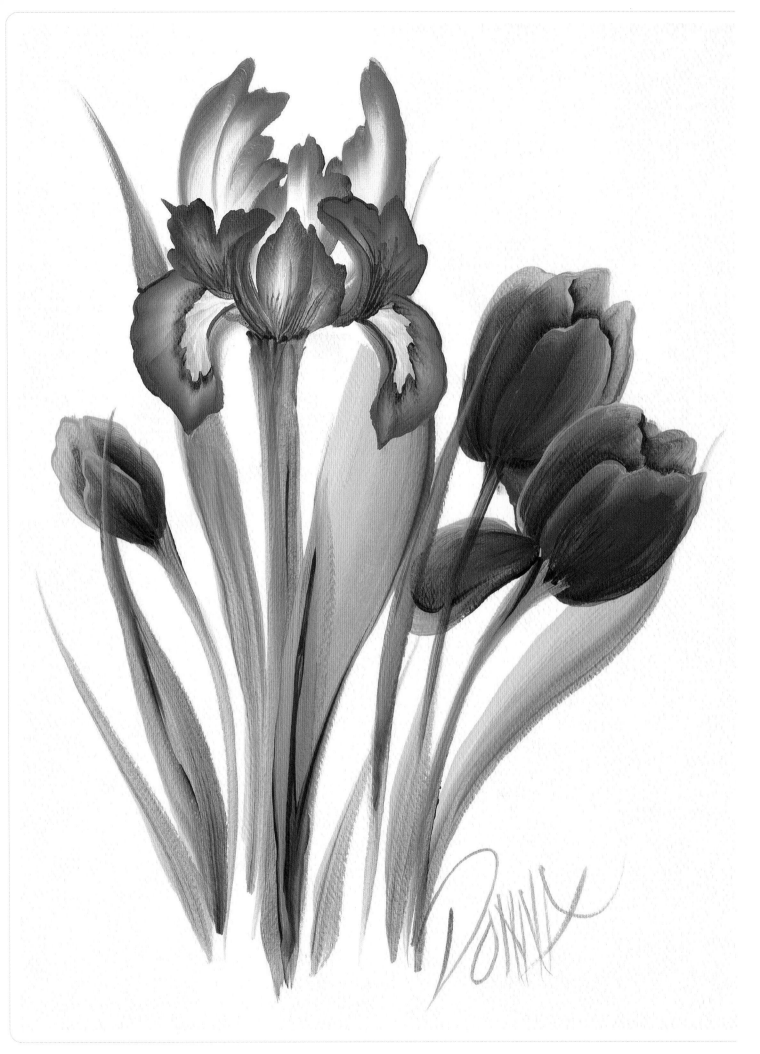

VERTICAL COMPOSITION

This is a simple design with two flowers, the tulip and iris, and leaves but no filler flowers. Use whatever colors you choose and darken or highlight as you desire.

1 Stroke in the leaves.

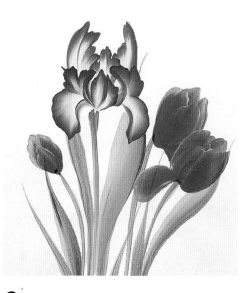

2 Paint the flowers.

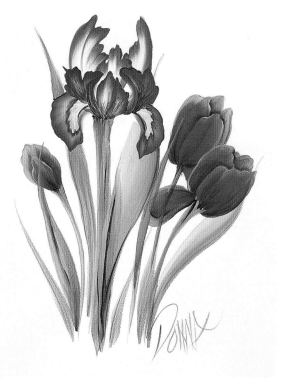

3 Enhance the flowers by defining, shading or adding to the design until the composition is pleasing to you.

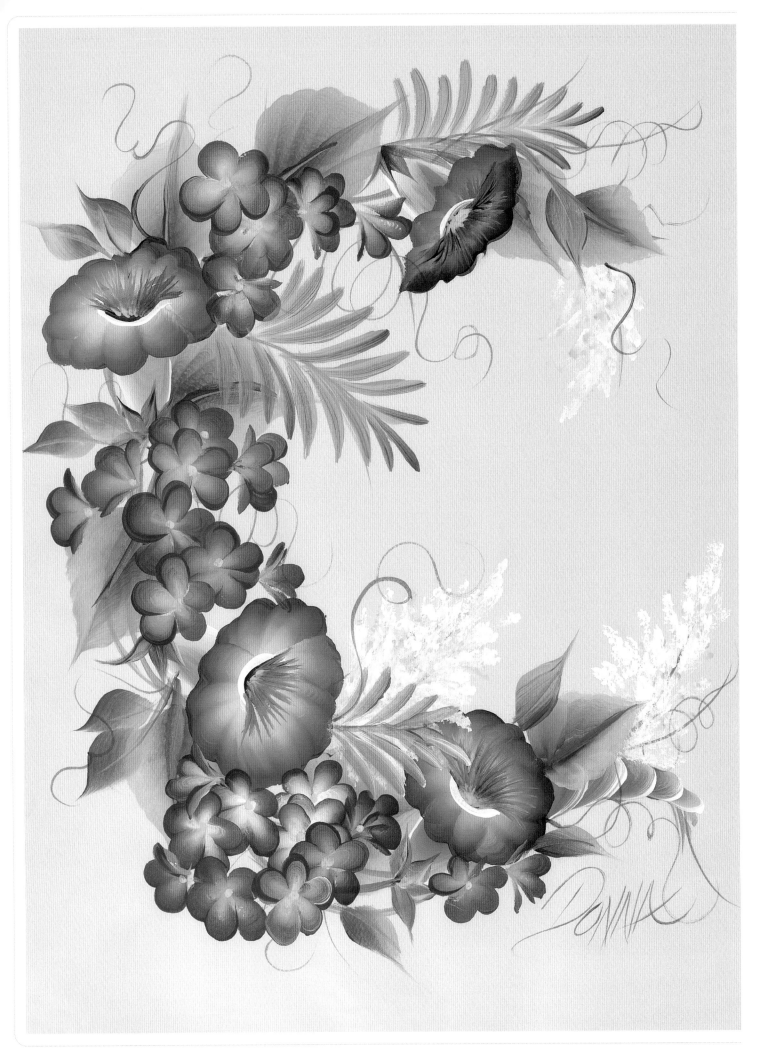

C-SHAPED COMPOSITION

This design is also based on two flowers, the morning glory and ruby glow. You begin by creating the shape with the leaves. Use whatever colors you like and darken or highlight as you desire.

1 Begin this C-shaped design by painting in the leaves and vines.

2 Add the morning glories and curlicues.

3 Add the ruby glow blossoms following the C-shape. Finish with some filler flowers, fern leaves and one-stroke leaves.

L-SHAPED COMPOSITION

This design is also based on two flowers, the chrysanthemum and daisy. Begin with the leaves to create the L-shape. Use whatever colors you like and darken or highlight as you desire.

1 Begin this L-shaped design by painting in the main leaves and stems.

2 Add the chrysanthemums.

3 Add daisies to fill in where needed and to help emphasize the L-shape of the design.

4 Finally, fill in some of the empty areas here and there with clusters of one-stroke leaves.

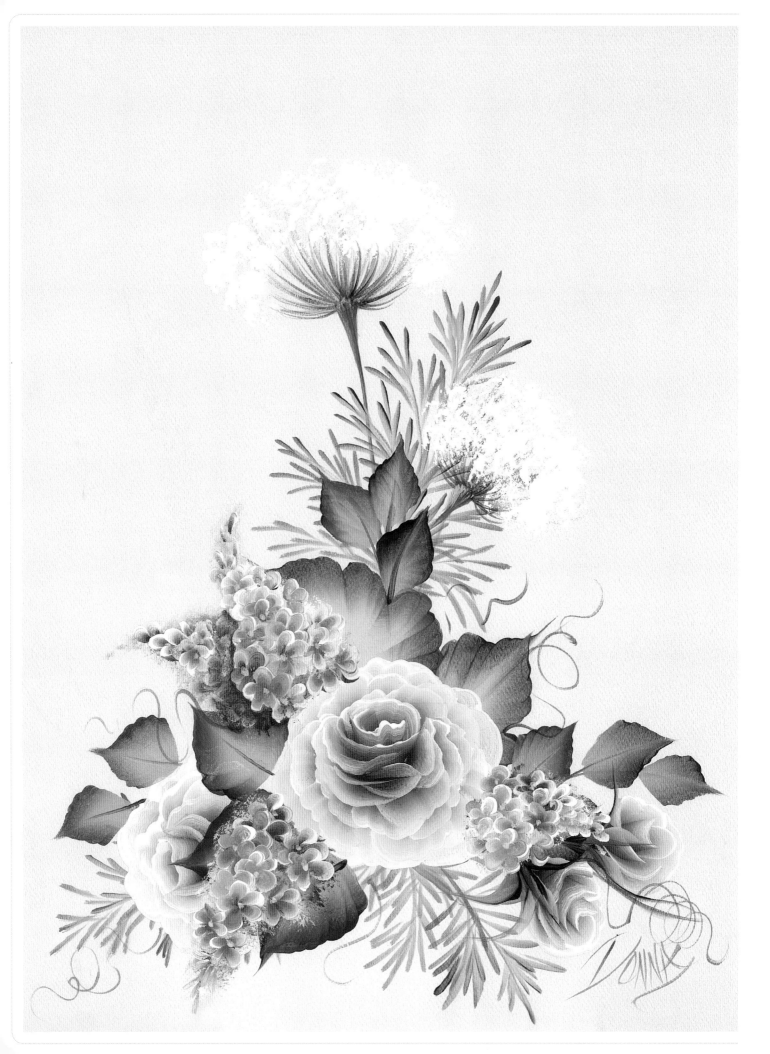

TRIANGLE COMPOSITION

This design is based on two main flowers, the peace rose and white yarrow, and filled in with clusters of pink five-petal flowers. Begin with the leaves to create the triangle shape. Use whatever colors you like and darken or highlight as you desire.

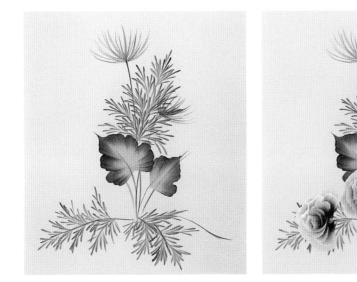

1 Begin by painting in the large leaves, fern leaves and stems.

2 Add the peace roses.

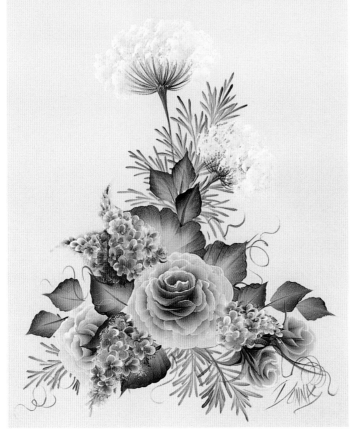

3 Finally, add the white yarrow and pink flower clusters to enhance the triangle shape. Finish with small filler leaves and some curlicues.

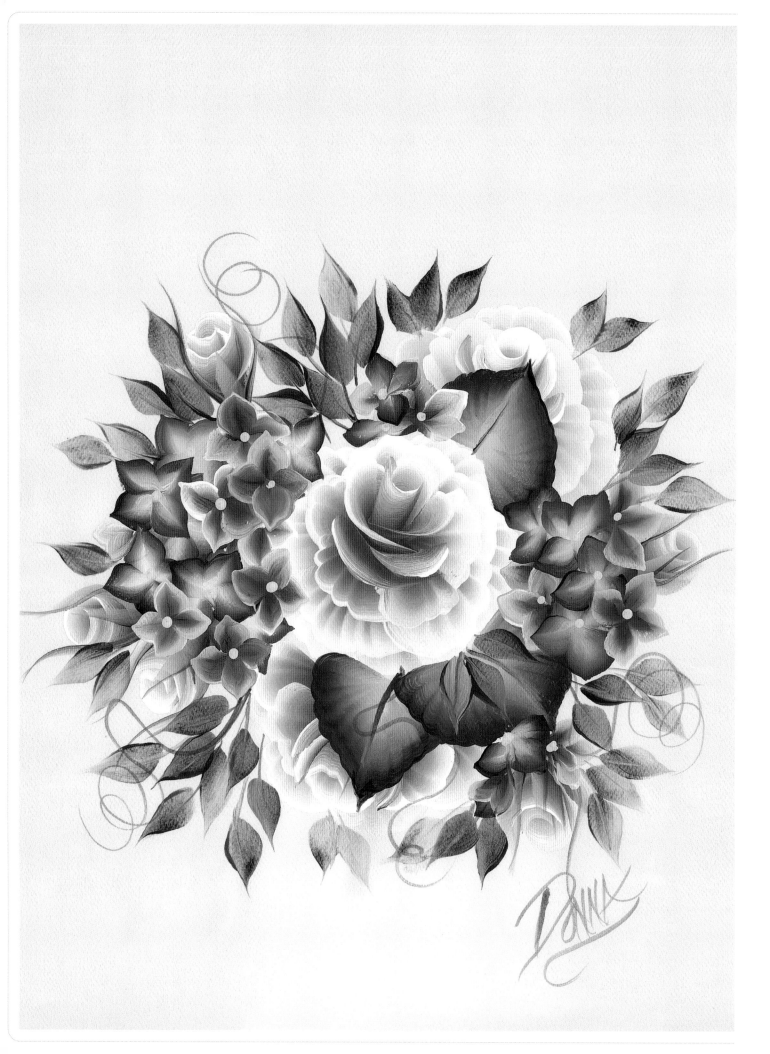

ROUND COMPOSITION

This design is based on two flowers, hydrangeas and roses, but small filler leaves and curlicues have been added. Use whatever colors you like and darken or highlight as you desire.

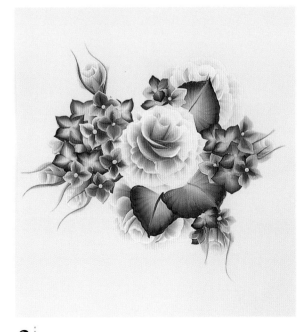

1 Begin by painting the open roses and rosebuds in a somewhat round design.

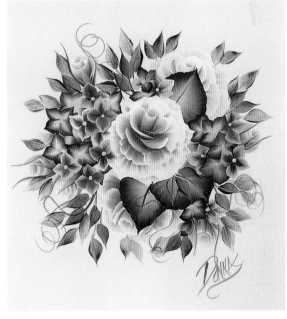

2 Add the large leaves and the calyxes.

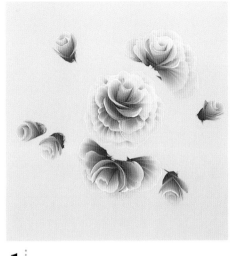

3 Fill in with hydrangeas, keeping the composition round. You could leave this design as is, if you like.

4 Here is the difference when filler leaves and curlicues are added. Remember, you can always use fillers to correct or enhance whatever shape you are designing.

A GALLERY OF
FLORAL PROJECT IDEAS

Here are some projects I have painted using flowers of all kinds. Use these ideas to jump-start your own creativity, and don't be afraid to combine your favorite flowers together and use your own favorite colors.

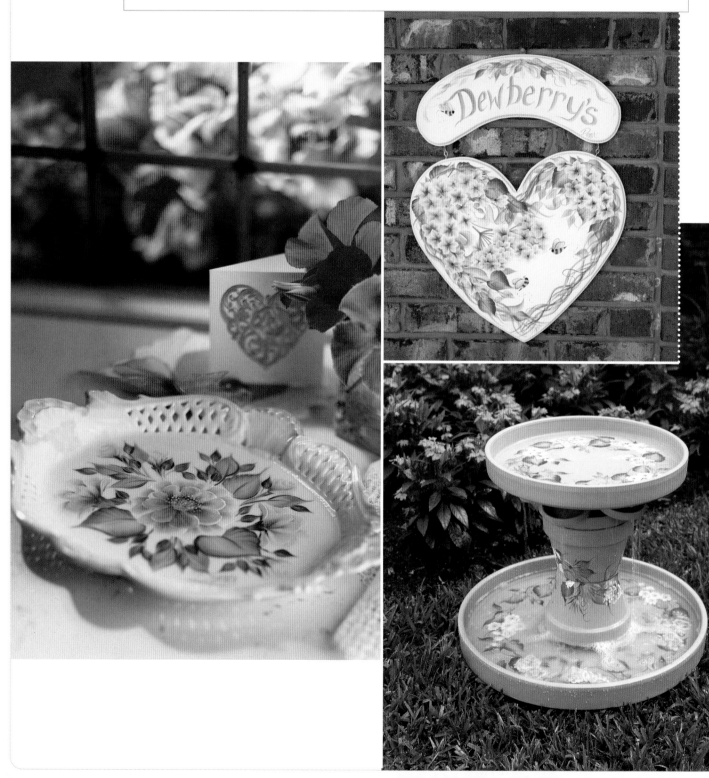

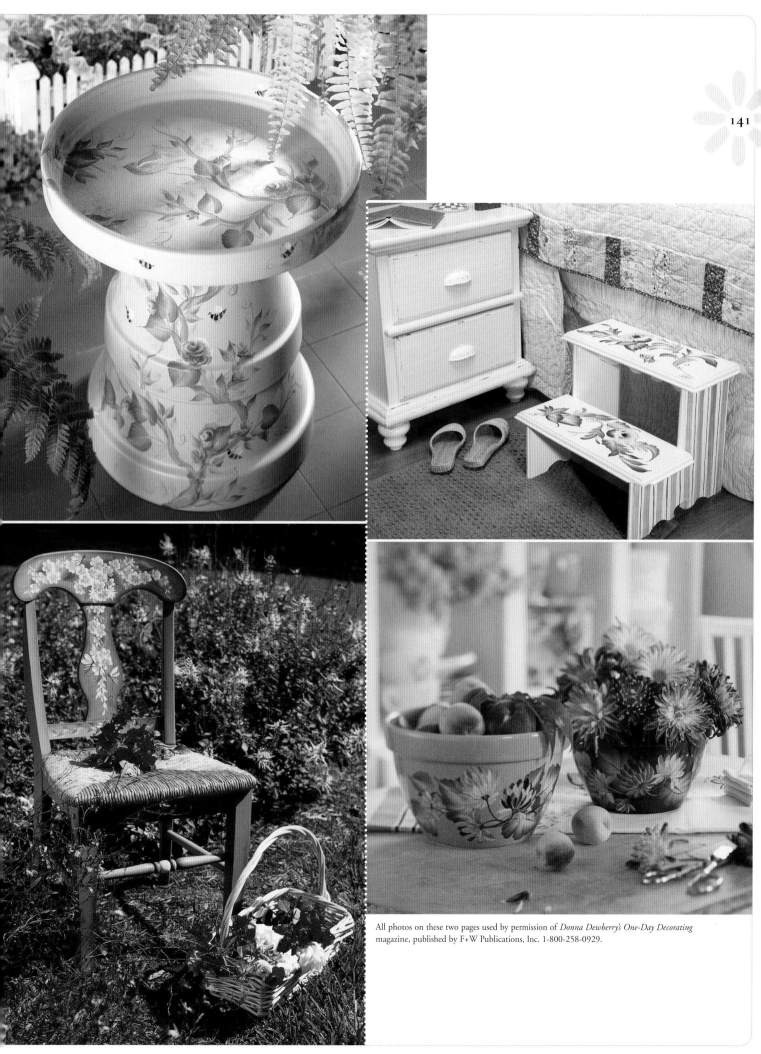

All photos on these two pages used by permission of *Donna Dewberry's One-Day Decorating* magazine, published by F+W Publications, Inc. 1-800-258-0929.

RESOURCES

Paints & Brushes

Plaid Enterprises, Inc.
P.O. Box 7600
Norcross, GA 30091-7600
USA
Phone: 678-291-8100
www.plaidonline.com

Dewberry Designs, Inc.
642 8th Street
Clermont, FL 34711
USA
Phone: 352-394-7344
www.onestroke.com

Canadian Retailers

Crafts Canada
2745 29th St. N.E.
Calgary, AL, T1Y 7B5

Folk Art Enterprises
P.O. Box 1088
Ridgetown, ON, N0P 2C0
Tel: 888-214-0062

MacPherson Craft Wholesale
83 Queen St. E.
P.O. Box 1870
St. Mary's, ON, N4X 1C2
Tel: 519-284-1741

Maureen McNaughton Enterprises, Inc.
RR #2
Belwood, ON, N0B 1J0
Tel: 519-843-5648
Fax: 519-843-6022
E-mail: maureen.mcnaughton.ent.inc@
 sympatico.ca
Web site: www.maureen.mcnaughton.com

Mercury Art & Craft Supershop
332 Wellington St.
London, ON, N6C 4P7
Tel: 519-434-1636

Town & Country Folk Art Supplies
93 Green Lane
Thornhill, ON, L3T 6K6
Tel: 905-882-0199

U.K. Retailers

Art Express
Index House
70 Burley Road
Leeds LS3 1JX
0800 731 4185
www.artexpress.co.uk

Atlantis Art Materials
146 Brick Lane
London E1 6RU
020 7377 8855

Crafts World (head office)
No. 8 North Street
Guildford
Surrey GU1 4 AF
07000 757070

Green & Stone
259 King's Road
London SW3 5EL
020 7352 0837

Hobby Crafts (head office)
River Court
Southern Sector
Bournemouth International Airport
Christchurch
Dorset BH23 6SE
0800 272387

Homecrafts Direct
PO Box 38
Leicester LE1 9BU
0116 251 3139

INDEX

THE BEST IN DECORATIVE PAINTING INSTRUCTION AND INSPIRATION IS FROM NORTH LIGHT BOOKS!

Give flea market finds a new life or transform unfinished pieces into fun focal points for your home! Inside Fabulous Painted Furniture you'll find 10 charming projects including a rocking chair with flourishes of roses, a functional tray with a wispy wreath, and an old-fashioned wash stand with an up-to-date design. Full color photos, step-by-step instructions and patterns make it easy to paint unique pieces to adorn your home.

ISBN 1-58180-462-8, paperback, 48 pages, #32719-K

Let Michelle Temares show you how to develop, draw, transfer and paint your own original designs for everything from furniture and decorative accessories to walls and interior decor. "Good" and "bad" examples illustrate each important lesson, while three step-by-step decorative painting projects help you make the leap from initial idea to completed composition!

ISBN 1-58180-263-3, paperback, 128 pages, #32128-K

Celebrate the seasons, holidays and family events with 25 quick and easy painting projects. You'll find gifts for all of your family and friends, most of which can be made in an afternoon or less. Easy to follow instructions and step-by-step photos make it easy for you create delightful projects for Mother's Day, Christmas, a new baby and more!

ISBN 1-58180-426-1, paperback, 144 pages, #32590-K

Transform your everyday outdoor furnishings into stunning, hand-painted garden accents. Acclaimed decorative painter Donna Dewberry shows you how to transform 15 deck, porch and patio pieces into truly lovely garden decor. Donna's easy-to-master brushwork techniques make each one fun and rewarding. No green thumb required!

ISBN 1-58180-144-0, paperback, 144 pages, #31889-K

These books and other fine North Light titles are available from your local art & craft retailer, bookstore, online supplier or by calling 1-800-448-0915.